THREE GENERATIONS
OF TWENTIETH-CENTURY ART

THREE GENERATIONS OF TWENTIETH-CENTURY ART

THE SIDNEY AND HARRIET JANIS COLLECTION OF THE MUSEUM OF MODERN ART

WITH A FOREWORD BY ALFRED H. BARR, JR.

INTRODUCTION BY WILLIAM RUBIN

THE MUSEUM OF MODERN ART NEW YORK

Distributed by New York Graphic Society Ltd., Greenwich, Connecticut

Published by The Museum of Modern Art, 1972
All rights reserved
Library of Congress Catalog Card Number:
68-17123
ISBN 0-87070-400-1
Printed in West Germany
Manufactured by Buchdruckerei
Brüder Hartmann, Berlin

Designed by James Wageman

The Museum of Modern Art
11 West 53 Street, New York, New York 10019

CONTENTS

ACKNOWLEDGMENTS viii

FOREWORD BY ALFRED H. BARR, JR. ix

INTRODUCTION BY WILLIAM RUBIN xiii

THREE GENERATIONS OF TWENTIETH-CENTURY ART
THE SIDNEY AND HARRIET JANIS COLLECTION OF THE MUSEUM OF MODERN ART

I. MODERN MASTERS AND MOVEMENTS IN EUROPE BEFORE THE SECOND WORLD WAR 1

Cubism, Expressionism, and Related Movements: *Léger, Picasso, Delaunay, Macdonald-Wright, Boccioni, Mondrian, van Doesburg, Lissitzky, Klee, Kandinsky, Jawlensky, Torres-García*

Dada, Surrealism, and Their Forerunners: *Duchamp, de Chirico, Dali, Magritte, Arp, Schwitters, Bellmer, Ernst, Brauner, Matta*

II. MODERN NAÏVE AND PRIMITIVE PAINTERS 77

Eilshemius, Kane, Sullivan, Doriani, Hirshfield, Vivin

III. POSTWAR MASTERS AND MOVEMENTS IN EUROPE AND AMERICA 97

Abstract Expressionism and Related Tendencies: *Dubuffet, Giacometti, Gorky, Tobey, Pollock, de Kooning, Kline, Still, Rothko, Newman, Klein*

Hard-Edge and Geometric: *Herbin, Albers, Anuszkiewicz, Kelly, Vasarely*

Pop Art and Affinities: *Steinberg, Fahlström, Johns, Dine, Lichtenstein, Rosenquist, Wesselmann, Oldenburg, Warhol, Segal, Marisol*

NOTES 170

CATALOGUE RAISONNÉ 175

APPENDIX: *Pollock "One"* 205

CHRONOLOGY 209

In the years devoted to the making of a collection touching upon three generations of twentieth-century art, there has been great pleasure and little despair—a brimful of ambrosia with a touch of bitterness.—Sidney Janis

turer." In the preface to the catalogue, Mr. Janis described the series of exhibitions as "the Advisory Committee's laboratory for experiment and research . . . a forum for untried ideas."

Mr. Janis produced another show in 1940 during the Museum's first Picasso exhibition. Using a full-size mounted photograph of Picasso's *Seated Nude* (or *Accordionist*) of 1911, Mr. Janis submitted one of the artist's most cryptic Cubist compositions to an exhaustive analysis of its formal and iconographic elements. He employed over fifty photographic details, linear diagrams with connecting rods, electrically lit color transparencies, but almost no words—a didactic tour de force.

Three years later Mr. Janis used a similar technique in an exhibition of paintings by Morris Hirshfield, the remarkable "modern primitive" whom he had included in his 1939 exhibition. The exhibition was not admired either by the critics or, indeed, by several Museum Trustees; but Mondrian was ardently enthusiastic. Duchamp and Giacometti were also to be impressed by Hirshfield's work, and his European reputation remains high.

Hirshfield had an important place in Mr. Janis's first book, *They Taught Themselves: American Primitive Painters of the 20th Century*, and so did John Kane and Patrick Sullivan; all three are well represented in the Janis collection (pages 89–92, 83, and 85). The Janises spent much time in the Museum's library, often sitting side by side while carrying on their researches for this and other publications.

Sidney Janis's scholarly attitude was expressed not only in his books and lectures but also in a number of enterprising exhibitions he presented later on at the art gallery he established in 1948. The Museum was glad to contribute to such shows but was slightly chagrined that a commercial gallery should anticipate by several years both the Museum's "Les Fauves" and "Futurism" exhibitions.

Fortunately for the Museum, the greatest Janis exhibition is his own collection, presented, thirty-two years after its first showing at The Museum of Modern Art, as a magnificent gift from Sidney Janis.

In every private collection one searches, often in vain, for capital works. There are, I believe, at least two such superb paintings in the Janis collection. Picasso's splendid *Painter and Model* of 1928 is remarkable for its intensity and complex invention. Perhaps of greater historic consequence is Boccioni's *Dynamism of a Soccer Player* of 1913 (page 23); gigantic in scale, furious in energy, it is the culminating painting by the leader of the Italian Futurists. The importance to the Museum of these paintings is obvious. Highly desirable, too, are many other works of exceptional quality: for instance, two Cubist Picassos of 1913 and 1914; Klee's *Actor's Mask*; a Dali of his best vintage; and a remarkable 1914 Mondrian (page 27), subtle in color and quite different from the six later Mondrians in the Janis collection and the ten already in the Museum.

Still other paintings have a special value because they fill gaps in the Museum's collection. None of the four Légers (page 5—9) approximates any of the sixteen we already have. The Cubist Delaunay (page 19) was badly needed, and so were the excellent late Herbin (page 135), the Dubuffet from the Corps de Dames series (page 103), Arp's *Pre-Adamite Doll* (page 63), and a late masterpiece by van Doesburg (page 35) that complements the Museum's two early works by the leader of the Dutch Stijl group.

The Museum buys many paintings by young, or at least little-known, artists in the hope that as time passes the purchases will seem to have been wise. Time then passes; some of the artists have indeed proved their worth, and to such a degree that we urgently need their more recent and mature work; but, quite rightly, their prices have often gone up beyond the limits of the Museum's purchase funds. To a remarkable degree, the Janis collection came to our aid. At the time of the gift, the Museum owned a single painting by Franz Kline, done in 1950 and acquired in 1952; one of the Janis Klines (page 125) was done about a decade later.

Of the three de Koonings we then owned, one was painted and bought in 1948, and the other two are dated 1952; but the Janis de Koonings (pages 121 and 123) were painted in 1958, 1960, and 1961. Six of the best younger Americans—Kelly, Lichtenstein, Marisol, Oldenburg, Segal, and Wesselmann—were represented in the Museum by one or two works each, dated between 1959 and 1962; works by the same six in the Janis collection were made in 1966, 1967, or 1968; and it may be added, almost all are of exceptional interest and quite different in style (pages 141, 153, 169, 159—160, 167, and 157). Equally desirable are representative paintings by the Swedish Fahlström (page 147), the French Yves Klein (page 133), and the American Rosenquist (page 155), none of whom was previously represented in our painting collection.

A number of other excellent works may parallel what the Museum already has; but such is the overall quality and relevance of the Janis collection that what at first may seem superfluous will be valuable in supplying material for study in depth, freshening the Museum galleries with unfamiliar works by familiar artists, and enabling us to make loans to other institutions in this country and abroad.

The value to the Museum rests not only in the collection itself, but in the generous conditions made by the donor. He did not ask that his gifts be shown together in special galleries after their first exhibition. Although he will retain partial ownership for years to come, Mr. Janis offered to let the Museum exhibit the works of art in New York and wherever else they are needed. Furthermore, with concern for posterity, Mr. Janis handsomely agreed that ten years after his death the Museum, after its usual careful deliberation, may sell or exchange certain works in the collection so that new additions may be acquired in the spirit and name of the donor. Subsequently, he modified even that liberal provision to allow the Museum to take advantage of the opportunity to acquire some exceptional works as they became available.

The Museum of Modern Art appreciates the magnanimous way in which Mr. Janis has given his collection as much as it welcomes the collection itself.

ALFRED H. BARR, JR.

INTRODUCTION

The Sidney Janis Gallery opened in 1948, during my junior year at college, with a Léger show that was a cameo retrospective, worthy in quality and historical emphasis of the best that one had come to expect from The Museum of Modern Art. With this single exhibition, the gallery became a "must" for discriminating amateurs. I did not know then that Sidney had met Léger in 1928 on the first of his trips to Paris as a young collector (at a time when collectors of avant-garde art were few in America), and that the quality of the show reflected two decades of familiarity with Léger's work. Later I saw the gallery's Matta exhibitions—an experience that triggered my subsequent involvement in that artist's work. When, almost a decade afterward, I was invited by The Museum of Modern Art to direct its Matta retrospective, I turned to Sidney for information and became aware, for the first time, just how close to the center of events he and his wife Hansi had been during—and even before—the war years. I had known, for example, that he had been a sponsor of the 1942 Surrealist exhibition "First Papers of Surrealism" and had written the foreword to its catalogue. But the extent of his personal contacts with the European artists in exile here during the war surprised me (for it was only recently that I saw the article "School of Paris Comes to U.S.," which he wrote on them, and which appeared in *Decision*, November–December 1941), as did even more the variety and number of his and Hansi's publications. The range of their research and the immediacy of their involvement with seeing and studying modern painting (activities detailed in the extensive Chronology) explained for me in part the particular kind of success their gallery was having, especially the *succès d'estime* of historical group shows like "Les Fauves" (1950), "Dada" (1953), and "Futurism" (1954), all held in advance of anything comparable by American museums.

Apart from the major art the gallery showed—and this drew one back there repeatedly—I, for one, also went there to chat about the work with Sidney and Hansi. An informal exponent of the comparative method, Sidney was more than commonly able to verbalize just what he felt was strong or weak in the work on exhibition. (I suppose I shouldn't have been surprised at Sidney's articulateness. He had sold his shirt company on the eve of the Second World War and had devoted himself to lecturing and writing about art for ten years before he became a dealer.) Whether or not one agreed with his conclusions, these were eye-sharpening sessions, and one came away with the feeling that it was certainly not by accident that the quality of the work he showed was so high.

Sometimes the art at hand during these chats would trigger reminiscences of particular interest. How many people did one know who had had the run of Picasso's studio every day for nine weeks? I recall his speaking, for example, of his first contacts with Pollock in 1942:

During 1942, my work on the book *Abstract & Surrealist Art in America* brought me into contact with abstract artists who were former pupils of Hans Hofmann. Lee Krasner was one of those whose work I decided to include. It was she who recommended as an interesting artist the then-unknown Pollock. Together we visited his studio on East Eighth Street. Pollock, silent and uncommunicative, had been working for some time, as I learned from Lee, on two paintings which showed quite an advance over his previous work. I liked both well enough to have them photographed for the book. Unfortunately, because of their close color values, the allover forms became so obscured in the black-and-white photographs as to make neither suitable for reproduction.

Early the next year, Pollock completed a painting in a new spirit which was to prophesy

even greater things to come. He named it *She-Wolf*. Two members of the Acquisition Committee of the Advisory Committee, Meyer Schapiro and myself, strongly recommended the purchase of this canvas by the Museum. It was reproduced in color in my book.

After leaving Pollock, I visited Hans Hofmann's studio next door. At this time Hofmann had been working on a series of still lifes with willow chairs, quite German Expressionist in spirit and unsuitable for the book. On this visit, I told Hofmann I was including the work of his neighbor, Jackson Pollock. Hofmann, however, did not seem to know him.

Some months later, Hofmann advised me he had just completed an abstract work, which he thought I might like to see. This I chose for the book, and it too appeared in color.

On other occasions, Sidney's recollections gave amusing insights into the tastes and personalities of the artists whom he had gotten to know. Different as they were, both as men and as artists, Mondrian and Hirshfield figured in the forefront of these friendships. Sidney had been a special champion of the latter and had organized the one-man exhibition of his work for The Museum of Modern Art in the summer of 1943. At the opening, he and Hirshfield met at the Museum entrance. Sidney recalls:

Upon entering, Hirshfield noticed a picture hanging on the main floor and asked, "What is that!" I said, "It's a Mondrian." This seemed to mean nothing to him, since he asked, "Who painted it?" "The artist's name is Mondrian." He wanted to know what it was doing there, and I replied, "It belongs to the Museum." Bewildered, he responded, "They paid money for that?"

Mondrian attended the Hirshfield opening and was favorably impressed by the exhibition. He spoke with enthusiasm about the two-dimensional aspect of Hirshfield's work and was pleased to note the artist's instinctive avoidance of perspective and deep space.

Shortly after Mondrian's arrival in New York, he had visited our apartment, where among paintings by Picasso, Léger, Klee, and his own [*Composition, 1933*] we had hung two works by Hirshfield, *Lion* and *Inseparable Friends*. He asked about the artist, whom he did not know, and concluded that "excepting the Picasso *Painter and Model*, these are the strongest works on the walls."

After knowing Sidney for a time, I raised the question of a visit to his and Hansi's private collection. Not surprisingly, and not unlike other dealers who have collections of their own, Sidney had always been somewhat guarded about what hung on the walls at home. (Clients always seem to want such pictures more than those at the galleries.) He was very gracious about it, however, and I spent a late afternoon among those pictures, many of which (with some more recent additions) constitute his magnanimous gift to the Museum.

Though the Janises' collecting touched on many of the main tendencies of twentieth-century painting, it reflected no attempt to form a synoptic or historical collection. There were blockbuster masterpieces, such as Picasso's *Painter and Model* (page 17) and Boccioni's *Dynamism of a Soccer Player* (page 23), and miniature masterpieces such as Dali's *Illumined Pleasures* (page 53); but there were also less famous, less "important" pictures of real quality—Brauner's *Talisman* (page 73), for example. Some were "difficult" pictures, which Sidney had originally offered at the gallery but which didn't get taken up. When he had a special love for such "rejects," he took them home, and they joined the collection. People learn in time, and one can imagine with what alacrity some of these Mondrians, Légers, Giacomettis, Magrittes, and Brauners would be snapped up today.

The anchor of Sidney's collection was Cubism in its various ramifications, and this forms the major constellation (pages 4–37) within the first section of this catalogue ("Cubism, Expressionism, and Related Movements"). Though Sidney and Hansi had once owned a Matisse (which they later exchanged for Picasso's *Painter and Model*), and the gallery held a "Fauves" exhibition in 1950, Fauvism did not figure in their private collection. Dada and Surrealism—the avant-garde movement of the period in which the Janises had been formed

as collectors and critics—played an important role and constitute the second grouping in the pre-World War II section of the catalogue (pages 48–75). The reconstruction of the *Bicycle Wheel* (page 49) witnesses Sidney's friendship with Marcel Duchamp (about whom he and Hansi had written an imaginative article in 1945) and anchors the Dada works, while a great de Chirico (page 51) does the same for the tradition of illusionist Surrealism.

More uniquely personal, and reflecting Sidney's long championship of American naïve artists, are the superb Hirshfields. These works, also for the most part pre-war, form the core of the second section of the catalogue (pages 77–95). Making no attempt to "survey" our native primitives (as he had in *They Taught Themselves: American Primitive Painters of the 20th Century*, published in 1942), Sidney's collection included works by other artists he had personally "discovered," such as Sullivan and Doriani.

Though Sidney had been familiar with the work of the younger New York artists in the 'forties and in 1944 had published some of their work in *Abstract & Surrealist Art in America*, the first seasons at the Janis Gallery were mostly devoted to showing European art. In 1951, however, following an exhibition, "Young Painters in U.S. & France," organized by Leo Castelli for the gallery the year before, Sidney at the invitation of the Galerie de France organized a show of American Abstract Expressionists. After its first viewing in New York, it was shown in Paris amid great controversy. Then, in November 1952, an exhibition of Pollock at the Janis Gallery opened a new phase of Sidney's activities as a dealer—a commitment emphasized later that same season with exhibitions of the work of Gorky and de Kooning. All these artists had, of course, already shown elsewhere, but Sidney's handling of them gave their exhibitions a new inflection. "His policy," Clement Greenberg wrote in 1958, "not only implied, it declared, that Pollock, de Kooning, Kline, Guston, Rothko, and Motherwell were to be judged by the same standards as Matisse and Picasso. . . . "

The Museum is indeed fortunate that The Sidney and Harriet Janis Collection contains major works by Pollock, Still, Rothko, Newman, and other Abstract Expressionists, which, together with works by their European counterparts Dubuffet and Giacometti, constitute the opening section (pages 100–131) of the third part of the catalogue, devoted to art after the Second World War. But it is equally fortunate that Sidney's collecting remained open-ended, so that as his activities as a dealer expanded to include younger artists who were just finding their originality, some of their key paintings and sculptures found their way into his home. The collection is particularly strong in work by Pop artists (pages 146–169), notably Oldenburg; but it is not without first-rate examples of hard-edge and geometrical abstraction by both older and younger painters (pages 134–143), among them Albers, Vasarely, and Kelly.

I have mentioned the open-endedness of Sidney's collecting. Nothing demonstrates this more dramatically than the terms of his gift, which allow the Janis collection to remain open-ended literally beyond his grave. In his Foreword Mr. Barr has already referred to the provision permitting—in fact, even urging—the Museum to sell or exchange paintings or sculptures in the Janis collection deemed less necessary in relation to the Museum's collection as a whole, in order to acquire others consistent with the spirit of the collection, including those exemplifying the vanguard of the future. Although it was originally stipulated that such sales or exchanges should take place beginning ten years after Sidney's death, he amended the terms of the original agreement to enable the Museum to acquire Pollock's key work *One* when it became available in 1968, and he has subsequently made further modifications in the agreement that have allowed the Museum to make other significant purchases. The inclusion of *One* as an Appendix to this catalogue (pages 205–208) is a tribute to Sidney Janis's generous and forward-looking attitude, virtually unique among donors to a museum.

WILLIAM RUBIN
Chief Curator, Painting and Sculpture Collection

I MODERN MASTERS AND MOVEMENTS IN EUROPE BEFORE THE SECOND WORLD WAR

CUBISM, EXPRESSIONISM, AND RELATED MOVEMENTS

DADA, SURREALISM, AND THEIR FORERUNNERS

EVEN IN THIS FIRST SECTION of the catalogue of The Sidney and Harriet Janis Collection, embracing masters who came to maturity before the Second World War, the range is remarkable. Taken together, these paintings and sculptures, and the dates at which they were acquired, reveal two noteworthy characteristics of Mr. Janis as a collector: first of all, considerable independence of any prevailing taste or fashion in art; and, coupled with this, a predilection for somewhat "tough" and difficult works rather than for those with more obvious sensuous appeal.

In this connection, an anecdote from the interview Mr. Janis gave in June 1967 is revealing. He reports that the first painting he and Mrs. Janis bought was a Matisse *Interior at Nice* of about 1923—a not-too-daring choice of a work in that artist's most conventional, relaxed, and decorative style. Four or five years later, he "fell in love" with Picasso's *Painter and Model* and succeeded in acquiring it from Paul Rosenberg in exchange for the Matisse. When he asked the dealer why, in fact, he was willing to part with such a magnificent Picasso on this basis, Rosenberg replied: "The Matisse I can sell immediately; the Picasso I wouldn't be able to sell for thirty years."

Looking over the collection, and noting some of Mr. Janis's recollections about the works and artists represented, one realizes that he has always responded with excitement to certain works and seems especially to prefer those that yield their secrets gradually to a viewer with the rare faculty for close attention and repeated scrutiny. Responding fully to aesthetic qualities, he is equally stimulated by any challenge to intellectual analysis. As regards this latter exercise, the title he gave one of his books, *They Taught Themselves*, might well be applied to its author—except for the fact that Mr. Janis, although an autodidact, was never a "primitive."

Many artists in the first rank among modern masters became his friends—Picasso, Mondrian, Léger, Duchamp, Arp, among others of the older generation we are considering. All had achieved fame by the time Mr. Janis came to know them, and many already had far wealthier patrons; the days in which he would open a gallery were still unforeseen. Obviously, what they responded to was the warmth of his enthusiasm and the perceptiveness of his mind as well as of his eye.

That these and later friendships with artists brought him great pleasure is apparent. Some he and Mrs. Janis sought out in their studios while on their yearly trips to Paris; others, like Duchamp, he came to know during their sojourn in the United States at the time of the war. His article discussing artists in exile ("School of Paris Comes to U.S.," published in 1941) was the first on that subject to appear. But his predilection for an artist's work seems not to have been dependent upon personal acquaintance; he never met Klee, for example, several of whose works were among the first that he acquired, nor Schwitters, although he eventually bought some two hundred of the Merz collages—six carefully chosen examples being included in his gift to the Museum.

"I like you because you are not interested in only one kind of art," Mondrian is reported to have once said to Sidney Janis. The Museum is indeed fortunate to be the beneficiary of a collector who could find delight in the intimate poetry of Schwitters and Klee, the furious energy of Boccioni's *Dynamism of a Soccer Player*, the schematic complexities and complex simplifications of Picasso's *Painter and Model*, the lyricism of Delaunay, the austere beauties of Mondrian, the intensity of Jawlensky, the pure elegance of the late Arp, the intricate symbolism of the jewel-like Dali, the mysterious suggestions of de Chirico, the sly wit of Magritte—and many, many more, epitomizing the astonishing diversity of modern art in the first half of the twentieth century.

FERNAND LÉGER French, 1881–1955

Bridge. 1908? Oil on canvas, 36 5/8 × 28 5/8 inches

The *Bridge* is an important picture that raises questions regarding the evolution of Léger's own style, his assimilation of influences from Paul Cézanne, and his relation to the Cubist works of Pablo Picasso and Georges Braque. The problem is complicated by the fact that, with the exception of some drawings, Léger destroyed almost all his work from 1902 to 1908, the transitional period that was the most painful of his life. The Cézanne memorial exhibition at the 1907 Salon d'Automne came as a revelation to Léger; as he declared later, he realized that "Cézanne, through his sensitivity to contrasts of form, was the only one of the Impressionists to lay his finger on the deeper nature of the plastic contrasts inherent in a work of art."[1] (Significantly, Léger gave the title "Contrasts of Form" to the series of cylindrical abstractions he painted in 1913.) Abandoning his earlier Neo-Impressionist and Fauve styles, Léger painted a number of works in which his assimilation of Cézanne's influence led him in a direction parallel to that being pursued independently by Picasso and Braque. Besides the *Bridge*, these include the *Woman Sewing* (page 191), a stiffly faceted figure painting that has been variously dated 1908, 1909, and 1910;[2] the *Nudes in the Forest* (page 191) of 1909–1910, exhibited at the Salon des Indépendants in April 1911, and the *Table and Fruit* (Minneapolis Institute of Arts), which has been given the date of 1909 but seems close stylistically to the *Wedding* (Musée National d'Art Moderne, Paris) of 1910–1911. In this sequence, the *Bridge* would seem to fall between the *Woman Sewing* and the tubular *Nudes in the Forest*, for it is more sophisticated in concept than the former, though stylistically less assured—perhaps owing to the greater difficulty Léger found in advancing Cézanne's ideas within the deep space of a landscape rather than in the relatively simpler theme of a single figure.[3]

Léger's assimilation of lessons from Cézanne is evident in the *Bridge* in the schematization of forms into simple geometric planes, the blurring of passages between the planes, and the tilting of the forms forward toward the picture plane to create an effect like bas-relief. The illusion of sculpturesque relief is further enhanced by the reduction of color to pale grays, greens, and buffs, accentuating the relationships between lights and darks.

During the summer of 1908, Braque evolved similar Cubist structures in the series of landscapes he painted at L'Estaque, while Picasso, in the north of France, was working independently along almost the same line. Léger spent that summer in Corsica and came to Paris at the end of the year, settling at La Ruche, where he met Guillaume Apollinaire, Max Jacob, Pierre Reverdy, Alexander Archipenko, and others conversant with Cubism as it developed. He did not meet Daniel-Henry Kahnweiler, Braque, or Picasso until 1910. Braque, however, exhibited his L'Estaque paintings at Kahnweiler's gallery in November 1908 and at the Salon des Indépendants in March 1909; and in the fall of 1909, Picasso showed at Kahnweiler's the landscapes he had painted during that summer at Horta de Ebro. Léger surely must have attended some of these exhibitions. The question is whether the *Bridge* was painted before Braque's exhibition in November 1908, thus representing an independent evolution based on Léger's assimilation of influences from Cézanne, or was done after he had come into contact with the early Cubist works of Braque and Picasso.

In any event, despite the affinities with those works, the *Bridge* already reveals certain tendencies prophetic of Léger's subsequent personal style. The simple, weighty forms suggest a peasant awkwardness and vigor. The recessional movement of the road in conjunction with the silhouetting of the monumental trees and houses emphasizes the contrast between space and sculptural solidity. By 1913, this solidity would mature into his cylindrical abstractions.

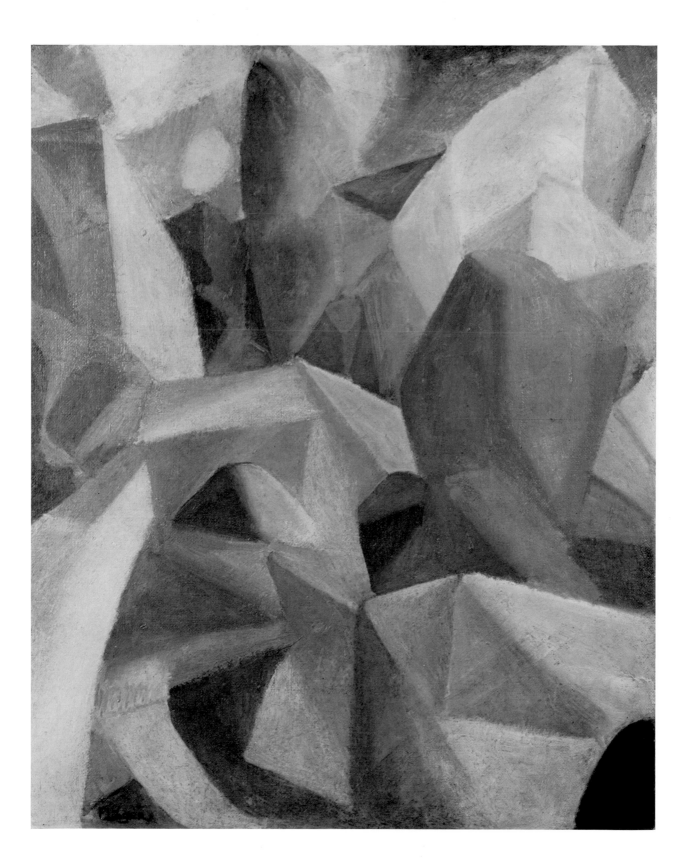

FERNAND LÉGER

Bargeman. 1918. Oil on canvas, 18 $\frac{1}{8}$ × 21 $\frac{7}{8}$ inches
Animated Landscape (Paysage animé 1^{er} état). 1921. Oil on canvas, 19 $\frac{7}{8}$ × 25 $\frac{3}{8}$ inches

At the outbreak of the First World War, Léger was inducted into the army. From then until 1918, he had little opportunity to paint, but the experience of those four years profoundly affected his subsequent style. "I was abruptly thrust into a reality which was both blinding and new," he wrote. "I was dazzled by the breech of a 75-millimeter gun which was standing uncovered in the sunlight: the magic of light on white metal . . . a complete revelation to me, both as a man and as a painter."[4]

The *Bargeman*, which dates from March 1918, was one of the first pictures Léger painted after his demobilization. The tubular structure of arms and legs, the division of single planes into more than one color (as in the right forearm of the bargeman with its passages of purple, green, rust, and cream), and the spatial displacement of the cylindrical drum are all survivals from his earlier style. This picture, however, shows Léger's new interest in the theme of the worker, which was to remain a favorite motif throughout his life. In subject and composition, it is related to the Tugboat series, painted after a drawing of 1917, to the *Sailor,*[5] 1918, and less directly to the *Acrobats in the Circus* and the *Mechanical Elements* in the Kunstmuseum, Basel, and the *Propellers* in The Museum of Modern Art—all of 1918. In these works, Léger appears well on the way to a new, schematic realism, in which rhythmically modeled forms are set against areas of flat, unbroken color.

In the *Animated Landscape*—one of a series painted in 1920 and 1921 showing men and animals in a rural setting—the tendency to flatten has progressed still further. The forms of the trees, peasants, and bull are modeled in low relief, allowing this central group to be more readily assimilated into the flat background design of landscape and houses. The forms in relief are also shaded with a single local color. Brushwork is smooth and tightly controlled, and color is used in a free, decorative way that shows affinities with the Synthetic Cubism of Picasso and Braque. In contrast to the energetic, motion-filled *Bargeman*, the composition is static and symmetrically organized around the central group; the mood is one of classic repose and pastoral calm.

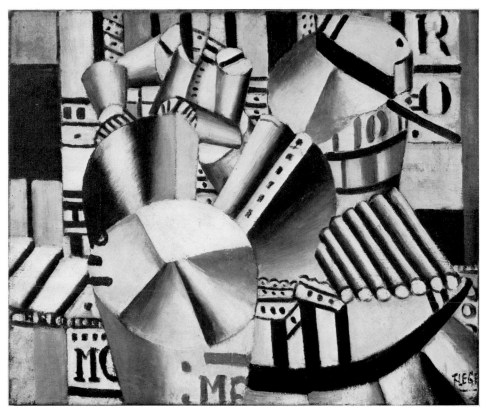

Bargeman

Animated Landscape

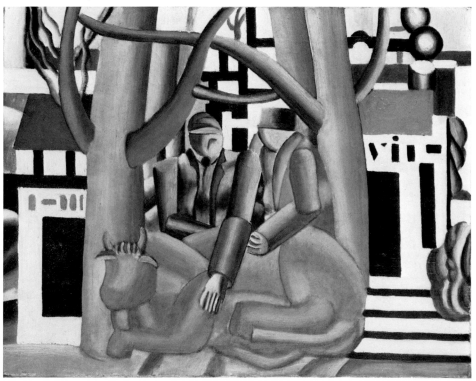

FERNAND LÉGER

Two Divers. 1942. Oil on canvas, 50 × 58 ¹/₈ inches

Léger's concern with dynamic movement and his opposite inclination toward the calm of immobility are fused in the suspended, frozen motion of the *Two Divers*, painted when he was in the United States as an exile during the Second World War. While in Marseilles in 1940 awaiting passage to America, Léger had observed young men plunging from the wharves into the sea, and he developed the theme in a series of paintings of Divers. In the earliest of these works, completed at Marseilles or in New York during 1940 and 1941 (and comparable to *The Divers, II* of 1941–1942 in The Museum of Modern Art), Léger retained the modeling, forms, and heavy, schematic chiaroscuro of his work of the 'thirties. In the Janis *Two Divers*, however, he totally eliminated the vestiges of modeling and concentrated instead on the rhythmic possibilities of heavy, black, curvilinear outlines. At the same time, he carried forward the possibility, already explored in his work of the 'twenties, of disengaging pure color from chiaroscuro. In the *Two Divers*, as in other later paintings (such as the more advanced of the Divers and Circus series), he also succeeded in divorcing color from drawing. The fluid black lines that define the slow-motion progress of the divers are superimposed over geometric slabs of red, green, and blue—an effect that Léger characterized as "painting outside of the drawing" (*peinture en dehors du dessin*). Each element functions in an unexpectedly independent manner. Picasso had attempted a similar feat in his *Running Minotaur* of 1928 (Zervos VII, fig. 423), in which a drawn figure moves across a large, flat, geometric shape. The powerful exactitude of Léger's heavy line, however, unites the figure and ground in a more tightly knit design. The black lines, primary colors, simple geometrical forms, and unqualified flatness of image suggest for the first time in Léger's art an affinity with the painting of Piet Mondrian, who also spent the years of the Second World War in exile in New York.

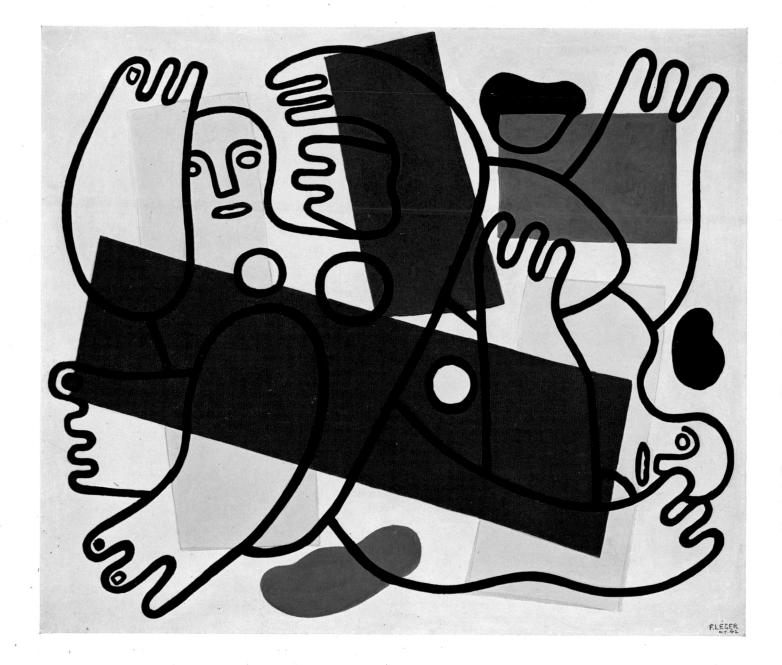

PABLO PICASSO Spanish, born 1881

Head. Spring 1913. Collage, pen and ink, pencil, and watercolor on paper, $17 \times 11^{3}/_{8}$ inches, irregular

Glass, Guitar, and Bottle. Spring 1913. Oil, pasted paper, gesso, and pencil on canvas, $25^{3}/_{4} \times 21^{1}/_{8}$ inches

Glass, Newspaper, and Bottle. Fall 1914. Oil and sand on canvas, $14^{1}/_{4} \times 24^{1}/_{8}$ inches

Taken together, these three works by Pablo Picasso demonstrate the transition from Analytical to Synthetic Cubism, and the early development of collage and its impact. During the winter of 1911/12, the painters working in the most advanced Cubist style widened the distance between image and motif, so that the latter was almost beyond recognition. Then, late in 1912, both Picasso and Georges Braque stepped back from the brink of total abstraction. Their invention of collage implied a return to the world of reality by virtue of the recognizable materials—newsprint, wrapping paper, labels, and other studio detritus—glued to the surface. At the same time, there was a return to recognizable imagery, which was to be carried further in Picasso's work of the next few years.

In this *Head,* one of Picasso's earliest collages, the representation is still schematic, but the facial features can be identified far more readily than in the immediately preceding paintings. (A similar collage, the *Man with a Hat,* December 1912, is in the collection of The Museum of Modern Art.) The graphic structure of the *Head* derives from these works but lacks their illusion of luminous, shallow space. Here, the lines delineate completely flat planes, and this two-dimensionality is reaffirmed by the newsprint and colored-paper collage on the surface. Daniel-Henry Kahnweiler, who once owned this work, has written of the collages of this period that in them the artists "proposed to renounce more than ever the artifices of the brush, replacing the 'hand-painted' surface with these 'readymade' elements."[6] The directness of the collage procedure is echoed in the simplicity of the line drawing and the unfussy way in which the gray watercolor is brushed in at the right. Beneath them, the vestiges of a preliminary pencil sketch are partly visible, and traces of erased lines measure the effort required to distill such simplicity.

For this *Head,* as for many of his 1912–1913 collages, Picasso took the formal components of human head and figure from those of musical instruments (such as the guitar, mandolin, and violin), his favorite still-life themes. Here the subject could, in fact, be mistaken for pure still life, were it not for the eyes and ears. The double curves at the right and the semicircles at top and bottom echo the lines of a violin, as does the lobed shape of the ears. Mr. Janis has noted that, in a sort of visual pun, the sound holes of the violin become the ears of the head.

Recently Robert Rosenblum has identified the newsprint used for the *Head* as a clipping from an article on the coronation of Czar Alexander III in Moscow, which appeared on the front page of the Paris newspaper *Le Figaro* for May 28, 1883. The brownish tonality of the old paper apparently appealed to Picasso, who incorporated snippets from the same article in at least three other collages. By a study of this group in relation to others securely dated by internal evidence, Mr. Rosenblum has established that they were executed in spring 1913 rather than during winter 1912/13, as previously believed.[7]

In the *Glass, Guitar, and Bottle,* which like the *Head* was also once owned by Kahnweiler, the guitar is still somewhat fragmented, as in Cubist works of 1911–1912; but the glass at the left and the bottle at the right have been synthesized into readable and integral forms, each accompanied by its shadow. The bottle, however, has been reduced to a single flat

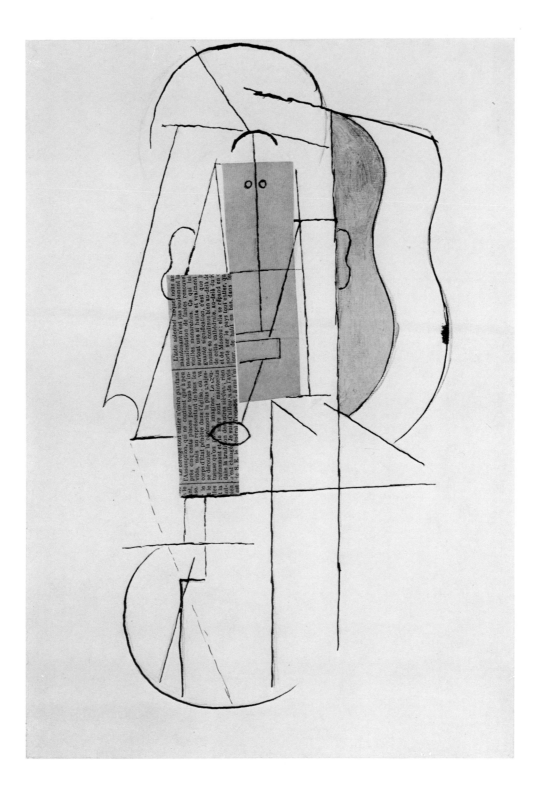

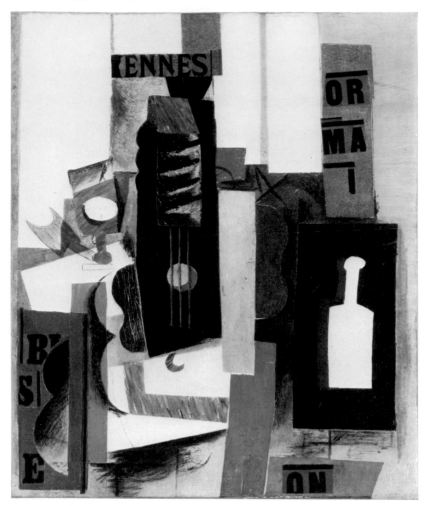

Glass, Guitar, and Bottle

Glass, Newspaper, and Bottle

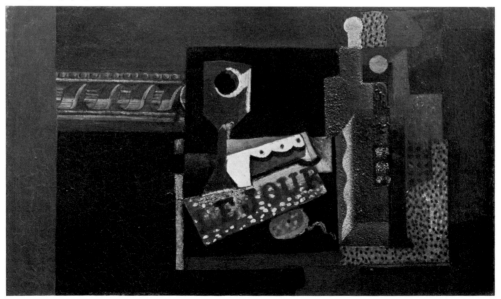

plane that seems almost cut out of its ground. Across the canvas there is an illusionistic play of ambiguously receding and advancing shapes, as in the hole of the guitar and the mouth of the glass.

Though its colors were originally more varied (some of the olive green has faded to coffee brown), this picture is still largely conceived within the monochromatic tonality of Analytical Cubism. Nevertheless, its textural richness and technical virtuosity, characteristic of much of Picasso's work of 1913, make this one of his superb pictures. Brushwork ranges from the sketchiness of the shadows and "ghost" guitar at the lower left to the sign painter's precision of the large black letters superimposed onto collage fragments; and only the closest scrutiny enables one to distinguish the applied bits from the details rendered in *trompe l'oeil.*

In the *Glass, Newspaper, and Bottle,* painted a year and a half after the *Head* and *Glass, Guitar, and Bottle,* subsequent refinements of Synthetic Cubism are apparent. The generally rigorous flatness is relieved only by the illusionism of the bottom of the bottle receding into space and by the band of simulated wallpaper border at the upper left. This element (perhaps a reminiscence of Braque's experience as decorator, which underlies the origins of collage) reflects the impact of collage, as does the "newspaper," lettered LE JOUR[NAL], which is not newsprint, however, but a surface painted in pointillist technique.

Stylistically, the *Glass, Newspaper, and Bottle* can be compared to The Museum of Modern Art's *Green Still Life,* painted the summer before. In both, sand is used to differentiate the textures of pigment and reduce shadows to decorative dots. Their iconography is also similar; however, in this painting, despite its later date, the prevailing blacks, browns, and dark greens, as well as the rectilinear structure, are more attuned to the severer aspects of Analytical Cubism than to the gaiety of the earlier canvas.

There is an even more direct relation between the *Glass, Newspaper, and Bottle* and the famous construction of the same year, the *Still Life* with upholstery fringe (page 199). The parallels are clear not only in composition, with an identical "empty" left side traversed by a patterned horizontal band extending from the vessel of a stemmed glass, but also in details, such as the scalloped handle of the knife, presumably there to cut the fruit lying before the newspaper in the painting—the counterpart of the tomato in the construction. The dotted newspaper in the one is analogous to the similarly dotted slice of bread in the other. In fact, apart from medium, the only major differences between the two works are the absence in the painting of the rounded table edge with fringe, and the presence of the bottle—which, however, incorporates some aspects of the construction.

PABLO PICASSO

Seated Woman. December 1926. Oil on canvas, $8^3/_4 \times 5$ inches

In contrast to the objectivity of his Cubist works, Picasso's paintings of 1926 evince a concern for psychological values, particularly those of an aggressive and disquieting nature, which during the following decade would relate his work to both Surrealism and Expressionism. This little painting, one of the first to manifest this tendency, relies for its effect largely on the double-head image, a device foreshadowed as early as 1907 in the *Demoiselles d'Avignon* (The Museum of Modern Art) and a standard in Picasso's repertory by the mid-'twenties.[8] Robert Melville has suggested that it derived from the scarification stripes painted on the cheeks of African masks, with which Picasso was familiar.[9] He gradually transformed it into a heavy emblematic shadow, and finally into a double image of front face and profile, perhaps climaxed in The Museum of Modern Art's *Girl before a Mirror*, 1932.

In the *Seated Woman*, there are actually two profiles, very different in mood—one based on the immense nose shape projecting to the left, with a receding chin, the second facing right, with hawk nose and open mouth. Both are contained within a larger form that may be identified as the frontal view of the head—an interpretation reinforced by the frontality of the elongated eye. The two discs at either side of the head, the lozenge and the arrow-target, are ambiguous but may indicate spots of rouge on the cheeks (although the arrow shape may be a visual variant of the toothed mouth). The body, also, is organized so that its frontal shape contains a profile—the area of the red-striped dress (again a forerunner of the *Girl before a Mirror*). The tension induced by these dual images is further expressed in the tightly clasped hands at the lower center, the culminating point of the painting's arabesques.

In contrast to the tension betrayed by the divided double-head image in this painting, the magnificent *Seated Woman* of the following year (page 199) conveys an impression of serene grandeur. In that large painting, the profile—angular and aggressive in the Janis picture—has become passive and mysterious.

14

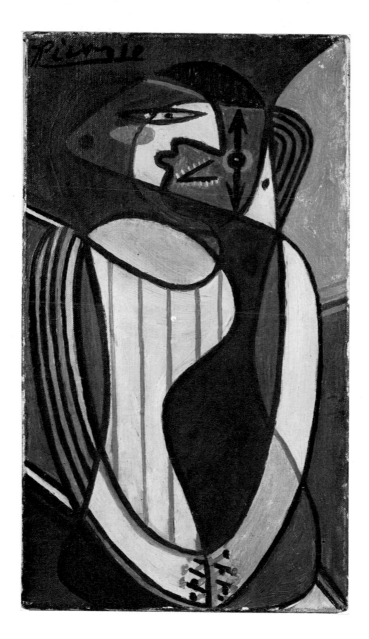

15

PABLO PICASSO

Painter and Model. 1928. Oil on canvas, 51 $^{1}/_{8} \times$ 64 $^{1}/_{4}$ inches

Between 1925 and 1933, Picasso painted five major abstractions of the painter and his model, a theme that he also realized in two suites of etchings, the neoclassical illustrations for Balzac's *Chef d'œuvre inconnu* (1927, published 1931) and *The Sculptor's Studio* (1933). In one of the Balzac prints, the artist's subject, a middle-aged peasant woman, knitting, is represented realistically, but her image on the artist's canvas appears only as a tangle of lines with no recognizable image, aside from the reference to the skein of wool. In the *Painter and Model*, as Harriet Janis pointed out in a detailed analysis, Picasso has wittily reversed this situation: "The artist and his model are abstracted to an advanced degree while the concept in the canvas on the easel is in terms of realism. By this reversal in the scheme of reality the extraordinary artist and model are declared ordinary and the natural profile becomes the astonishing product of the artist's invention."[10]

The major prototype for this work is The Museum of Modern Art's painting of 1927–1928, *The Studio* (page 200), a far sparser, more geometric version of the theme. In it, the model is a sculptured bust or cast, which may also be the case in the Janis painting, although it has always been taken for granted that the model in the latter was a full-length living figure. The profile head on a graceful sloping neck, however, is cut off at the shoulders by four heavy lines over gray that clearly seem to represent the molding on a sculpture's pedestal. The entire left side of the canvas, even down to the white line at the left of the otherwise yellow frame of the mirror, is painted in black, white, and gray, bearing out the inanimate character of the model—a scheme repeated also in the picture on the easel. On the other hand, the lines beneath the pedestal can be read either as its base or as the lower part of a standing figure in a skirt. This ambiguity is entirely characteristic of Picasso and is related especially to the Pygmalion iconography of many drawings and prints of the sculptor's studio.

The elements of the composition are predominantly geometric. Both the *Painter and Model* and *The Studio* are structured upon an armature of black lines that form a horizontal-vertical grid; in both, the triangle is a dominant formal motif, reflected in minor shapes throughout the picture. The triangles are formed by the intersection of nearly parallel diagonals with the grid. Besides the triangle, there are repeated rectangles and circles.

In contrast to the geometrical elements in the *Painter and Model* are the kidney-shaped palette and the curved back of the yellow chair, decorated with a fleur-de-lis reminiscent of Matisse. As in *The Studio*, the heads of painter and model each contain three oval features; the arrow shape that splits the top of the artist's head is a more resolved variant of the arrow in the head of the 1926 *Seated Woman* (page 15). Forms are embodied in essentially light-and-dark relationships, with the bright color occurring primarily as accent; the surface throughout is a heavy impasto.

The Armenian-born American painter Arshile Gorky was particularly fond of this canvas and often came to the Janises' apartment to see it. It is second only to Picasso's *Girl before a Mirror* in its influence on Gorky's work of the 'thirties; the heavy impasto and outlining of the forms in black were adapted by Gorky for such pictures as the *Composition with Head*, c. 1934–1936 (Private collection),[11] and the kidney shape of the artist's palette is the focal point of the *Enigmatic Combat*, c. 1936 (San Francisco Museum of Art).

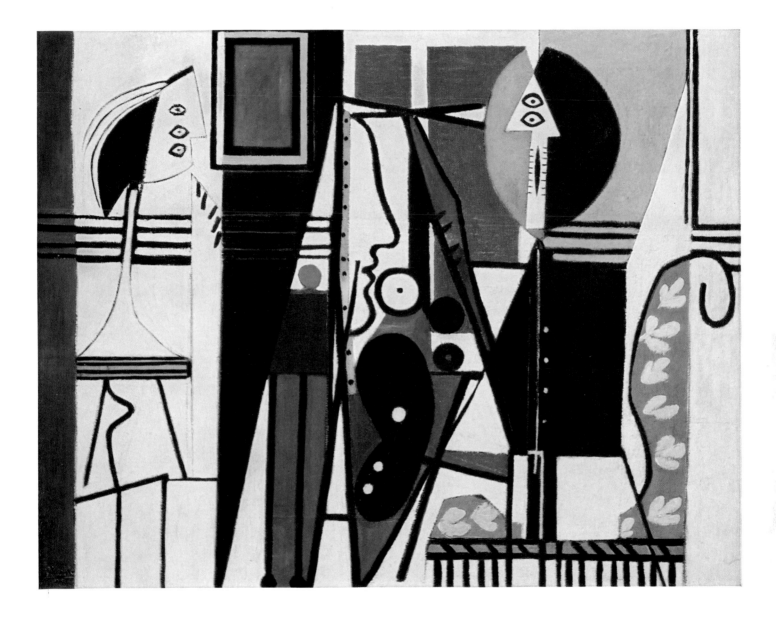

ROBERT DELAUNAY French, 1885–1941

Windows. 1912. Encaustic on canvas, $31\,^1/_2 \times 27\,^5/_8$ inches

At the Salon d'Automne of 1912, Robert Delaunay showed one of a series of Window paintings that he had executed during the preceding summer. In two notable respects, these pictures—of which the Janis *Windows* is a typical example—marked a departure both from his previous art and from the principles of Analytical Cubism. The heretofore monochromatic, semitransparent tones of Cubism were replaced with color, which was, however, kept pale and delicately shaded in order to preserve the underlying light-dark armature of eliding planes. Further, whereas the motifs in Delaunay's previous Eiffel Tower and City series had been clearly legible, the Windows verged upon total abstraction, like the most advanced paintings done by Picasso and Braque during the winter 1911/12. In the Janis picture, we can make out suggestions of houses and roofs in the foreground and the Eiffel Tower in the top center; but for the most part the composition has been reduced to a sequence of subdivided squares and rectangles, tilted and interlocking in space.

Paul Klee, as a young artist and critic, was quick to recognize the innovations introduced by Delaunay. When one of the paintings of the Window series was shown in a group exhibition in Zurich in 1912, he wrote a review for a Swiss journal, in which he stated that Delaunay had created "the sort of painting which is self-sufficient, and borrows nothing from nature, possessing an entirely abstract existence as far as the form is concerned."[12] In general, the almost watercolor effect of these pictures influenced German, rather than French, painting and in fact is reflected in Klee's own work.

The Windows series also impressed Guillaume Apollinaire, who termed this new development in Delaunay's art "Orphic Cubism" and was inspired late in 1912 to create a poem of the same title, "Les Fenêtres." Written in free verse, it is one of the earliest poems in which Apollinaire eliminated punctuation and used seemingly disconnected phrases, arranged in a way that he considered analogous to the composition of the paintings.

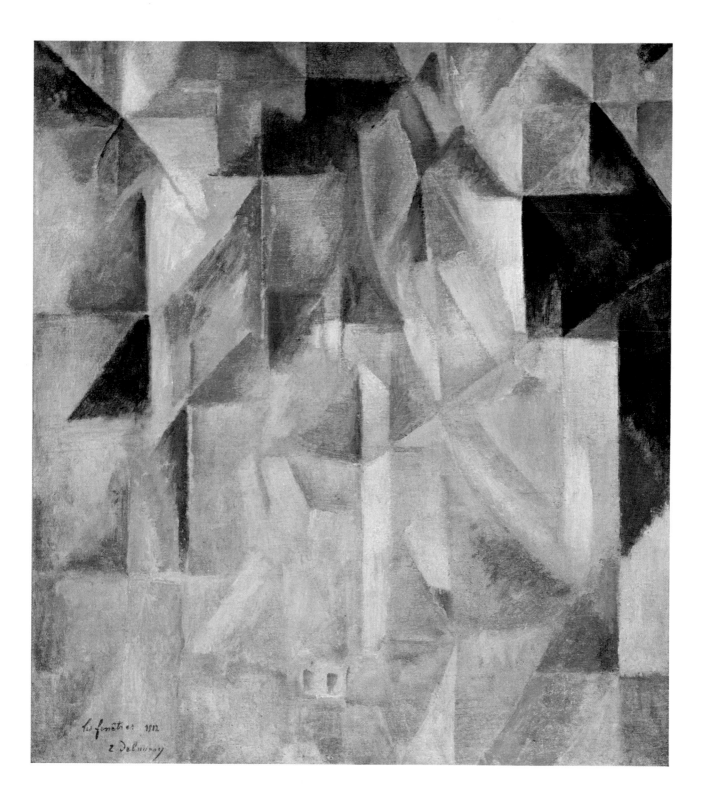

STANTON MACDONALD-WRIGHT American, born 1890

Synchromy in Blue. c. 1917–1918. Oil on canvas, 26 ¼ × 20 ⅛ inches
Trumpet Flowers. 1919. Oil on canvas, 18 ⅛ × 13 ⅛ inches

Robert Delaunay's paintings of 1912–1913 were to prove widely influential, but they functioned most directly as catalyst for the emerging styles of Stanton Macdonald-Wright and Morgan Russell. The meeting in Paris in 1911 of these two young Americans, who shared an interest in color abstraction, began an association that led to their joint exhibitions in Munich and Paris in 1913 as "Synchromists." Though this name literally means "with color," it also carries obvious allusions to the musical term "symphony" as well. The name of their movement, together with their insistence upon color alone as the generating force behind their Cubist forms, connected them with Delaunay's Orphic Cubism.

Combining Delaunay's manner of focusing on color and light (through the overlapping and dissolving planes of Analytical Cubism) with their own readings in color theory (especially the writings of Michel Chevreul and Ogden Rood), they eventually succeeded in finding expression for their ideas. Particularly important to them was a chapter in Rood's *Modern Chromatics* of 1879 on the harmony of color in pairs and triads. Developing this principle in their paintings, they used a dominant color key and variations on it in a manner analogous to major and minor variations on a musical theme.

Most of Macdonald-Wright's fully evolved Synchromies were made after his return to New York in 1916. His work was shown at Alfred Stieglitz's "291" gallery in 1917. Like The Museum of Modern Art's *Synchromy*, painted in that year, the Janis collection *Synchromy in Blue* is based on the figure of a seated nude (according to the artist, a self-portrait), depicted in Analytical Cubist forms infused with color and light. Sidney Janis has remarked on certain similarities between this painting and Umberto Boccioni's *Dynamism of a Soccer Player* of 1913 (page 23),[13] suggestive perhaps of an unconscious influence, or at least a mutual source of inspiration, upon Macdonald-Wright, who quite probably saw the 1912 Futurist show in Paris.

The *Trumpet Flowers*, executed in California in 1919, is less structured than the earlier work and more obviously derived from a model; yet the picture's effulgent and loose brushwork still suggest a kind of musicality.

Synchromy in Blue

Trumpet Flowers

21

UMBERTO BOCCIONI Italian, 1882–1916

Dynamism of a Soccer Player. 1913. Oil on canvas, 6 feet 4 1/8 inches × 6 feet 7 1/8 inches

In 1910, in the Futurist Painting: Technical Manifesto, Umberto Boccioni and his associates in the movement announced that "the gesture which we would reproduce on canvas shall no longer be a fixed *moment* in universal dynamism. It shall simply be the dynamic sensation itself."[14] Three years later, Boccioni executed the *Dynamism of a Soccer Player*, one of the masterpieces of Futurism and the most perfect realization of his goals. Identical principles found sculptural expression the same year in his *Unique Forms of Continuity in Space* (page 177), in which the running figure in the painting is transformed into a striding one.

By adapting the transparencies and shallow space of Analytical Cubism, with which he had become familiar at the 1911 Salon d'Automne in Paris, Boccioni in this painting fulfilled his intention of showing forms that interpenetrated with their surroundings. In so doing, he translated the rectilinear grid of Cubism into an almost baroque composition of swirling forms. In accordance with the cinematic principles set forth in the Manifesto, the player's successive positions are rendered simultaneously. The suggestions of his anatomy dissolve into radiating planes of atmospheric light. The Divisionist brushwork that Boccioni had used in his earlier work of 1910, *The City Rises* (The Museum of Modern Art), is here translated into staccato lines of force. As he developed the centrifugal patterns that communicate the soccer player's motion through space, Boccioni found the canvas too small for his conception and sewed additional pieces onto three sides, enlarging its area by approximately one-fifth.

The painting was first exhibited in the United States in the show of their work that the Futurist artists themselves organized as part of the Panama-Pacific International Exposition in San Francisco in 1915. Until 1953, the year before it was acquired by the Janis collection, the *Dynamism of a Soccer Player* remained in the possession of Filippo Tommaso Marinetti, the progenitor of Futurism, and his widow, Donna Benedetta.

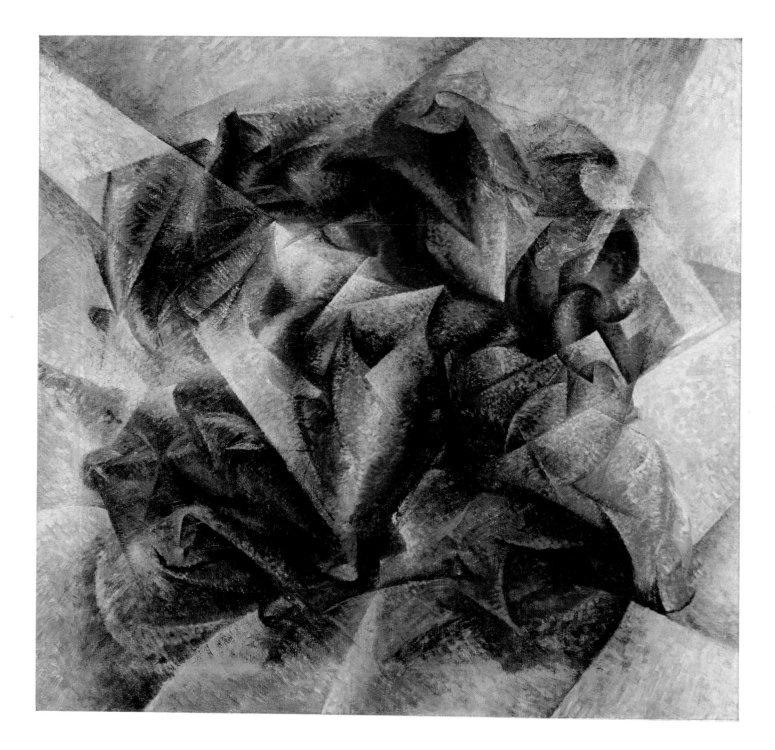

23

PIET MONDRIAN Dutch, 1872–1944

Red Amaryllis with Blue Background. c. 1907. Watercolor, $18^{3}/_{8} \times 13$ inches

The eight paintings by Piet Mondrian in the Janis collection range from the artist's early naturalistic style through his progressively more severe abstraction to the more freely optical effects of the works done shortly before his death.

In a memoir about his work before 1910, Mondrian recalled, "Even at this time, I disliked particular movement, such as people in action. I enjoyed painting flowers, not bouquets, but a single flower at a time, in order that I might better express its plastic structure."[15] And in a letter of 1916 about the 1907—1908 oil, *Dying Chrysanthemum* (page 195), he wrote, "You are surprised that I wish to dissect the delicate beauty and transform it into vertical and horizontal lines. I very readily admit your wonder, *but* it is not my intention to depict the delicate beauty. . . . I too find the flower beautiful in its physical appearance, but there is hidden in it a deeper beauty. I did not know how to depict this when I painted the dying chrysanthemum with the long stem. I formed it through emotion and the emotion was human, perhaps universally human; later I found too much emotion in this work and painted a blue flower differently. This stood stiffly staring and already promised more of the immutable."[16] The *Red Amaryllis with Blue Background* in The Sidney and Harriet Janis Collection is clearly of the same series as the "stiffly staring" blue flower (*Blue Chrysanthemum*, The Solomon R. Guggenheim Museum). Despite its lyrical grace and the symbolic nuances of its cruciform shape, this watercolor is absolutely symmetrical, with a distinctly rectilinear composition that predicts Mondrian's mature work. Later, Mondrian was to note that the flaccid line in the natural appearance of things is a relaxation of form, and that "much of this early work has no permanent value." Nevertheless, he insisted, "I never painted these things romantically; but from the very beginning, I was always a realist."[17] In 1911, he was to take the kind of pictorial analysis and abstraction of nature suggested in the *Red Amaryllis with Blue Background* much further in a series of Trees. These in turn led to the still more rigorously reduced Façades, to which the *Composition, V* of 1914 in the Janis collection belongs (page 27).

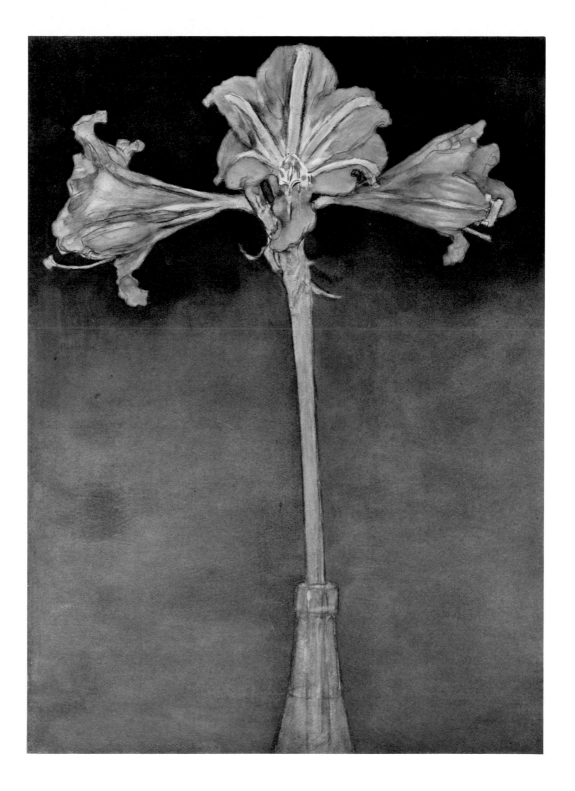

PIET MONDRIAN

Composition, V. 1914. Oil on canvas, 21 ⁵/₈ × 33 ⁵/₈ inches
Composition with Color Planes, V. 1917. Oil on canvas, 19 ³/₈ × 24 ¹/₈ inches

In December 1911, Mondrian moved to Paris, where he became fully aware of Analytical Cubism. He recognized it as "the right path,"[18] but he came to find Cubism "still fundamentally naturalistic"[19] and unwilling to follow "the logical consequences of its own discoveries."[20] In his Analytical Cubist pictures of 1912 and 1913 (such as the Museum's *Composition in Brown and Gray*, 1913, or *Composition, VII*, painted slightly later that same year, in The Solomon R. Guggenheim Museum), Mondrian had adhered to the muted monochromatic tonalities of the style as developed by Picasso and Braque. The tender blue, ocher, and rose of the 1914 painting *Composition, V*, however, are pastel versions of the pure primary colors to which he later restricted himself. By 1914, Mondrian had gone further than either Braque or Picasso in abstracting the motif and in fragmenting planes into smaller and smaller units, until a more evenly articulated, almost allover lattice was formed. The *Composition, V* is insistent upon the rectilinear grid, but it still floats in a very shallow atmospheric space, fading toward the edge in a vestige of the Analytical Cubist resolution of sculptural into painterly effects that Mondrian had achieved between late 1910 and early 1912. The relation of this painting to The Museum of Modern Art's *Blue Façade* (page 195) is an intriguing one. Though the latter has sometimes been placed as early as late 1913, its more summary execution, the way its scaffolding of black lines reaches out to the edge of the field, and its greater commitment to color suggest that it is later than the Janis painting.

Although the paintings of this period appear nonfigurative, Mondrian continued to work from his Paris sketches of trees, houses, and church façades after returning to the Netherlands in July 1914. He simplified and reorganized them until their naturalism almost disappeared. The *Composition, V* may have originated in drawings of the church of Notre Dame des Champs on the boulevard Montparnasse; there is an echo of the Greek cross of its rose window at left center, and the painting's curvilinear lines reflect the arched forms of the façade.

In this painting Mondrian has moved away from the symmetrical and has assumed the point-counterpoint structure that informs his mature work. Nevertheless, he wrote later that he felt he had still been working "as an Impressionist, and was continuing to express particular feelings, not pure reality."[21] The Façade paintings, with their muted color and painterly touch, might have paid unconscious homage to Monet's Cathedral series, but they also looked ahead to the emphasis on the flat plane by their sheer choice of absolutely frontal subject matter. The "plus-and-minus" paintings that followed eliminated the curved line; the grid broke up into blocks of color, and the emphasis on brushwork disappeared.

In 1915, Mondrian met Theo van Doesburg, and in 1916, Bart van der Leck, whose work with flat color planes was particularly important to both Mondrian and van Doesburg at this time. In 1917, the three collaborated in founding de Stijl. Its program called for rectangular form, primary colors, and asymmetrical composition. The *Composition with Color Planes, V* in the Janis collection is one of a series in which Mondrian began to explore the possibilities of these principles.[22] In the white-based mauve, blue-gray, and ocher of the 1917 work, he retains the tonality of his *Composition, V*, but the paint is flatter, the edges more precise; the rectangles are autonomous shapes rather than the colored interstices of a loosely knit grid, and there is no longer any trace of natural image. The *Composition with Color Planes, V* represents an advanced stage in the direct evolution of Mondrian's work from a blocky

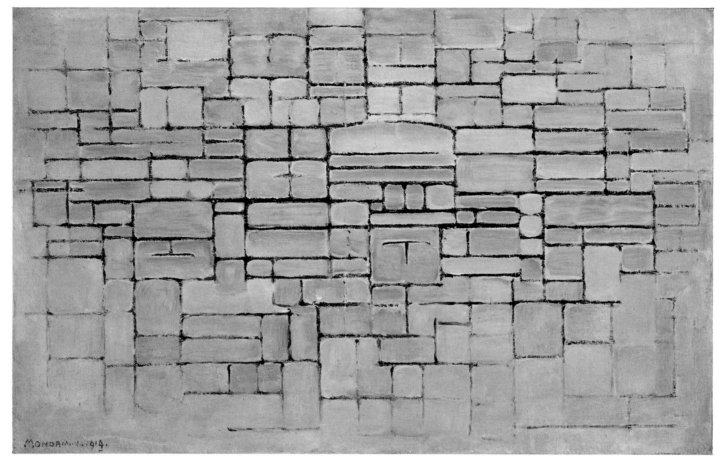

Composition, V

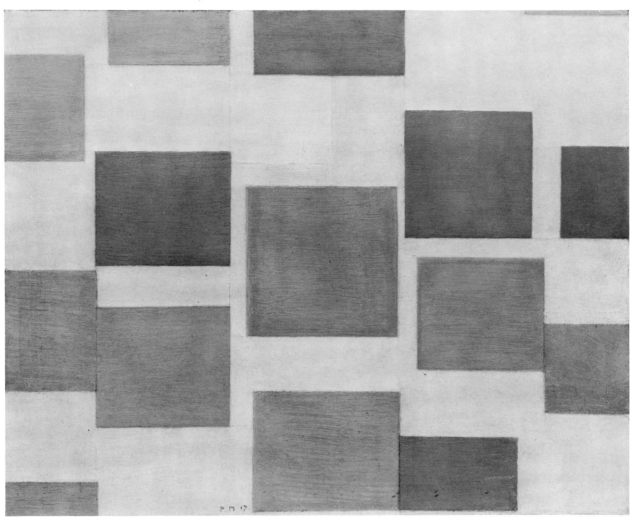

Composition with Color Planes, V

pointillism to linear patterning to rectangular blocks of color and, finally, to the rigorously developed program of de Stijl.

Despite the fact that Mondrian was working toward the "exclusion of the arbitrary," the *Composition with Color Planes, V* and similar paintings are still somewhat tentative, and some seem crowded with ambiguously related shapes. In this work, the large central ocher square stabilizes the other shapes to some extent, but at the cost of the ordered movement sought by the artist. While working on this series, Mondrian realized that he had still not achieved an entirely flat plane: "In my early pictures space was still a background. . . . Feeling the lack of unity, I brought the rectangles together: space became white, black or gray; form became red, blue or yellow. Uniting the rectangles was equivalent to continuing the verticals and horizontals . . . over the entire composition. It was evident that rectangles, like all particular forms, obtrude themselves and must be neutralized through the composition. In fact, rectangles are never an aim in themselves, but a logical consequence of their determining lines, which are continuous in space; they appear spontaneously through the crossing of horizontal and vertical lines. . . . Later, in order to abolish the manifestation of planes as rectangles, I reduced my color and accentuated the limiting lines, crossing them one over the other. Thus the planes were not only cut and abolished, but their relationships became more active."[23]

PIET MONDRIAN

Composition, I. 1931. Oil on canvas, 19⁷/₈×19⁷/₈ inches
Composition. 1933. Oil on canvas, 16¹/₄×13¹/₈ inches
Composition with Blue Square, II. 1936–1942. Oil on canvas, 24¹/₂×23⁷/₈ inches
Composition in Yellow, Blue, and White, I. 1937. Oil on canvas, 22¹/₂×21³/₄ inches
Composition in Red, Blue, and Yellow. 1937–1942. Oil on canvas, 23³/₄×21⁷/₈ inches

The two paintings of 1931 and 1933, *Composition, I* and *Composition,* exemplify the "classic" style that Mondrian followed from 1921 to 1935. In both works, his principle of a "dynamic equilibrium" between the vertical and horizontal of the picture's framing edge reaches a climax of pure clarity—which seems to prove his point that the right angle is the only satisfying relationship. The *Composition, I* (formerly owned by Friedl Vordemberge-Gildewart, a late adherent of de Stijl) is one of the most architecturally monumental of the classic pictures. All color is located in the lower half, with only a single band of black dividing the upper half of the field. This rare compositional structure is paralleled in the *Composition with Yellow* Spot of 1930 (Kunstsammlung Nordrhein-Westfalen, Düsseldorf) that was seemingly its model.

Mondrian was his own most severe critic, later judging the work of this period as too static, too monumental. However, if the 1931 work is square and decidedly earthbound in its emphasis on the lower horizontal, the 1933 *Composition* stresses the column of red at the upper left, throwing the weight off to one side but not allowing the column to unbalance the whole, since it moves steadily upward in an extension of the painting's vertical format. This was the first of the eight Mondrians in the collection to be acquired by Mr. Janis; he chose it in 1932 in the artist's studio, before it was completed. Because of his special feeling for this work, George Segal incorporated it into his *Portrait of Sidney Janis with Mondrian Painting* (page 167).

The *Composition with Blue Square, II,* the *Composition in Yellow, Blue, and White, I,* and the *Composition in Red, Blue, and Yellow* were all begun in 1936–1937 while Mondrian was working in Paris and London, but he completed the first and third only during his wartime exile in New York. They mark stages in his tendency, first observable in 1936, to multiply the number of black bands traversing the entire surface so as to allude more clearly to the underlying grid and further vitalize the picture plane. (If Mondrian had continued to work on the *Yellow, Blue, and White* as he did on the other two compositions, he would probably have extended the horizontal bands to the edge.) Furthermore, the multiple bands endow the surface with an overall unity, allowing a more eccentric placement of color. The single touch of blue in the *Composition with Blue Square, II* introduces one irregular section into the regular pattern of the rest of the plane. The prototype for this painting is the *Composition with Blue* of 1935 (Collection Mrs. Lydia Malbin, Birmingham, Michigan), although in that work the blue square is larger and exists as an architectural block rather than as an accent.

With the exception of some pictures of 1921 and 1922, in which the black bands were seemingly abandoned short of the framing edge, all the color planes in Mondrian's classic pictures were bounded on all sides by such bands or by the edge of the canvas. The color plane becomes liberated, however, in such later works as the *Composition in Red, Blue, and Yellow,* in which the red plane at center right is contained only on two sides. Mondrian was moving toward the extraordinary optical effects of his last works, particularly The Museum of Modern Art's great *Broadway Boogie Woogie* of 1942–1943. This openness parallels Mondrian's refusal to frame his paintings, in favor of mounting them so that they project into the room as objects among other real objects.

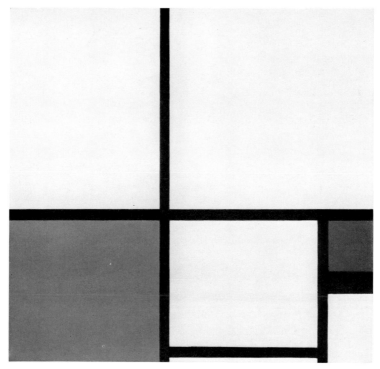

Composition, I

Composition

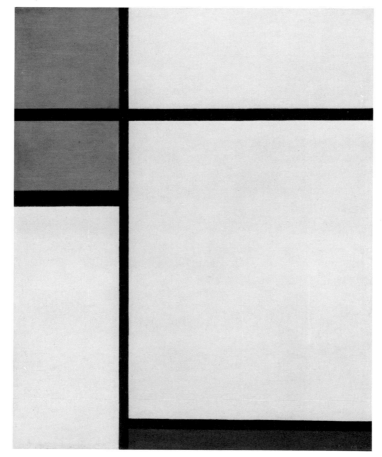

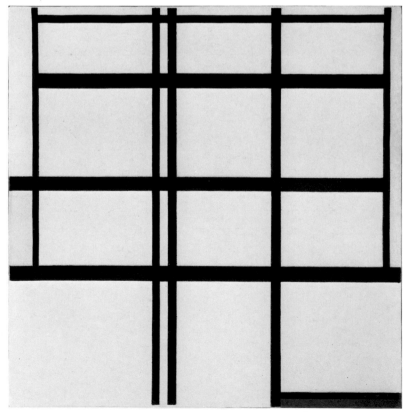

Composition with Blue Square, II

Composition in Yellow, Blue, and White, I

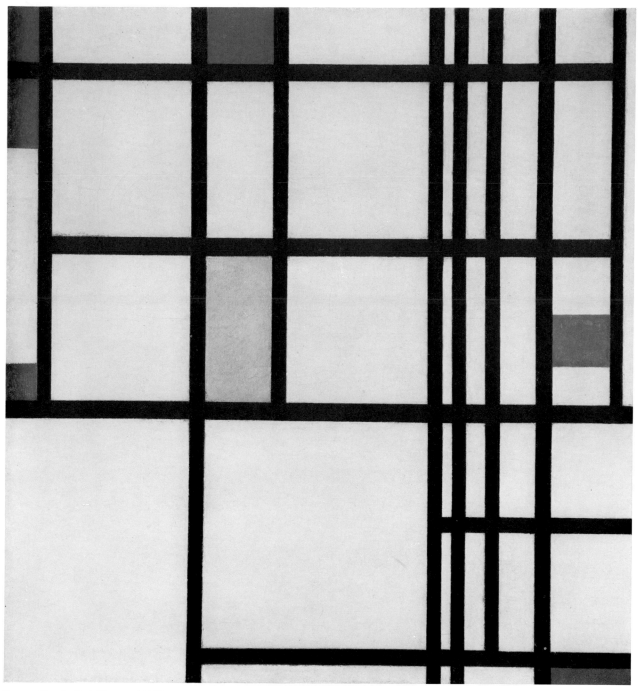

Composition in Red, Blue, and Yellow

THEO VAN DOESBURG Dutch, 1883–1931

Simultaneous Counter-Composition. 1929–1930. Oil on canvas, $19^{3}/_{4} \times 19^{5}/_{8}$ inches

Theo van Doesburg was the founder of *De Stijl*, the periodical of the group by the same name, which became the instrument for the creation of the Neo-Plastic movement as well as an outstanding organ for other avant-garde movements of the time. Critic, lecturer, poet, novelist, designer, typographer, and architect, as well as painter and sculptor, van Doesburg gave the magazine a broad, determinedly international and experimental character. Unlike Piet Mondrian, he was restless, even expressionist, by nature. Under the pseudonym I. K. Bonset, he participated in the Dada movement by publishing five issues of *Mecano* in 1921 and 1922, while at the same time he associated himself with the German Bauhaus and strongly influenced the very different direction it was taking. In reaction to this eclecticism, Mondrian resigned from the Stijl group in 1925.

Van Doesburg began to develop his painting about 1916, fusing Bart van der Leck's flat color planes and Mondrian's vertical-horizontal grid. About 1920, he began to experiment with mathematical devices, and finally, in defiance of Mondrian's premise, he introduced the "forbidden" diagonal axis and began to call his own work Elementarism. The *Simultaneous Counter-Composition* in the Janis collection is a prime example of this development. The four flat color rectangles appear to be shifting their positions on the surface; the superimposed tilted right angle contradicts and similarly shifts the rectangular format, while freezing the color planes in mid-movement. The vestigial extension of the left-hand bar below the angle in order to overlap the square in the lower left serves as a further controlling device. This type of dynamic composition is closer in effect to Suprematist and Constructivist principles, and especially to the work of El Lissitzky (page 37), who was a friend of van Doesburg, than it is to Mondrian's more static paintings of about the same date, such as the *Composition, I,* 1931, and the *Composition,* 1933 (both, page 31).

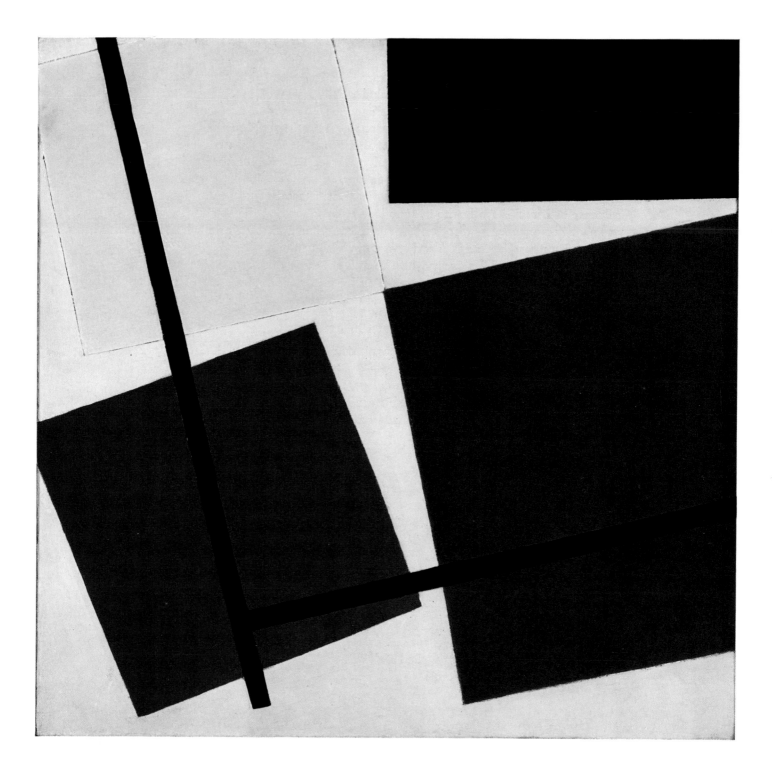

EL LISSITZKY Russian, 1890–1941

Study for page from *About Two Squares in Six Constructions: A Suprematist Story*. 1920.
Watercolor and pencil on cardboard, 10$^{1}/_{8}$×8 inches

The designs for *About Two Squares in Six Constructions* were made in 1920, while El Lis-
sitzky was teaching at the Vitebsk Academy. The content of this "Suprematist Story" is "a
symbolic representation of the 1917 Revolution; the arrival of a red square, its destruction of
the black square, and the eventual establishment of the red square on the black, the new order
on the old."[24] In formal terms, it was probably intended—although ostensibly a children's
book—as a way of filtering Constructivist ideas into adult consciousness. The medium of book
illustration was a natural choice for Lissitzky, who earlier in his career had been an illustrator
of Yiddish stories and tales from Russian folklore.

Lissitzky was trained as an architect in Darmstadt but turned to painting under the
influence of Marc Chagall, who in 1919 hired him to teach at the Vitebsk Academy. Chagall
was shortly succeeded as director of the academy, however, by Kasimir Malevich, who had
founded Suprematism in 1915; and it was under his impetus that Lissitzky embarked on a
series of paintings and designs in which he sought to unite painting and architecture. He gave
them the name "Proun," an acronym for "Project for the Affirmation of the New." They,
represented a uniquely lyrical and architectural fusion of the basic concepts of Malevich's
Suprematism and Vladimir Tatlin's Constructivism. To the accepted vocabulary of square,
circle, and rectangle, Lissitzky added the parallelogram and a three-dimensionality or spatial
dynamic quite at variance with the flatness insisted upon by Malevich (and independently by
Piet Mondrian).

About Two Squares in Six Constructions, first published as a ten-page booklet in Berlin
in 1922, has an important place in the history of graphic art, because it is considered the first
example of the "new typography." Lissitzky was active in Germany between 1921 and 1923,
and his influence was particularly strong there at this time. He came into contact with László
Moholy-Nagy and Mies van der Rohe, who were instrumental in transmitting Lissitzky's
principles of the "new typography" to the Bauhaus; and these principles gained still wider
dissemination through the publication (also in 1922) of *About Two Squares in Six Construc-
tions* in Theo van Doesburg's international periodical *De Stijl*.

This watercolor is the basis for the second "construction," the sixth page of the book;
the image is the same, although the typography differs slightly from the printed version. The
caption corresponds to the third line of the full story, which in translation is as follows:

Don't read; get paper, rods, blocks, set them out, paint them, build.

Here are two squares.

They fly on to the Earth from far away and

And see a black storm

Crash—and everything flies apart.

And on the black was established Red Clearly

This is the end—let's go on.[25]

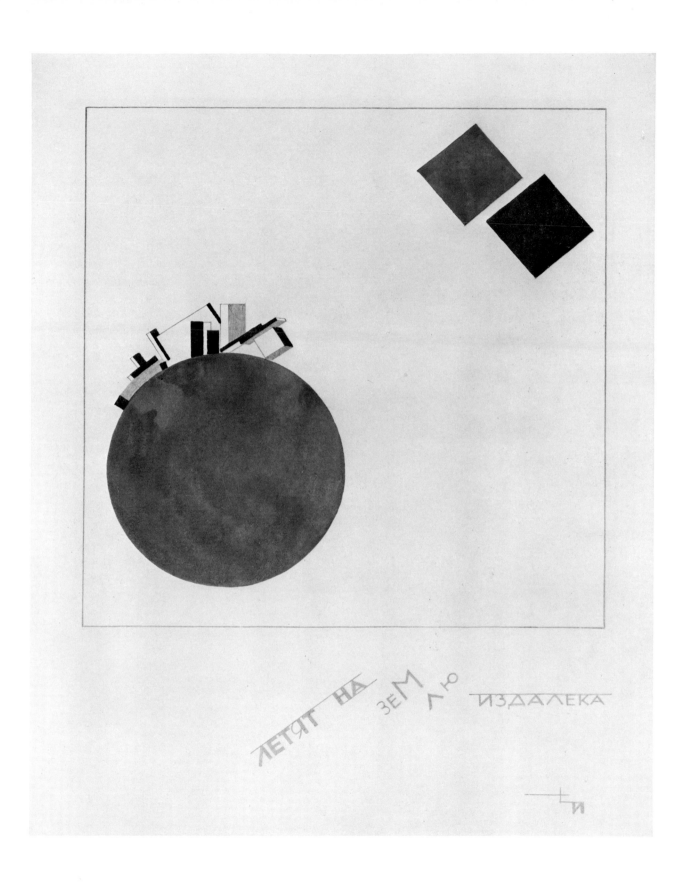

PAUL KLEE German, born Switzerland. 1879–1940

Actor's Mask (Schauspielermaske). 1924. Oil on canvas mounted on board,
14 ½ × 13 ⅜ inches

Together with a third painting by Paul Klee, the *Actor's Mask* and *In the Grass* were among the earliest works to be acquired by the Janises. All three entered their collection shortly after being shown in The Museum of Modern Art's exhibition "Weber, Klee, Lehmbruck, Maillol" in 1930.

The actor's mask was one of the earliest themes in Klee's phenomenally rich iconography, going back to his drawings and Comedian etchings of 1903–1904 and reflecting the influence of James Ensor, an important one for Klee in his early years. The theme is an outgrowth of Klee's love for the theater (together with music, perhaps the most constant of his interests), which led him to study in theatrical and ethnographical museums, and later to make puppets. The *Actor's Mask*, painted in 1924, reflects this study of primitive cultures through its strong resemblance to certain Melanesian masks, a resemblance that is even clearer in some later works of Klee. The impassive frontal stare characteristic of all Klee's figures and heads, both animal and human, is in itself a reflection of an ancient mask aesthetic. There is an extremely close connection between man and animal in his work, a connection that at times amounts to a confusion of the two, such as one finds in primitive cultures and in children's tales. Here, the eyes resemble the hypnotic gaze of a cat.

As the critic Andrew Forge has noted, "Unlike the early etchings, which are drawings of imaginary faces and masks, in the *Actor's Mask*, mask and face are one. The strata-like formation out of which the features grow is ancient. It is as though time had slowly pressed out the eyes, the mouth. Pressure seems to bear across the face in the parallel red lines."[26] Thus the striated patterning of the face is suggestive both of tattooing and of geological strata, giving the face a primordial appearance. Such striations were later to be specifically identified with landscape in the series of images that Klee produced following his trip to Egypt in the winter of 1928/29.

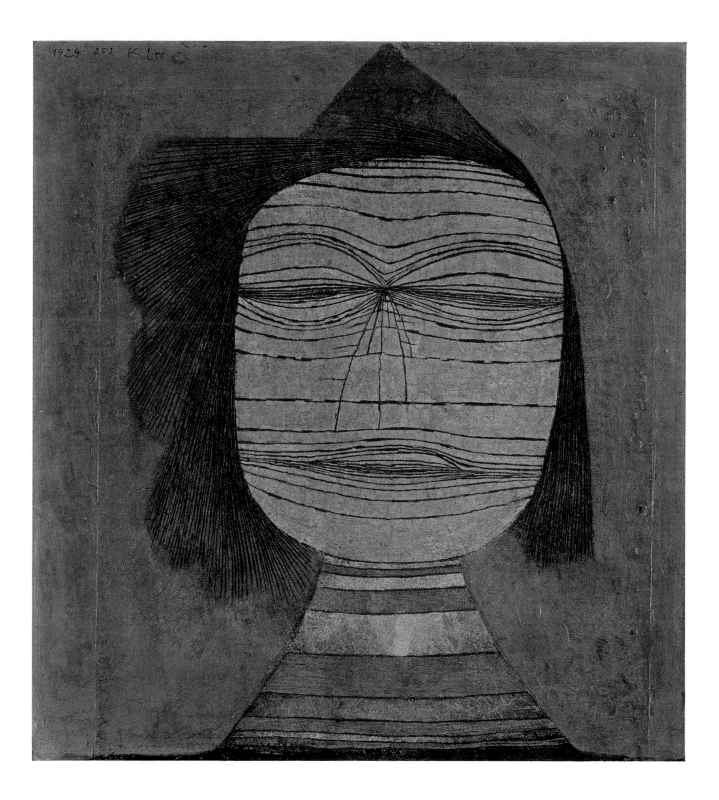

PAUL KLEE

In the Grass (Im Gras). 1930. Oil on canvas, $16\,^5/_8 \times 20\,^3/_4$ inches

From 1929 to 1931, Paul Klee taught at the Bauhaus; like Kandinsky, his fellow teacher there, he was involved with theoretical studies, which, however, found very different expression in his work. In the *Pedagogical Sketchbook*, published in 1925, Klee was concerned primarily with line and its kinetic possibilities. Despite its apparently random and graffitolike appearance, *In the Grass* is constructed upon a basic grid and an almost musical geometry. Compared to *Hohei*, an etching on a similar theme made two years earlier, this painting is carefully and schematically drawn.

Klee believed, nevertheless, that "communication with nature" was still more basic for the artist than any formal structure.[27] He loved to get his eye exceedingly close to the surface patterning of things and, by the insightful process that he called *Hineinsehen*, derive from them an empathic, animated world. In many of his works, which seem to anticipate Jean Dubuffet's Botanical Elements (see page 108), Klee concentrated on the minutiae of the world of biological and ultimately cosmic growth that he wanted to express. The figures, flowers, and animals of his *In the Grass* all seem as if composed of blades of grass, a poetic basis for his almost total restriction of line to scratchings on the green ground.

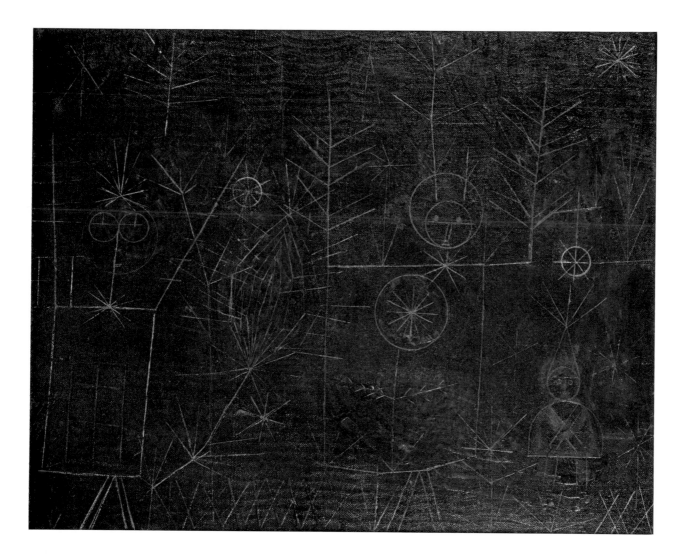

WASSILY KANDINSKY Russian, 1866–1944

Lightly Touching (Leicht berührt). 1931. Oil on cardboard, 27 $^5/_8$ × 19 $^1/_4$ inches

The *Lightly Touching* is typical of the precise geometric style of Wassily Kandinsky's Bauhaus period (1922–1932), in which the circle, triangle, and square replaced the expressive, freely undulating forms of his Blue Rider paintings. The rational atmosphere of the Bauhaus and Kandinsky's association with other artists teaching there, especially his friend Paul Klee, led him to channel his mysticism and fondness for systematic analysis into the formulation of a pictorial grammar. Whereas his first book, *On the Spiritual in Art*, 1912, had set forth his psychological theory of color, *Point and Line to Plane*, published by the Bauhaus in 1926, was subtitled a "contribution to the analysis of pictorial elements." Forms and planes were defined according to their potentialities for movement; the horizontal was postulated as the most concise form of the infinitely cold, and the vertical of the infinitely warm. Some of Kandinsky's Bauhaus paintings are almost diagrams of intent in their use of arrows for directional thrust and of segmented or perspectival forms to define the relationship to the picture plane. In some, color is reduced to a background tone.

The Janis painting, *Lightly Touching*, treats the tensions that result from an overall structure defined only by points of contact between forms. None of these forms fits squarely into the next; those at the lower right seem magnetically attracted to the gently balanced central structure. Fairly homogeneous in size, all the shapes remain on the flat surface, their implied linear movement vitalizing the plane. The result is a rigorous composition that trembles on the brink of either disintegration or reconstruction.

Anticipated by such of Kandinsky's works of 1927 as the *Angular* (Collection Mme Nina Kandinsky, Paris)[28] and the *Square* (Galerie Aimé Maeght, Paris),[29] the structure of the *Lightly Touching* in turn prefigures the work of Victor Vasarely and Optical art. Elements are dispersed over the plane in a way that closely relates this painting to some of Kandinsky's more fragmented compositions of about the same date, such as his *Heavy and Light*, 1930 (Collection Philippe Dotremont, Brussels),[30] the *Individual Forms*, 1931 (Collection Aimé Maeght, Paris),[31] and the ceramics for the music-room mural at the International Exhibition of Architecture, Berlin, 1931.

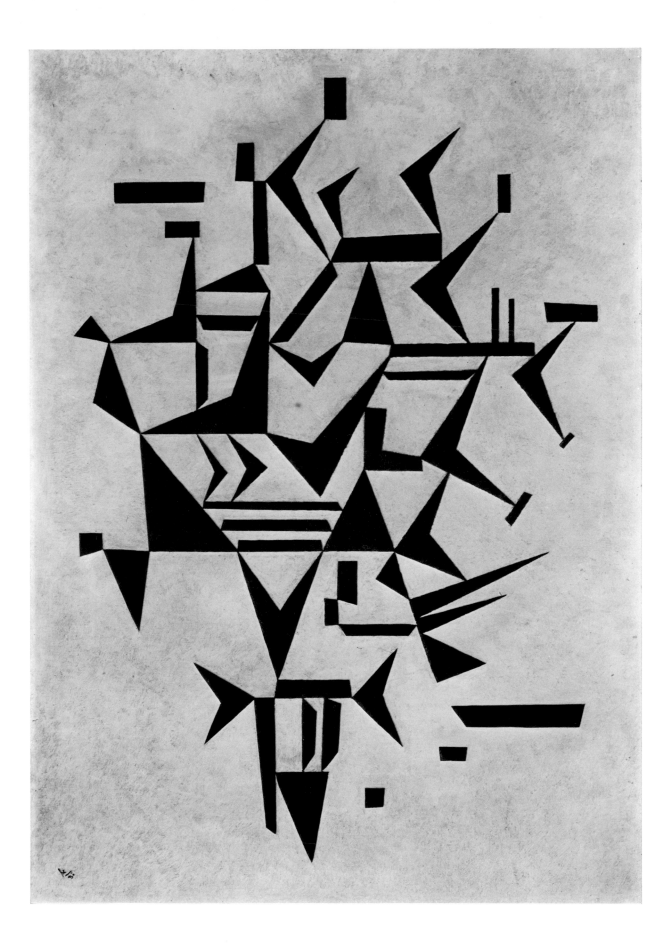

ALEXEY JAWLENSKY Russian, 1864–1941

Meditation: Yellow Head. 1936. Oil on cloth-textured paper, $9^3/_4 \times 7^3/_8$ inches

The *Yellow Head* is one of a series of paintings on the Meditation theme—the last series undertaken by Alexey Jawlensky. From 1930 on, he was ill and only rarely able to paint. Between 1934 and 1937 he restricted himself to two subjects: the almost identically depicted faces of the Mater Dolorosa and the Christ Crucified. The close-up image of a face pressing against the framing edge was, however, characteristic of his art long before these little-known late works. A group of women's heads from the Blue Rider period, between 1910 and 1913 (of which one example of 1910 is in the Museum's collection), anticipates the format; by 1916 the head nearly fills the canvas.

Jawlensky's use of serial imagery began with his landscape Variations, made between 1914 and 1919. A single composition might be repeated two hundred times, each repetition showing only minor alterations in color and placement. The Head series, begun in 1922, crystallized between 1925 and 1933. These paintings were planar and extremely geometric, with hard lines used to vary the facial structure. They were apparently influenced by the theories of Jawlensky's friends and colleagues at the Bauhaus, Wassily Kandinsky, Paul Klee, and Lyonel Feininger, who, with him, were known as the "Blue Four." Thereafter, Jawlensky moved into the more personal Meditation series.

Paul Cézanne and Vincent van Gogh had been the earliest influences upon Jawlensky's art, and it was from them that he developed the curious combination of structural clarity and mystical expression, strong composition and emotive paint handling, that continued to provide the core for his last works. The transformation of the human head into pure form, of flesh into spirit, induced greater spiritual concentration through discipline, and the works in the Meditation series have rightly been compared to the icons of the Russian-born Jawlensky's Orthodox faith. The possibilities for modification within the fixed norm of these heads are sharply reduced, so that the viewer is forced to seek out those features that vary.

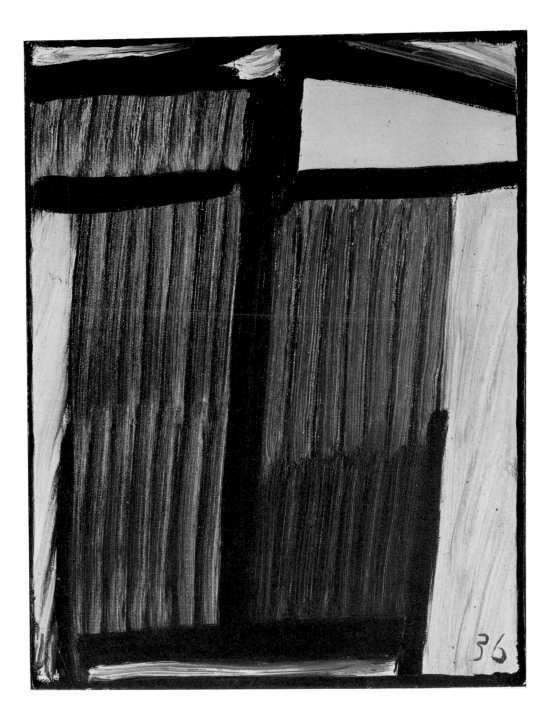

JOAQUÍN TORRES-GARCÍA Uruguayan, 1874–1949

Constructive Painting. c. 1931. Oil on canvas, 29⅝ × 21⅞ inches

The monochromatic palette and shallow space of Joaquín Torres-García's Universal Constructions are directly traceable to Cubism, but the rectilinear compartmentalization of these paintings reveals a strong debt to Piet Mondrian and Neo-Plasticism. This *Constructive Painting* of about 1931 was made at the high point of Torres-García's association with Mondrian and the Cercle et carré group in Paris, of whose magazine he was a co-founder. It is probable, therefore, that the letters "NPF" in the center refer to "Neo-Plasticism" and "France."[32]

Born in Montevideo, Torres-García lived and worked in Barcelona, New York, Italy, and Paris before returning to his native Uruguay, where he remained for the last fifteen years of his life. Despite the sophistication of his experience and his espousal of the principles of nonobjective art, he invested his painting with a quite contradictory and highly personal aesthetic. His rendering was deliberately rough, his pictorial symbolism naïve and direct. Here, the gray-brown surfaces, touched with warmer colors, recall the stone bas-reliefs of primitive cultures, and the symbols can be related to Pre-Columbian hieroglyphs. These symbols may be of several origins—religious, astrological, and architectural, as well as drawn from everyday life; the central image here seems to be as simple as a table setting, suggesting a kind of symbolic still life.

The 1930s were undoubtedly the period of Torres-García's major accomplishment. The Museum of Modern Art owns two others of his "Constructivist" paintings and a drawing of about the same date, 1931–1932, all entitled *Composition* and repeating some of the same symbols as those in the Janis picture.

Although his work had been seen previously in group shows, with the exception of an exhibition at the Whitney Studio Club in spring 1921, while he was resident in New York, Torres-García had never had a one-man show in the United States until that held by the Sidney Janis Gallery in 1950. Planned as a retrospective, it turned out to be a memorial, for while he was helping to organize it, Torres-García died in Montevideo.

MARCEL DUCHAMP American, born France. 1887–1968

Bicycle Wheel. 1951; third version, after lost original of 1913.
Assemblage: metal wheel, diameter 25 $^1/_2$ inches, mounted on painted
wood stool, 23 $^3/_4$ inches high, overall 50 $^1/_2$ inches high

The *Bicycle Wheel* was the first of Marcel Duchamp's Readymades and is probably the best known. Although, a year or two earlier, Cubist collage had introduced commonplace materials into art, the Readymades constituted a radical attempt to create anti-art. By the simple act of mounting a wheel on a stool, Duchamp reduced the heroic art-making process to one of mere selection: any mass-produced artifact can become art, in the spectator's view, if it has been chosen and isolated within an art context. "Anything is art if an artist says it is" has become one of the key tenets of twentieth-century art. Duchamp provided generations of artists with the license to choose anything at all—form, subject matter, materials—as art or for art, and the implications of this concept are still being pursued today.

The *Bicycle Wheel* has also been cited as the first kinetic sculpture. Undoubtedly, such works as Jean Tinguely's irrational assemblages of machine parts are the outcome of its pointless spinning.

Actually, this is an "assisted Readymade," since the wheel has been mounted on another object and therefore "transformed" to a minimal extent, as well as being further denatured by having been turned upside down. It was selected not because of its beauty (though it may seem beautiful today), but because of its total lack of uniqueness. In fact, when the 1913 original was lost, Duchamp in 1916 simply replaced it by another, which in turn was lost. This, the third version, was made in 1951 for the Sidney Janis Gallery's exhibition "Climax in 20th Century Art, 1913." Mr. Janis found the wheel and fork in Paris and brought them back to New York, where the stool was bought and the piece reconstructed by Duchamp. (The signature was added later, in 1959.) Since then, two other versions have been made, for exhibitions in Stockholm, 1961, and London, 1963; and in 1964 the Galleria Schwarz in Milan produced, under the artist's supervision, a multiple in an edition of eight signed and numbered copies.

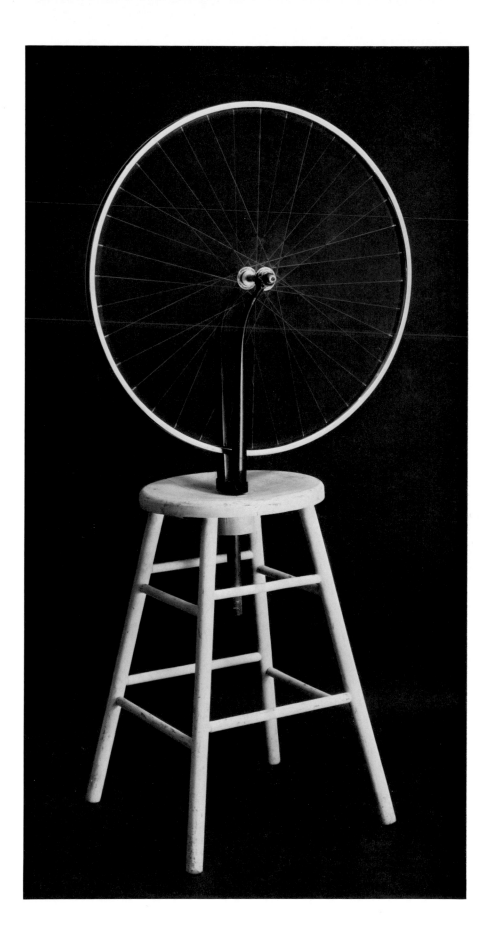

GIORGIO DE CHIRICO Italian, born Greece 1888

Evangelical Still Life. 1916. Oil on canvas, 31 $^3/_4$ × 28 $^1/_8$ inches, irregular

Giorgio de Chirico's *Evangelical Still Life* was painted in 1916, during his stay in Ferrara. He had left Paris for Italy in the summer of 1915 for military service and entered the 27th Infantry Regiment. When he became ill, he was assigned to a job at headquarters, which allowed him enough free time to be able to begin painting again in the fall.

During his five years in Paris, de Chirico had concentrated on deep perspectives and open squares; but in his Ferrarese period, he concentrated on closed rooms dominated by strange "metaphysical" groupings of real and imagined objects. What struck him above all, he wrote, "was the appearance of certain interiors in Ferrara, certain window displays, certain shops, certain houses, certain quarters, as for instance the old ghetto where one could find candy and cookies in exceedingly strange and metaphysical shapes."[33]

In the *Evangelical Still Life,* de Chirico has created an interior that might be the studio of an engineer or a cartographer rather than a painter, judging by the T-square, map, and wooden armature at the right. It was an ambience familiar to him as the son of an engineer. The cookies and the map might be elements seen in Ferrarese wanderings—the former in the ghetto shop windows referred to above, the latter, according to James Thrall Soby, in other store windows where maps were placed to trace the course of the First World War.[34] In this painting, some of the components tend to the baroque, with dots here and there evoking the image of an eye.

A pervasive malaise is communicated in the *Evangelical Still Life,* as in the outdoor vistas, by the divergent perspective tensions—the orthogonals leading the eye to different vanishing points. The contours of the two paintings within the painting are distorted, and the window is seen from far below, cut off by a plane that might be a tabletop. The canvas itself is not a perfect rectangle, and this reinforces the sense of "space out of joint" induced by the scene depicted upon it, as though de Chirico had come to participate so fully in the strangely tilted world of his art that his fantasy had seeped out into the spectator's world.

De Chirico's paintings derived more strength from Cubism than is commonly realized. The armature at the right resembles the abstract scaffoldings of high Analytical Cubism transmitted into a fantasy of studio carpentry—or an anticipation of Dada and Surrealist objects. The meticulously painted map and cookies call to mind textured bits of collage, while the pointillistically dotted armature components and broad, flat, unmodeled planes suggest the orderly world of Synthetic Cubism turned askew.

In this picture, de Chirico seems to be making several comments about the nature of painting itself. Traditionally, paintings provide a "window" into space. Here, the real window and the unnaturalistically colored sky are abstracted into geometric pictorial elements, while the two paintings within provide the anticipated landscape views. The two views are somewhat disconcerting, however, for in one, the two Ionic columns (one upside down) are seen only through their shadows; in the second, the landscape is a contour map. In the following years, de Chirico was to expand these curious puns—this illusionism within an illusionist style—in works such as *The Scholar's Playthings,* 1917 (Collection R. W. Finlason, Toronto), and the *Metaphysical Interior with Waterfall,* 1918 (Collection Carlo Frua de Angeli, Milan), in which the internal paintings contain standard landscapes with *repoussoirs,* while the surrounding components are radically flattened out toward the picture plane. He seems also to have been obsessed with the quality and juxtaposition of angles through which he could manipulate pictorial space in an ever more complicated manner.

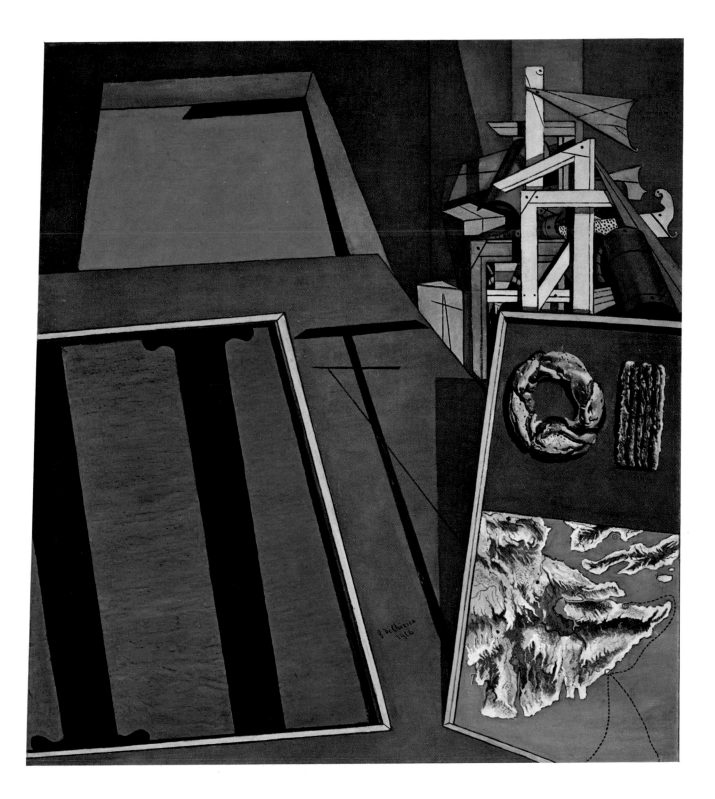

SALVADOR DALI Spanish, born 1904

Illumined Pleasures. 1929. Oil and collage on composition board, $9\,^3/_8 \times 13\,^3/_4$ inches

One of the most famous paintings in the Janis collection, the *Illumined Pleasures* is a key work of Salvador Dali's most important period, his early days as a Surrealist. It was once owned by Louis Aragon, the leading Surrealist poet. The painting is characteristic of Dali's style as well as of his complex iconography, and of the dependence of both on a variety of influences from other artists, particularly Giorgio de Chirico and Max Ernst, in combination with Dali's own intensely personal vocabulary.[35]

In the *Illumined Pleasures*, as in virtually every one of Dali's 1929–1930 pictures, the artist himself is portrayed. The male head in the largest of the three wooden boxes clearly resembles him. It faces downward with eyes closed in an attitude suggested by two anthropomorphic rocks at Cape Creus on the Costa Brava, known to local fishermen as the "rocks of slumber." Above this head is an insect that is a symbolic self-portrait, alluding to Dali's youthful fantasy of himself as a "grasshopper child" and to his associations with the locust and the praying mantis, "an insect endeared to the artist by its habit of devouring the male immediately following the act of procreation."[36] Still another self-representation is the youth to the right of the large central box, with his head turned away as if in shame.[37] The source of this image Dali found in paintings by de Chirico and Ernst, including the former's *Return of the Prodigal Son,* 1929 (Collection Carlo Frua de Angeli, Milan)—a subject reenacted by tiny figures in the distant landscape of the *Illumined Pleasures.*

The bearded, mustached personage in the lower center of the picture is a father image often recurring in Dali's paintings of this period and derived from similar images in works by de Chirico and Ernst. Dali has identified the lion's head at the top as also a symbol of his father, related to a childhood hallucination of a cat. The adjacent female face is a double image, both woman's head and pitcher, based upon the Freudian association between women and receptacles.

The shape at the horizon to the left, with its seamed surface, was apparently inspired by mannequins in paintings by de Chirico, whose influence appears further in the disembodied, elongated shadow at the lower left and in the boxlike "pictures within pictures." The arcaded building bordering a square in the left of these is especially reminiscent of that Italian forerunner of Surrealism. The handling of these boxed pictures, however, is closer to the art of René Magritte, who visited Dali in Spain at about this date; and so is the imagery in the box with multiple bicycle riders, at the right. The influence of two other Surrealist contemporaries of Dali can also be detected in the *Illumined Pleasures.* Besides the father figure, already mentioned, the totem of colorful bird's heads at the left center and the use of photomontage in the left box have antecedents in works by Ernst; while the infinitely receding plains, exquisite illusionist technique, and sculpturally rigid biomorphic shapes recall Yves Tanguy.

From this eclectic vocabulary, Dali refined his distinctly personal style, which in the public mind was to become the epitome of Surrealism in the 'thirties. Part of Dali's popular appeal was due to his technical virtuosity and the "reality" with which he depicted his intricate subconscious visions, giving them the effect of "hand-painted dream photographs." The miniature dimensions of the *Illumined Pleasures* are especially ideal for a scene projected from the imagination, analogous in size to the "screen" of the mind's eye, which we feel to be located just inside the forehead.[38] Another kind of screen projection may also be relevant, since at this period Dali was making films with Luis Buñuel—*Le Chien andalou* and *L'Âge d'or*; in the fall of 1929 Dali moved to Paris, where he and Buñuel joined the Surrealists.

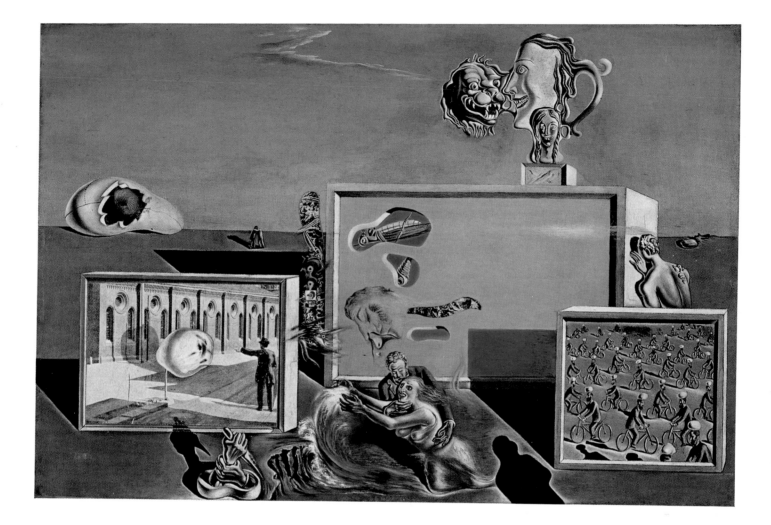

SALVADOR DALI

Frontispiece for Second Surrealist Manifesto. 1930. Pen and ink and watercolor on paper, 12×10⁵/₈ inches

Many of the images in the *Illumined Pleasures*—the pitcher-head, lion's head, birds, ants, boxes, and biomorphic shapes—recur in the second work by Dali in the Janis collection, the drawing for the Second Surrealist Manifesto, as well as in another closely related major painting of 1929, the *Accommodations of Desire* (page 180). In the drawing, the men on bicycles have become ants, and the vessel-head, though obviously female, is mustached. In the *Portrait of Paul Éluard*, 1929 (Private collection, Paris),[39] it is apparent that this is a representation of Gala, the wife of the Surrealist poet, whom Dali loved and later married; the lion is attached to her as well as to the head of Éluard. The slumbering head of Dali in the *Illumined Pleasures* becomes a bust in the drawing (labeled *femme-Enfant*—"child-woman") and is organically attached to the lion, bird, and mustached pitcher-head. This entire constellation of elements is found in almost identical form in an unfinished painting of about 1929, which bears the title *Imperial Monument to the Child-Woman* (page 179).

Most of the remaining imagery in the drawing for the Manifesto appears in still another painting, *The Font*, 1930 (page 180). Here, the bust of Gala appears both as a font and as a vessel-head set on a shrine decorated with a key; the chalice does not stand within the shrine but before the vessel. The superimposed images of keys, ants, and nails or screws at the left of the drawing are prominent in the right of the painting, as also in the *Imperial Monument to the Child-Woman*. The ants appear again in one of Dali's most famous paintings, *The Persistence of Memory*, 1931 (The Museum of Modern Art), where they are shown preying upon one of the watches. Like many of the motifs in Dali's work, they arouse a vague sense of uneasiness, or more overtly imply mutilation or violent destruction.

Nothing in André Breton's text of the Second Surrealist Manifesto serves as a basis for the iconography of the drawing. Dali himself declared, however, that the three cardinal images of life were excrement, blood, and putrefaction, and that nothing should be expected from the new Surrealist imagery but "disappointment, distaste, and repulsion."[40] The drawing was not used when the Second Surrealist Manifesto was first issued in book form in 1930,[41] but it was reproduced as the frontispiece to the limited edition of sixty copies published the same year for the "Club des Soixantes" (Paris: Éditions Kra).

Rubis Emeraude
Grenat Lapis - Lazuli
Turquoise Diamant
Topaze Saphir
Améthyste Opale
 Agathe

Diamant

femme-Enfant

Salvador Dali 1930

RENÉ MAGRITTE Belgian, 1898–1967

The Palace of Curtains, III. 1928–1929. Oil on canvas, 32 × 45 ⁷/₈ inches

René Magritte painted *The Palace of Curtains, III* in Paris, during his only extended sojourn —from 1927 to 1930—outside his native Belgium. In Brussels, he had been co-founder of a Surrealist group whose activities paralleled those of their counterparts in Paris, and in the latter city he continued his close association with leading Surrealists, notably André Breton and Paul Éluard. At a time when, in keeping with the pronouncements of the 1924 manifesto, Surrealist painting was totally dominated by automatism, Magritte anticipated Dali by re-newing the "dream-image" illusionism that had been explored earlier by Giorgio de Chirico. The work of that artist, which Magritte first encountered in reproduction in 1922, greatly im-pressed him, and, together with the collages of Max Ernst, it became a prime influence on his development.

The picture-within-a-picture device in *The Palace of Curtains, III* is a legacy from de Chirico, but Magritte uses it in a way at once blander and more abstract. Typical of his own style, and quite different from that of de Chirico, are the shallow space and frontality of the composition, as well as the meticulous illusionistic finish. Also characteristic of Magritte is the incorporation into the painting of a word as if it were an object. Throughout his career, Magritte was preoccupied with the encounter of words, images, and meanings. In 1954, the Sidney Janis Gallery presented a group of his 1928–1929 paintings, taking the exhibition's subtitle, "Word vs Image," from an article Magritte had written in 1929, which was translated and reprinted in the show's catalogue. In this essay, Magritte offered some axioms: "In a painting the words are of the same substance as the images. ... Any shape may replace the image of an object. ... An object never performs the same office as its name or as its image."[42] He always insisted that to equate his painting with symbolism, conscious or unconscious, was to ignore its true nature; for symbolism would imply a supremacy of the invisible over the visible, whereas the latter was rich enough to form a poetic language evocative of both realms. "My paintings," he declared, "have no reducible meaning: they *are* a meaning."[43] In like vein, the titles of his pictures are poetic in themselves but usually lack any specific association with the image represented; thus, the two other paintings with the title *The Palace of Curtains* bear little if any visual resemblance to this one. More closely related is *The Empty Mask* of 1928 (page 193), in which an irregularly shaped frame set before the wall of a room is divided into four compartments, the upper left one containing the French word for sky, as in the Janis picture.

The sky is a frequent motif in Magritte's paintings. It is almost always depicted in some disquieting context that confuses the "real" painted sky with a representation of it (often framed), the vaporous with the solid, exterior with interior, or day with night. In The Mu-seum of Modern Art's 1928 painting, *The False Mirror*, for example, a cloudy sky sur-rounded by a huge eyelid constitutes the iris of an enormous eye with a pupil like a black sun set in its center; the Museum's *Empire of Light, II*, 1950, shows a nocturnal street scene with buildings illuminated by artificial light, set below a bright, cloud-filled daytime sky.

The polygonal frames and "empty" expansive surfaces within *The Palace of Curtains, III* now seem like prototypes for certain aspects of present-day art. The young American painter Geoff Hendricks, in fact, has concentrated on a single Magrittean sky image, which he has applied to surfaces as varied as a clothesline full of sheets, a billboard over New York's Fifth Avenue, a postcard, and a traffic sign (page 194).

JEAN (HANS) ARP French, born Alsace. 1887–1966

Man at a Window. 1930. Oil and cord on canvas, 31 $^3/_4$ × 27 $^1/_4$ inches
Constellation. 1932. Painted wood relief, 11 $^3/_4$ × 13 $^1/_8$ × 2 $^3/_8$ inches
Constellation with Five White and Two Black Forms: Variation 2. 1932.
 Painted wood relief, 27 $^5/_8$ × 33 $^1/_2$ × 1 $^1/_2$ inches

The three reliefs and one sculpture in the round from the Janis collection enrich The Museum of Modern Art's already considerable collection of works by Jean Arp and illustrate the range of his expression, from the whimsical and linear *Man at a Window* to the biomorphic forms of the Constellations and the *Pre-Adamite Doll.*

Though the three reliefs were executed in the 'thirties, when Arp had already begun his sculpture in the round, they are comparable to his work of the 'twenties, and in some respects to that of his Dada years as well, despite their more abstract character. The 1930 string relief *Man at a Window* is in the style of The Museum of Modern Art's *Two Heads,* done three years earlier, and represents the most accessible side of Arp's work. Its portrayal of a man seeing out of and into himself through a tilted frame is characteristic of Arp's humorous pathos; its double image and "automatic" line, reminiscent of his drawings and woodcuts, relate to essentially Surrealist ideas. The fluid line of the string both establishes a contour and holds the surface by its substance.

The other two reliefs are representative of a large series of Constellations that Arp began about 1928 and continued into the 'sixties. This format seems to have provided him with unlimited possibilities for exploring shapes and their relationships to a ground. The biomorphic forms go back to those developed by Arp as early as 1915–1916; they were to become essential constituents in the work of Miró, Matta, and others. The *Constellation with Five White and Two Black Forms* (one of the first of Arp's works acquired by Sidney Janis, obtained from the artist himself at Meudon) is one of many in the series composed of the same white and black shapes, differently arranged.

The other *Constellation* floats over the edge of the pictorial rectangle. It recalls images standard to Arp's vocabulary—clouds, eggs, navels, fruits, and the fusion of plant forms and the nude. Here, more geometric forms, found in earlier works such as the Museum's *Leaves and Navels,* 1929, and *Objects Arranged according to the Laws of Chance,* 1930, have become fluid and irregular. Yet by 1930, Arp had not only been firmly ensconced in the Surrealist enclave but had also joined the quite opposite Cercle et carré group, and in 1932 he became a member of the Abstraction-Création movement. This dualism is at the heart of his expression. Despite the organic and fantastic nature of his imagery, Arp's handling seems pristine and pure, almost antiseptic (a quality that, together with his reliance on elementary forms, has had much appeal for artists of the 'sixties). His execution was similarly contradictory and is also relevant to some artists' procedures today: although the forms were in part engendered by "subconscious" methods, the work was executed by a carpenter after a template and painted in the flattest, most even manner, suppressing any suggestion of the artist's hand.

Although the two Constellation reliefs are actually almost as flat as the *Man at a Window,* they seem to be forcing themselves off the picture plane into a fuller three-dimensionality. Not only the shadows cast by the protruding forms, but their biomorphism, which implies fully rounded volume, recall Arp's sculpture in the round, begun a year or so earlier.

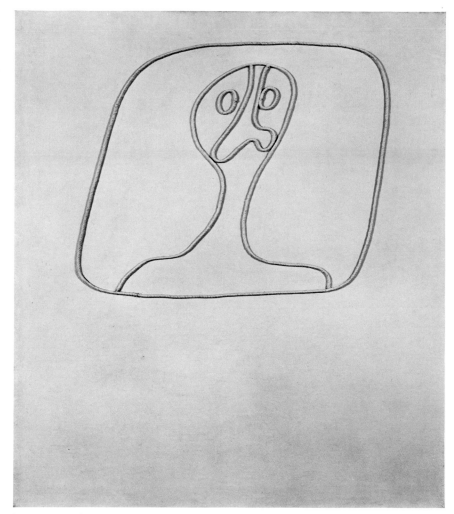

Man at a Window

Constellation

Constellation with Five White and Two Black Forms: Variation 2

JEAN ARP

Pre-Adamite Doll. 1964. Marble, 19 $^1/_4$ × 13 inches diameter, on marble base,
 4 $^3/_8$ inches high × 11 $^1/_8$ inches diameter

From about 1930 until his death, Arp was primarily concerned with three-dimensional sculpture. These works, too, like the wood reliefs, were fabricated by others. Using a manner employed by such earlier masters as Auguste Rodin, for example, Arp worked outward from a nucleus, building up each sculpture improvisationally in clay and plaster. His assistants then carved the marbles from these models; the polished surfaces of the finished works, free from tool marks or other signs of their facture, are comparable in their purity to Arp's reliefs and drawings. The personal quality of his art emerges nevertheless, depending upon his forms rather than upon any superficial phenomena.

The *Pre-Adamite Doll* is one of the works in which Arp departed from his usually entirely organic forms to reintroduce a stricter geometry. It suggests a human form, but as a partial cross section of a natural image. Deep slices from one side produce sharp angles that expose the figure's artificiality. Title and shape suggest a human form in some primordial state, resembling both ancient Cycladic figures and certain of Constantin Brancusi's sculptures, as well as Arp's own earlier Human Concretions.

Although Arp called several earlier works "Pre-Adamite" (for example, the *Pre-Adamite Fruit* and the *Pre-Adamite Torso,* both of 1938,[44] the only one formally related to the Janis sculpture is a little wood relief of 1952, *Pre-Adamite Figure,*[45] which simulates the line of a string relief and presents a similarly curved shape with an angular chunk cut out of one side. Other works introducing a faceted area are the *Torso of a Muse,* 1959,[46] and the *One-Eyed Doll,* 1964 (Sidney Janis Gallery, New York). Arp's "doll" has erotic qualities and perhaps even an overtly erotic pose, but its controlled abstraction distinguishes it from the specifically sexual image of Hans Bellmer's *Doll* (page 69).

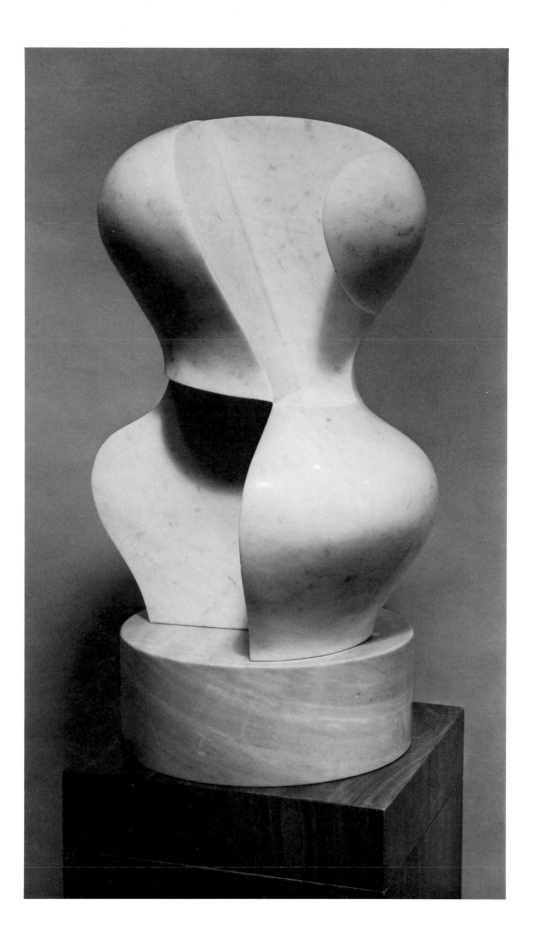

KURT SCHWITTERS British subject, born Germany. 1887–1948

Merz 88: Red Stroke (Rotstrich). 1920. Paper collage, 5 ¼ × 4 ⅛ inches
Merz 252: Colored Squares (Farbige Quadrate). 1921. Paper collage, 7 ⅛ × 5 ¾ inches
Famiglia. 1922. Paper collage, 5 ¾ × 4 ¼ inches
Merz 48: Berlin. 1926. Paper collage, 4 ¾ × 3 ½ inches
V-2. 1928. Paper collage, 5 ⅛ × 3 ½ inches, irregular

Kurt Schwitters called collages such as these "Merz-drawings," although he acknowledged that they were "essentially painted, that is colored and flatly formed. But by some chance this mistaken expression happened to creep in quite early and now this word cannot be changed very easily. But please regard the small 'MERZ-drawings' as paintings."[47] This ambiguous way of classifying his collages is typical of his Dadaist outlook about 1919, in which year he devised the term "Merz" to characterize his artistic production. According to Käte Steinitz, it derived from the large capital letters—in actuality, the second syllable of the word KOM-MERZ, from which Schwitters cut off and discarded the first three letters—that he had incorporated as a compositional element in one of his earliest collages. The formal dignity of the black-and-white capitals attracted him visually, the sound appealed to him phonetically, and ultimately he adopted this meaningless word to apply to all his art.[48] Over the years Sidney Janis bought and sold over two hundred of Schwitters' Merz-drawings; he selected these five for his personal collection, as exemplifying the artist's range.[49]

Like Jean Arp, Schwitters combined aspects of Dada with wholly abstract styles. The earliest of the five Janis collages, the *Merz 88: Red Stroke,* is the least "pure" in composition and materials, only the *V-2,* 1928, showing a similar multiplicity. The inclusion of a toll-bridge ticket, stamps, and various other throw-away elements is characteristic of Dada attempts to erase the "arty" from art, and the jagged diagonals and bold use of typography reflect Schwitters' interest in Futurist dynamics as applied to Cubist paper collage. His collages (as opposed to his reliefs, the Merzbau, and his sound poetry) were, in fact, essentially Cubist in principle and structure. Despite the use of materials found in gutter or wastebasket, the increased abstraction, and the more frequent puns or dashes of humor, there is no fundamental difference between these works and collages made by artists in France about 1913 (see pages 10–12).

In the early 'twenties, Schwitters visited the Netherlands, where he established relations with the Stijl artists, and in particular with Theo van Doesburg, whose work was widely acclaimed in Germany at that time. Soon Schwitters' own work began to reflect the Purist aims and rectilinear format espoused by Piet Mondrian and his colleagues, as well as the influence of the Russian Constructivists. Materials that had been used iconoclastically or associatively in the Dada days began to be divested of their history and employed solely for their shape, color, and texture. The *Merz 252: Colored Squares* is an early example of these developments. Both the *Famiglia* and the *Merz 48: Berlin* employ "impure" materials in a very pure way. The delicate overlay of colors and shapes in the former is sharpened by the fragment of an Italian Dada or Futurist exhibition catalogue at the lower left, but this Merz-drawing bears little aesthetic resemblance to the products of those movements or of the artists (Evola, Story, Bragaglia) whose names appear therein. Even in the midst of his most rigorously abstract period, however, Schwitters continued to make collages that harked back to a livelier, less somber structure. In the 1930s and 1940s, he returned entirely to the sardonic play of recognizable words and pictures; and in some cases, such as a 1947 comic-strip collage, *For Käte* (Collection Kate Steinitz, Los Angeles), he even anticipated Pop art.

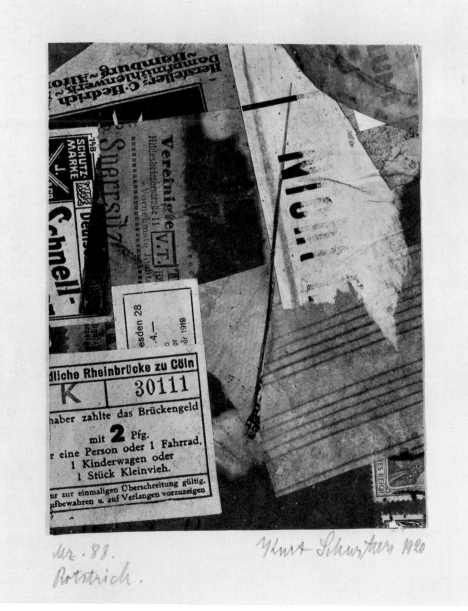

Merz 88: Red Stroke (Rotstrich)

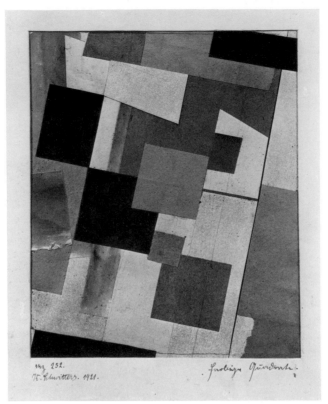

Merz 252: Colored Squares (Farbige Quadrate)

Famiglia

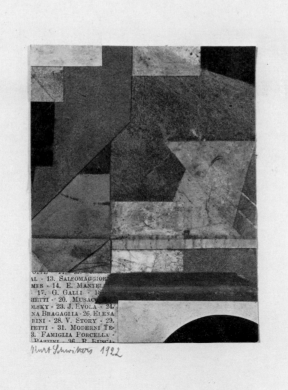

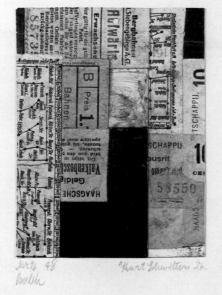

Merz 48: Berlin

V-2

MAX ERNST French, born Germany 1891

Birds. 1926. Oil on sandpaper over canvas, $8\,^{1}/_{8} \times 10\,^{3}/_{8}$ inches

Max Ernst's obsession with birds has been evident in his work since his earliest Dada period. The artist has said that it is rooted in a childhood memory involving the simultaneous death of a pet cockatoo and the birth of his baby sister.[54] His avian avatar is Loplop, Bird Superior, an androgynous and often highly erotic figure to whom he devoted a collage and a series of paintings in the early 'thirties.

This little *Birds* isolates the pairing motif that occupied Ernst in many forms during the mid-'twenties, notably in such canvases as the *To 100,000 Doves*, 1925 (Collection Mme Simone Collinet, Paris), the *Bride of the Wind*, 1926 (Collection Dr. and Mrs. Abraham Melamed, Milwaukee), and the *Monument to Birds*, 1927 (Collection la Vicomtesse de Noailles, Paris). In 1924, he also made a series of small pictures on sandpaper depicting birds in cages, to which the Janis work seems related.[55] This is the first example of the group to be acquired by the Museum, which, however, has owned since 1937 Ernst's painted wood construction of 1924, *Two Children Are Threatened by a Nightingale*—the subject of a long analysis by Sidney Janis in 1942.[56]

The *Birds* was done at a time when Ernst had begun adapting his *frottage* ("rubbing") technique to oil: it involved scraping paint off prepared canvases while they were lying on such materials as wire mesh, chair caning, and haphazardly coiled twine, thus achieving a patterned texture. Here, Ernst's interest in texture is manifest particularly in the heavy, uneven surface of the birds and the fine-grained sandpaper ground. The painted shadow serves to bring the birds into deceptively high relief, which in turn relates the painting to later birds Ernst made in plaster relief.

The Janises acquired this work from Ernst's former stepdaughter Pegeen, daughter of his divorced wife Peggy Guggenheim and the British artist Lawrence Vail.

MATTA (Sebastian Antonio Matta Echaurren) Chilean, born 1912

Paysage flammifère. 1940. Crayon and pencil on paper, 18$\frac{1}{8}$ × 22$\frac{1}{2}$ inches

Matta went to Europe in 1933 from his native Chile to pursue the study of architecture and for a while worked in Le Corbusier's Paris office. Through Salvador Dali, he became a member of the Surrealist circle and began to paint in 1938. The following year he left for the United States, where he shortly became the center of the group of painters who formed the nucleus of the so-called New York School.

The *Paysage flammifère* dates from 1940, the year after Matta arrived in New York. It is not a study for any particular painting but is closely related to some of his major works of the period, such as the *Prescience,* 1939 (Wadsworth Atheneum, Hartford) and *The Earth is a Man,* 1942 (Collection Mr. and Mrs. Joseph R. Shapiro, Oak Park, Illinois). Matta called such compositions "psychological morphologies" or "inscapes," implying that they referred both to the cosmos and to the individual subconscious—a projection of psychological states into fantasy landscapes. In an article written in 1941, Sidney Janis quoted Matta as saying that his architectural studies had crystallized in him a desire for "a structural sense of life as we have a sphere-like conception of the earth"; he wanted to "be conscious of the web of relations which is the structure of life; to paint the colossal structure of life as science relates it, in a town-like geometry."[59]

The word *flammifère* may simply be a composite of the French word for "flame" and the suffix -*fère,* derived from the Latin and meaning "bearing" or "containing"; thus, the title might be translated "Flaming Landscape." On the other hand, given Matta's Surrealist predilection for punning titles, he may have invented a Franco-Spanish conglomerate *flamme y fer,* "flame and iron." Certainly this amorphous landscape suggests a fusion of the organic and inorganic, of hard and soft, of fire and ice, and of the solid, vaporous, and liquid.

Matta has always been a mystic, yet at the same time he has been deeply concerned with current actualities. He was certainly profoundly disturbed by the cataclysm of the war, for which this and related works may constitute a kind of apocalyptic metaphor. Recently, however, when questioned about any circumstances that might have been pertinent to the execution of this drawing, he wrote only that he had in mind "les grands transparents that surround us in this world"[60]—presumably taking the phrase from André Breton's Prolegomena to a Third Surrealist Manifesto, published in 1942 and illustrated by Matta. One section, headed "The Great Invisibles," begins: "Man is perhaps not the center, the focus of the universe. One may go so far as to believe that there exist above him . . . beings whose behavior is alien to him . . . completely escaping his sensory frame of reference. . . . Considering perturbations like the cyclone, in the face of which man is powerless to be anything but victim or witness, or like war . . . it would not be impossible . . . to succeed in making plausible the complexion and structure of such hypothetical beings, which obscurely manifest themselves to us in fear and the feeling of chance."[61]

Matta's technique and intellect, which influenced many American painters in the 'forties, was particularly important for Arshile Gorky, as becomes clear by comparing Matta's *Paysage flammifère* with Gorky's 1946 study for *Summation* (page 115). As Breton noted in an essay written in 1945, Gorky was "the only one of the Surrealist artists to maintain direct contact with nature, placing himself *before her* to paint."[62] Whereas Gorky took as his starting point illustrative images, often based on observation of nature, and moved from there into abstraction, Matta proceeded from the suggested images created by washes of color on the surface of his canvas or paper, and moved from those to more particularized forms.

II MODERN NAÏVE AND PRIMITIVE PAINTERS

ALTHOUGH NOT ALL the artists included in the first section of this catalogue had won wide public acceptance at the time when Sidney Janis acquired their works, none of them could be considered his "discovery." A different situation prevails with regard to several of the American primitive artists whose paintings constitute the major portion of this second section. In this field, Mr. Janis set out on a conscious voyage of exploration. He has said that it was Rousseau's *Dream,* bought in 1934, that first launched him on a quest for works by naïve artists in America. One should also remember that Surrealism was then the prevailing avant-garde movement, and the Surrealists highly esteemed the "childlike" qualities of innocence and fantasy that they discerned in the art of Rousseau and other primitives. Mr. Janis may also have been inspired to search for contemporary self-taught American artists by seeing Joseph Pickett's *Manchester Valley* of 1914–1918 in the exhibition "American Folk Art: The Art of the Common Man in America 1750–1900," organized by Holger Cahill and Dorothy C. Miller and presented at The Museum of Modern Art in the winter of 1932/33. (In 1939, *Manchester Valley* entered the Museum's collection as the gift of Abby Aldrich Rockefeller, an early collector of American folk art.)

Although not a self-taught artist, Louis Eilshemius, as Marcel Duchamp once observed, "painted like a primitive" and worked completely outside the currents of either academic or modernist art. After a long period of neglect, Eilshemius began to attain success in the later 1920s. The Janises acquired their first works by him in 1934 (the same year in which they bought *The Dream*), and the warm friendship that developed between Mr. Janis and Eilshemius lasted until the latter's death seven years later.

The three naïve artists in the collection whom Mr. Janis can truly claim to have discovered are Patrick J. Sullivan, William Doriani, and Morris Hirshfield. After having bought Sullivan's first painting at the Society of Independent Artists show in 1937, Mr. Janis entered into correspondence with him. They met for the first time when Sullivan and his family came to see the exhibition "Masters of Popular Painting: Modern Primitives of America and Europe," held at The Museum of Modern Art in 1938. It included, as loans from Mr. Janis, all three of the paintings Sullivan had completed by that date. Later in the year, the Janises went to West Virginia to visit the Sullivans, establishing a friendship kept up thereafter by an extensive correspondence, in which the painter revealed in detail the metaphysical content of his pictures and freely expressed his opinions about other primitive artists and the way in which they were generally regarded.

Doriani's *Flag Day* was singled out by Mr. Janis amid an even larger and more miscellaneous assemblage of paintings than that at the Society of Independent Artists: the Spring 1938 outdoor art show in Washington Square. Besides including Doriani's work in the exhibition "Contemporary Unknown American Painters," which he organized for the Advisory Committee of The Museum of Modern Art late in 1939, Mr. Janis was instrumental in arranging a one-man show for him at the Marie Harriman Gallery, earlier that year, and wrote the foreword for its catalogue.

Undoubtedly, in terms of both the quality of his work and the degree of commitment that Mr. Janis felt toward him throughout the years, Morris Hirshfield was the most important of his three discoveries. Once again, encounter with the artist's painting led Mr. Janis to seek out the man himself, to encourage him in his lonely production, and to make his work known by including several of his pictures in "Contemporary Unknown American Painters." The one-man show of Hirshfield's work that Mr. Janis organized at The Museum of Modern Art in 1943 was only the first of its kind, the last being "Morris Hirshfield, 1872–1946" presented at the Sidney Janis Gallery twenty years after the artist's death. Too confident of his own judgment to require that it be validated by the opinion of others, Mr. Janis was nevertheless delighted that Mondrian expressed admiration for Hirshfield, and that André Breton, dean of the Surrealists, termed him "the first great mediumistic painter." When Mr. Janis

went abroad on his first postwar trip in 1945, he took along several of Hirshfield's canvases, hoping they might arouse the interest of Picasso and other artists there; in the case of Giacometti, at least, he was successful.

The circulating exhibition "They Taught Themselves," which Mr. Janis organized in 1941, the book by the same title issued the following year, and the concurrent exhibition shown at the Marie Harriman Gallery in New York culminated years of devoted investigation by Mr. Janis and constituted the most thorough and comprehensive surveys of American self-taught artists ever attempted. In the catalogue of the latter exhibition, Breton declared: "There is no guide here to trust as well as Sidney Janis. No one understands better than he the subtle clews which are scattered over this country. I know of no more open and piercing eye, of no better equipment for description and definition. It is impossible to be more in love with and more consciously aware of one's material. This is, as far as I know, the first time that an exceptional gift of observation and deduction, of an altogether scientific character, has been identified with an admirable sense of quality which is as much poetic as artistic. This gift has also asserted itself in the infallible selection which he has brought to the choice of his collection of paintings. Each one has been an intellectual event, or a landmark in the direction of mystery and fire."

The characteristic bent for description and definition, the gifts of observation and deduction "of an altogether scientific character" noted by Breton are manifest in the book *They Taught Themselves*, which focused on the lives and thought, as well as on the art, of thirty self-taught American painters and brought to light much previously unknown material. Mr. Janis's discussion of the fifty-four paintings reproduced reveals the same kind of approach and stylistic analysis as that which he brought to bear in his second exhibition for the Museum's Advisory Committee in 1940, "Picasso's Seated Nude, 1911: A Visual Analysis of a Cubist Painting." His respect for creativity precludes Mr. Janis from establishing hierarchies among different types of artistic expression. In this connection, it is worth noting that during the same years in which he was organizing the above-mentioned exhibitions of self-taught artists and writing the book devoted to their work, he was renewing, or establishing for the first time, his acquaintance with such eminent foreign artists in exile as Léger, Mondrian, Ernst, and Matta (whose works are included in the first section of the present catalogue). Virtually simultaneously, he was also engaged upon research on these artists and their American counterparts, in preparation for his second book, *Abstract & Surrealist Art in America*. Published in 1944, it included several painters still relatively unknown, whose work is presented in the final section of this catalogue.

LOUIS MICHEL EILSHEMIUS American, 1864–1941

Samoa. 1911. Oil on cardboard, 10×8 inches
Dancing Nymphs. 1914. Oil on composition board, 20^1/$_8$×20^1/$_4$ inches
Nymph. 1914. Oil on composition board, 20^1/$_8$×19^3/$_4$ inches

The *Nymph* and *Dancing Nymphs,* two of many works by Louis Michel Eilshemius that the Janises bought over the years, were purchased in 1934. Eilshemius, then seventy, had only relatively recently achieved a measure of success after a lifetime of comparative obscurity. He was not a Sunday painter; his early years had been devoted to study both in the United States and in Paris. Although early encouragement in the form of acceptance of a painting for exhibition by the National Academy of Design came in 1882, this triumph was followed by almost thirty years of public neglect. Then, when the Society of Independent Artists held its first exhibition in 1917, one of his works captured the imagination of Marcel Duchamp, who declared "in a loud persistent voice that *Supplication* was one of the two really important paintings in the entire exhibition."[63] The outrageous asking price, reported as ranging from $6,000 to $10,000, that the artist placed on the work was perhaps as much responsible for Duchamp's interest as the painting itself; for as Eilshemius became older and more embittered by the public's indifference, he asked higher and higher prices for his work, while selling none. The critic Henry McBride, who later became interested in Eilshemius's paintings and once owned *Samoa,* at the time described *Supplication* as a "faded, dingy, and quite countrified *Venus,*"[64] not worth anything like $6,000.

In 1920, Duchamp and Katherine Dreier gave Eilshemius a one-man show (his first) at the Société Anonyme, and another in 1924; but it was only in 1926, when the art dealer Valentine Dudensing showed his work, that his reputation was established at last, and his paintings began to sell, although by then he had virtually abandoned working.

The three works in the Janis collection had been painted well before that time—the little *Samoa* in 1911 and the *Nymph* and *Dancing Nymphs* in 1914. In 1901, the thirty-seven-year-old Eilshemius, under the mounting pressure of rejection and disillusionment, had set off on a trip to Samoa. There he found, as he never had in Paris, North Africa, or any other place he visited, a genuine innocence and spontaneity that set him at ease.

The *Samoa* is a re-creation of memories that Eilshemius also recorded in poetry, which was as much ignored as his painting:

In front of me I see thee;
Beside my root-seat is the long, deep pool.
The brook, and thou, neat brooklet!
Are dense engirt by palms, and shrubs, and trees,
All loved by sun, and birds, and a soft breeze,
That keeps the nook and all the tropic wilds half cool.[65]

The gentle fantasy of nymphs had entered his world even before the trip to Samoa (see the Museum's *Afternoon Wind,* 1899). But the young Polynesian girls, with their forthright acceptance of the human body, came to symbolize for him an ideal freedom from hypocrisy, that "Farce of Convention" about which he wrote in his short-lived publication *The Art Reformer.* The nymphs enlivened his private world and came to him freely, as the critics and the world had not. Two years after his death, Duchamp wrote of him, "He painted like a primitive—and this is the origin of his tragedy. His landscapes were not landscapes of a definite country; his nudes were floating figures with no studied anatomy. His allegories were not based on accepted legend."[66]

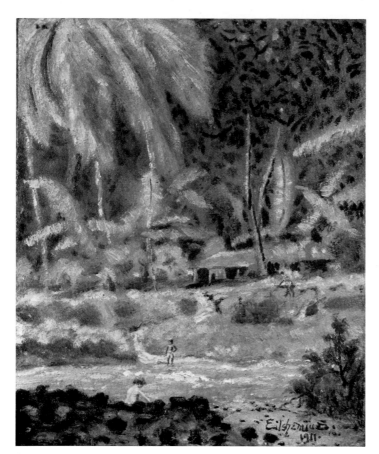

Samoa

Dancing Nymphs

Nymph

JOHN KANE American, born Scotland. 1860–1934

The Campbells Are Coming. 1932. Oil and gold paint on paper
over composition board, 20×16 ¹/₈ inches

The solitary piper in *The Campbells Are Coming* is set against the distant Great Castle of Edinburgh, of which John Kane fondly wrote in his autobiography, "[It] sits high upon a rock shining in the sun like a fairy castle. Its towers touch the silver sky. I have painted that sight from memory but I can never make it one-hundredth part as beautiful as it was to us boys."[67] Scottish scenes were a favorite with Kane, who was born near Edinburgh and came to the United States from Scotland at the age of nineteen. After arriving in America, he traveled about as a manual laborer from job to job, eventually settling outside Pittsburgh, where, as it turned out, he was able to refresh his memory of the kilts and customs of his youth at the annual Scots' Day celebration, commemorated in his *Scotch Day at Kennywood Park,* 1933 (The Museum of Modern Art).

Kane was a famous fistfighter; over the years he worked as a miner, gandy dancer, carpenter, steelworker, and house painter. Remote as these activities may seem from the world of easel painting, he found much of his work relevant to his artistic inclinations. Early in the century, he got a job painting steel freight cars. "So it was," he wrote, "I learned the use of paint. . . . I had always loved to draw. I now became in love with paint"; and he concluded, "The best thing in the world for a young artist would be to hire himself out to a good painting contractor who knows his job."[68]

Although Kane had made paintings from 1904 on, recognition came only in 1927, when one of his paintings of the Scottish Highlands was accepted for the Carnegie Institute's International Exhibition. He was the first primitive to be so honored. Two years later, three of his pictures were included in The Museum of Modern Art's exhibition "Living Americans." Unfortunately, fame did not bring him prosperity; he died in poverty of tuberculosis in 1934.

Kane's *Self-Portrait,* 1929 (page 188), in the Museum's collection is perhaps his most powerful and moving work. The figure who confronts us with an iconlike frontality is clearly a man of great physical strength and moral fortitude.

PATRICK J. SULLIVAN American, 1894–1967

The Fourth Dimension. 1938. Oil on canvas, 24 $^1/_4$ × 30 $^1/_4$ inches

Sidney Janis discovered the work of Patrick J. Sullivan in the spring of 1937 at the Society of Independent Artists, where his first painting, with the intriguing title *Man's Procrastinating Pastime* (1936), was exhibited. Mr. Janis acquired it and entered into a correspondence with the artist, from whom he bought *The Fourth Dimension* in 1938. The same year, Sullivan was included in The Museum of Modern Art's exhibition "Masters of Popular Painting," although at the time he had completed only three pictures.

Like John Kane (page 82), Sullivan worked for a while as a house painter; it was not until the forced leisure of the Depression that he found time to take up painting seriously. His self-taught technique was so painstaking and methodical that he sometimes required a year to complete a canvas. In subject as well as in execution, each picture was elaborately conceived, the themes being "an extension of the paintings themselves," as Mr. Janis has pointed out.[69] It was Sullivan's intention to paint "powerful stuff that will make people think,"[70] as the complexly developed *Fourth Dimension* reveals; and his admiration for Salvador Dali as "a master of the hidden theme"[71] comes as no surprise.

According to the artist's own explanation of the iconography of this picture, "Man, a three dimensional creature is chained securely . . . to a three dimensional planet. . . . He studies the multitudinous planetary system. He looks out into this infinite system of worlds and wonders, ponders on this and that . . . the most intriguing of all is the question 'What is the fourth dimension?' . . . but with all his studying . . . he cannot go beyond his limit. A finite creature cannot delve into infinitude.

"However, when death [represented by the reclining figure] ensues, the chain holding man here is broken and his spirit . . . leaves the vehicle in which it toured this three dimensional earth and is absorbed into Time from whence it came. The spirit then is not cognizant, or aware of any dimensions. It is infinite. . . . The geometrical lines show height, width, length going out into infinity. The lines go thru' the hour glass which represents time. . . . Time then is the 4th dimension. The hour glass is red to represent or show that all life has its being in time (pulsing, vibrant, red life)."[72]

Sullivan identified the "finite Man" with his back turned, contemplating the heavens, as a representation of Mr. Janis.[73] The bleak earthly terrain, the severe curve of the horizon line, the harsh, chill blue of the sky, and the impressive array of planets all contribute to the ethereal quality of the landscape.

WILLIAM DORIANI American, born 1891

Flag Day. 1935. Oil on canvas, $12\frac{1}{4} \times 38\frac{5}{8}$ inches

A successful opera singer who at the age of forty turned to painting as an avocation, William Doriani hesitated for years to show his work publicly. In the spring of 1938, however, he exhibited several of his paintings, including the festive *Flag Day,* 1935, at the Washington Square Art Mart in New York. The lively, unframed pictures caught the attention of Sidney Janis, who arranged an exhibition for Doriani at the Marie Harriman Gallery soon after.

In this work Doriani, a naturalized American citizen, celebrated his return from Europe in 1935, after an absence of thirteen years. The day of his arrival happened to be Flag Day. Mr. Janis has commented about the picture: "The long line of the parade undoubtedly influenced his choice of canvas . . . three times as wide as it is high. . . . Where Doriani may have consciously hoped to attain forward movement in painting the marching feet, he succeeded only in creating a treadmill, but in the two upper horizontal bands, the flags and the blooms, where movement was not his intention, he succeeded in producing a forward motion. . . . Doriani's respect for the flag is evidenced in the careful way he has given it exact detail. Although there are many more than a score of flags, the thirteen stripes of each are visible, and the forty-eight stars clearly indicated."[74]

MORRIS HIRSHFIELD American, born Russian Poland. 1872–1946

Beach Girl. 1937–1939. Oil on canvas, 36 1/4 × 22 1/4 inches
Angora Cat. 1937–1939. Oil on canvas, 22 1/8 × 27 1/4 inches
Lion. 1939. Oil on canvas, 28 1/4 × 40 1/4 inches
Inseparable Friends. 1941. Oil on canvas, 60 1/8 × 40 1/8 inches
Girl with Pigeons. 1942. Oil on canvas, 30 × 40 1/8 inches
Parliamentary Buildings. 1946. Oil on canvas, 36 1/8 × 28 inches

Morris Hirshfield came to America from Russian Poland at the age of eighteen. After working for several years in a women's coat factory, he and his brother set up their own firm, which they subsequently sold to enter the manufacturing of boudoir slippers. This training was to have a marked influence on Hirshfield's style as a painter, giving him an inclination for precision in detail and a special feeling for line and texture.

In 1937, after a severe illness, the sixty-five-year-old Hirshfield retired from business and began to paint. The *Beach Girl* and the *Angora Cat*, his first two attempts, were painted on old canvases from which he retained elements of the original pictures—the face of the girl in the former, and the small metal lion above the head of the cat in the latter. Like many primitive artists—the *douanier* Rousseau among them—his aim was a literal rendition of reality; but at the outset, as he wrote in his autobiographical notes, "my mind knew well what I wanted to portray but my hands were unable to produce what my mind demanded."[75] Despite meager encouragement from his family, he persisted, working alternately on the two pictures for two years.

In the fall of 1939, Sidney Janis, in quest of paintings for his forthcoming exhibition of our native primitive artists, "Contemporary Unknown American Painters," at The Museum of Modern Art, came upon the mesmeric cat in Hudson Walker's gallery. He immediately borrowed both that picture and the *Beach Girl* for the show, and at its opening he met Hirshfield for the first time. They became friends, and in 1942 Mr. Janis devoted a chapter of his book *They Taught Themselves* to Hirshfield's life and a close analysis of his paintings.[76] The following year he directed at the Museum a one-man show of Hirshfield's work, which contained all his thirty paintings to date, and which became highly controversial.[77] "Enough is enough of an oddity," declared one typically unappreciative critic, who termed the pictures the work of a "fumbling old man," not worthy of being shown at the Museum;[78] others took particular exception to Mr. Janis's lengthy pictorial analyses and explanatory captions, which one characterized as "a combination of preciosity and the hunting down of butterflies with the aid of caterpillar tractors."[79] Nevertheless, as Mr. Janis has recalled, Hirshfield's paintings were admired by no less an artist than Piet Mondrian.[80]

Mr. Janis has compared Hirshfield's inclusion of borrowed images in the *Beach Girl* and the *Angora Cat* with the collages of such Surrealists as Max Ernst and Salvador Dali; he points out that "unconsciously Hirshfield, by the same relating of the unexpected, has caused the same element of surprise." He also notes that Hirshfield's meticulous rendering of textures is comparable to the effects of Surrealist *frottage*. In the *Beach Girl*, for example, "the waves are stippled and grained like the pores and ridges on two huge thumbprints. . . . Their pigment strokes give the impression of interminable stitchings on the interlining of clothing, and the all-over effect of texture and color is that of woven salt-and-pepper tweed."[81]

Hirshfield spoke of the figure he created in this painting as his "dream girl." The creature in the *Angora Cat* is likewise a symbol of femininity, as well as of the disturbing conflicts at home, where his efforts to paint were constantly disparaged. Mr. Janis describes her as "a

Beach Girl

Angora Cat

Lion

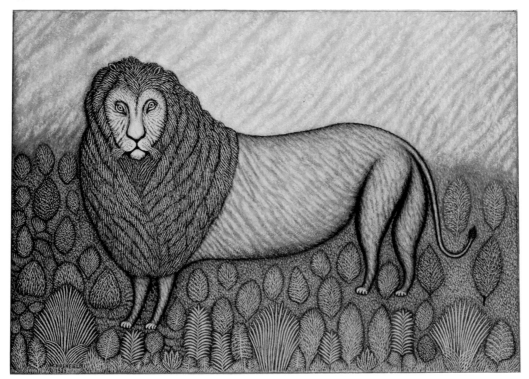

Inseparable Friends

Girl with Pigeons

Parliamentary Buildings

strange mysterious creature . . . at once spell-binding and mirth-provoking. Her deep-set eyes, staring intensely, take immediate possession of the beholder. . . . But she is such a homey creature, round and fluffy, that the terror is not quite convincing, and the ripples of fear that run up and down the spine eventually turn to laughter."[82]

The *Lion* was Hirshfield's next painting. After searching for a model at the zoo, the public library, and the American Museum of Natural History, he found a point of departure in a cheap colored lithograph; but in the picture this model has been completely transformed, much like the animals in Edward Hicks's various renderings of the Peaceable Kingdom. (A closely related *Tiger* is owned by The Museum of Modern Art.) The lion is a male symbol, and Mr. Janis believes that its "gentle and quizzical countenance, its humanized features, as well as the ashen and reddish blonde coloring in the area of the face, suggest that this is perhaps an unconscious self-portrait."[83] He points out, however, that the color and texture of the mane resemble the gilt embroideries on the velvet coverings of Torah scrolls. Hirshfield's preoccupation with texture is again apparent in this painting; Mr. Janis relates, "In an effort to get the mane of the lion to resemble hair, Hirshfield first used a fine comb. . . . His idea was to comb the pigment into place, but he did not get the result he wanted. Therefore with a brush he painstakingly worked out the individual strands throughout the mane, building up the pigment for each detail."[84] He also notes that Hirshfield's occupational background in the cloak-and-suit industry is reflected in the way in which the mane is adjusted like a snug fitting furpiece, overlapping from the wearer's right to left, as in women's clothing, rather than from left to right as in men's attire.[85]

The *Inseparable Friends* and the *Girl with Pigeons* are two of Hirshfield's most evocative canvases, charged with a highly personal symbolism enhanced by a unique style that owes much of its effect to curvilinear rhythms. His painting of nudes was stimulated by Rousseau's *The Dream* (The Museum of Modern Art), which he had seen in the Janises' apartment,[86] and his first attempt in this genre was the *Girl in the Mirror*, 1940 (The Museum of Modern Art). He explained that "while artists generally painted the front view of nudes, he considered the back view even more beautiful,"[87] but in the *Inseparable Friends*, done the following year, he attempted both. Although the figure in *Girl with Pigeons* is fully clothed, this composition, too, may reflect Hirshfield's response to Rousseau's image, in the *Dream*, of Yadwiga reclining on her couch.

The subject of the *Parliamentary Buildings*, painted in the last year of Hirshfield's life, is actually the church of Sacré Coeur, based on a postcard that Mr. Janis sent to him from Paris in 1946. A comparison with a second version, *Sacré Coeur, II* (page 187), affords an interesting sidelight on Hirshfield's transformation of his motifs. The rigid symmetry of the earlier Janis painting has been subtly varied by the decorative birds, plants, trees, and fountain; at the same time, the building itself assumes a more dominant role in the total composition. Seen from a closer vantage point, it occupies two-thirds of the canvas; its façade is articulated with greater simplicity, and the steps extend across the entire front of the building. In an intuitive response to the church's neo-Byzantine architecture, Hirshfield enhanced the total effect of Oriental exoticism throughout this painting, which calls to mind the decorative pages in medieval East Christian manuscripts.

LOUIS VIVIN French, 1861–1936

The Pantheon. 1933. Oil on canvas, 15 × 21 ³/₄ inches

An innate sense of meticulous, inescapable order pervades the work of Louis Vivin, who died in 1936 in Montmartre, having spent most of his lifetime in the French postal service. He began to paint in earnest only after his retirement. Whereas his earlier pictures had been of narrative subjects, he developed an increasing interest in tactile values and in some of his pictures even applied plaster to create surface relief.

Sidney Janis acquired *The Pantheon* in 1950 from the Galerie Bing in Paris, which two years before had held a Vivin exhibition dedicated to the great German collector and critic Wilhelm Uhde. A long-time friend of Vivin, Uhde had been instrumental in bringing him to the attention of the French public, as he had other modern primitives, including the *douanier* Rousseau and the kitchen helper Séraphine. Uhde observed that to Vivin, finding "no true relationship between life's pleasures, all too soon ended, and the desperate normality which endures . . . a career of drab monotony seemed as ineluctable as salt water to a fish at sea."[88] Not unlike other primitive artists who have earned their living in mundane pursuits, however, Vivin seems to have discovered an escape from this drabness in his painting. Working from postcards and reproductions, he filled his pictures with buildings such as *The Pantheon*, painted three years before his death. The precision with which each block of masonry is rendered reflects both his patient nature and his fascination with every detail of the architecture.

III POSTWAR MASTERS AND MOVEMENTS IN EUROPE AND AMERICA

ABSTRACT EXPRESSIONISM AND RELATED TENDENCIES

HARD-EDGE AND GEOMETRIC

POP ART AND AFFINITIES

JEAN DUBUFFET

Corps de Dame: Blue Short Circuit. 1951. Oil on canvas, $46\,^{1}/_{8} \times 35\,^{1}/_{4}$ inches

This is one of the last of a series of thirty-six Corps de Dame paintings by Jean Dubuffet, made between April 1950 and February 1951 (of which the Museum owns one, *The Jewess*, 1950, as well as several drawings and lithographs related to the series). In the *Blue Short Circuit*, a squared torso reflects the shape of the canvas and dominates the surface; the flat little head and cropped vestigial legs typically serve only to anchor the subject, which is placed symmetrically and inescapably before the possibly reluctant viewer. The gross corporeality of the body engulfs the entire picture and seems to metamorphize into the type of landscape that simultaneously preoccupied Dubuffet at this period. The surface somewhat resembles that of the *hautes pâtes*, although the paint is not contaminated with sand or other foreign matter; and in the interest of color—here almost decorative at moments—the contours are more diffused, the linear contours more swirling.

The brutal sexuality of the Corps de Dame series celebrates another of Dubuffet's "anti-cultural positions." Its ambivalent reference to a devouring earth mother or primitive fertility goddess has frequently evoked comparisons with de Kooning's Woman series, the first of which were coincidentally painted about this time (the Janis collection *Woman, XI*, page 123, being a later example). In his attitude toward painting, Dubuffet had certain affinities with the Abstract Expressionists. In the early 'fifties, he wrote, ". . . I am inclined to leave in my paintings, for example, the accidental blotches, clumsy blunders, forms that are frankly wrong, anti-real, colors that are unwelcome, inappropriate, all things that would probably seem insufferable to certain people. They even make me a little uneasy because, in many cases, they destroy the effect. But this uneasiness I voluntarily maintain, for it keeps the painter's hand ever present in the painting and prevents the object from dominating and from things taking shape too clearly."[92]

JEAN DUBUFFET

Façade. 1951. Watercolor on gesso on paper, $9^{7}/8 \times 13$ inches, irregular

One of a series called Barren Landscapes (*Paysages désertiques*), the *Façade* depicts a theme that first appeared in Dubuffet's work early in the 'forties—the cityscape or street scene boiling with life. It resembles the oil *Fixed Façades,* 1946 (Collection Mr. and Mrs. Ralph F. Colin, New York) and other works, as well as similar subjects to which Dubuffet reverted in the early 'sixties. The panoramic view of a city block or a large building provided him with an antidote to the concentration on single figures or objects that had begun in the 'forties, and to his preoccupation with textures throughout the 'fifties. Here again Dubuffet is examining the apparently insignificant lives of ordinary people, in accordance with his dictum, "My art is an attempt to bring all disparaged values into the limelight."[93] The technical experimentation is also characteristic. In contrast to his previous use of thick impasto, here watercolor lines are drawn on top of a fluid, allover pattern made by gesso on paper. The accidental effects thus produced may have initially suggested the subject, for Dubuffet has said that his pictures of 1950–1951 "are closely linked . . . to the specific behavior of the material used."[94]

JEAN DUBUFFET

Table aux souvenirs. 1951. Oil and sand on canvas, $32\,^1/_8 \times 39\,^1/_2$ inches

The series called Landscaped Tables, Landscapes of the Mind, Stones of Philosophy, to which this painting belongs, occupied Dubuffet during 1951 and 1952. The *Table aux souvenirs* was painted in March 1951, a month after the *Blue Short Circuit* (page 103), which it echoes in its anthropomorphism and figure-ground relationship. The texture is drier here and the patterns less turbulent, but the concern with paint as sheer matter—whether heavy or fluid—is still paramount. Sand has been mixed with the paint for additional weight; in another canvas from this series, The Museum of Modern Art's *Work Table with Letter*, 1952, Swedish putty was added. (The Museum also owns a drawing from the series, *Table Laden with Objects*, March 1951.)

The tables are private memories made tangible. The objects upon them are not stressed, although here a loaf of French bread can be discerned at the right, and there may be a plate and a wineglass in the center and to the left. "I must say I have all my life always loved tables," Dubuffet has written. "[They] respond to the idea that, just like a bit of land, any place in this world (especially if it relates to an object so inseparable and so cherished a companion as is a man's own table), is peopled with a swarm of facts, and not only those which belong to the life of the table itself, but also, mixing with them, others which inhabit the thought of man, and which he impresses on the table looking at it. I am convinced that any table can be for each of us a landscape as inexhaustible as the whole Andes range."[95]

ALBERTO GIACOMETTI Swiss, 1901–1966

Three Men Walking, I. 1948–1949. Bronze, $28\,^1/_2 \times 16 \times 16\,^3/_8$ inches, including base, $10\,^5/_8 \times 7\,^3/_4 \times 7\,^3/_4$ inches

The three works by Alberto Giacometti in the Janis collection were produced in three different decades and are representative of three mediums in which he worked—sculpture, drawing, and oil painting.

After having worked successfully in Cubist and Surrealist styles, in the mid-'thirties Giacometti reached an impasse in his art and entered a period during which, for five years, he struggled to work from a model; then, in order to overcome his difficulties, he began to work from memory rather than from life. But, as he recalled, "to my terror the sculptures became smaller and smaller, they had a likeness only when they were small, yet their dimensions revolted me. . . . A large figure seemed to me false and a small one equally unbearable, and then often they became so tiny that with one touch of my knife they disappeared into dust. . . . All this changed a little in 1945."[97] Sidney Janis recalls that at the time of his first postwar visit to Paris in the winter of 1945/46, "Giacometti was doing very small elongated figures, such as those in the *Three Men Walking,* but those figures were only about an inch or an inch-and-a-half high. He carried them around in the palm of his hand and in his pockets, and he'd pull them out and show them to you; and he said, 'I think about these as being two meters tall, and they come out this big!'"[98]

The *Three Men Walking, I* of 1948–1949 relates not only to a second version, dated 1949, but also to The Museum of Modern Art's important *City Square* of 1948 (page 184). The figures in the *City Square* are smaller in relation to the overall space, and their physical isolation is therefore more accentuated; within the tighter format of the Janis sculpture, the self-contained quality of each figure evokes a great Existentialist loneliness. The three men do not form a group; the relationship among them seems purely random and temporary.

While working, Giacometti always maintained a consistent distance of about nine feet from his subject, and most of his works are best viewed from that distance. In a curious way, they seem sealed into a package of space defined by the artist. If his sculptures from the 'forties on are approached too closely, they tend to become less rather than more clear. Their irregular surfaces catch light and shadow and blur the contours, which in the case of the extremely elongated figures become almost a straight line.

ALBERTO GIACOMETTI

The Artist's Wife. 1954. Pencil on paper, 16 ⁵/₈ × 11 ³/₄ inches, irregular
Annette. 1962. Oil on canvas, 36 ³/₈ × 28 ⁷/₈ inches

Giacometti's wife Annette, like his brother Diego, was a frequent subject in his portraiture. The pencil drawing and the oil *Annette* were done almost a decade apart but are alike in the frontal pose and the position of the hands. In both works, the sitter's direct, obsessive stare establishes an abyss between subject and spectator, creating a detachment like that in the sculpture.

The Artist's Wife

Annette

ARSHILE GORKY American, born Turkish Armenia. 1904–1948

Good Hope Road, II. 1945. Oil on canvas, 25 $^1/_2$ × 32 $^5/_8$ inches
Study for *Summation.* 1946. Pencil and colored crayon on paper, 18 $^1/_2$ × 24 $^3/_8$ inches

These two works, done in the last few years before Gorky's death in 1948, exemplify his mature style, which, as William Rubin has pointed out, spanned the transitional period in American avant-garde painting that "extended from 1942 through 1947 and thus corresponded simultaneously to the last phase of Surrealism and to the early work of the artists who would later emerge as innovators of the new American painting."[99] The *Good Hope Road, II* reveals the influence of Joan Miró's attenuated line and Matta's diaphanous color space—in other words, of the two artists who had most visibly affected Gorky's Surrealist style. The relaxed painterliness of this work, however, belongs more to Abstract Expressionism than to Surrealism.

This painting takes its name from the road on which Gorky lived in Connecticut from 1944 until his death in 1948. There is another painting of 1946 with the same title; the Janis picture, however, is actually an oil sketch for a work called *Impatience,* 1945 (page 185). The final version is more compact, its forms and rhythms directionally focused on the center; the figure at the left is more coherent, and the relationship between the two figures is more specifically sexual. But while the line in the *Impatience* is more controlled, in the Janis painting it retains the almost balletic grace characteristic of Gorky's drawings and sketches. Line became especially important to Gorky after Willem de Kooning introduced him to the sign painter's liner, a brush designed to make long, thin strokes. "Having bought one," de Kooning recalled, "Gorky sat around all day in ecstasy painting long, beautiful lines."[100] The *Good Hope Road,* and even the *Impatience,* are still quite loose and lyrical. The handling of the paint is transparent, whereas in later works, such as The Museum of Modern Art's *Agony,* 1947, it becomes bolder and more substantial, corresponding to the emotional density of Gorky's last paintings.

The drawing for *Summation* is one of several smaller studies in pencil, pastel, and charcoal for a work over eight feet long, which it closely resembles. This large *Summation,* 1947 (page 185), was apparently the cartoon for what would have been Gorky's most complicated and ambitious oil. Although its title was bestowed posthumously, it does indeed constitute a summation of Gorky's work of 1946, as William C. Seitz has pointed out.[101] The nervous surface of the Janis version teems with small forms, which bear direct reference to human figures or Surrealist presences. The dramatic character of these personages and their relationship to one another appear to reflect some of Matta's paintings of about 1945 and even earlier, such as *Paysage flammifère* (page 75). Deep space is more meaningful for Matta, as evidenced by the Chiricoesque perspective lines and clear demarcations of areas, whereas Gorky's stage is shallower and more Cubist. Although Gorky's frontal forms are more loosely drawn, they seem more humanoid than Matta's fragmented, ephemeral, and floating shapes, and their sexual references are more direct and personal. Both artists share the biomorphic fluidity and quality of line that characterize automatic drawing.

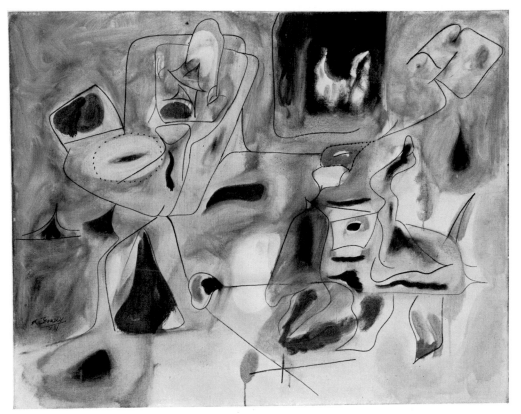

Good Hope Road, II

Study for *Summation*

MARK TOBEY American, born 1890

Fata Morgana. 1944. Tempera on cardboard, $14^{1}/_{8} \times 22^{1}/_{4}$ inches
Wild Field. 1959. Tempera on cardboard, $27^{1}/_{8} \times 28$ inches

About 1936, Mark Tobey began to explore the kind of calligraphic drawing in painted line that came to be called "white writing." By the early 'forties, it had been freed so entirely of all descriptive reference as to constitute an autonomous and abstract allover web. The *Fata Morgana* was painted in 1944, shortly after Tobey's one-man show at the Willard Gallery in which works in this style were first exhibited, among them The Museum of Modern Art's *Threading Light,* 1942. In his introduction to the exhibition catalogue, Sidney Janis described white writing as a style in which "the result transpires not by accident but through sensitively controlled freedom . . . a form of automatism taking place in the foreconscious . . . presumably different from psychic automatism in that it is essentially under conscious direction."[102] Tobey has acknowledged the sources of the style to be Cubism, Impressionism, and Oriental calligraphy, which he first studied in 1923.[103] The fusion of these elements produced a new pictorial configuration that in certain respects anticipated Pollock's allover patterning.

In the *Fata Morgana,* the white writing is still superimposed upon a basically Cubist infrastructure. The *Wild Field,* executed fifteen years later, moves away from the pure allover configuration that Tobey had explored in his white writing. Though still abstract in its notation, the transition of the ground color from dark to light alludes inescapably to the horizon line of landscape.

Fata Morgana

Wild Field

JACKSON POLLOCK American, 1912–1956

Free Form. 1946. Oil on canvas, 19 $^{1}/_{4}$ × 14 inches
White Light. 1954. Oil, aluminum, and enamel paint on canvas, 48 $^{1}/_{4}$ × 38 $^{1}/_{4}$ inches

Jackson Pollock had used spilled or dripped paint in his work as early as 1942, but not in a consistent or thoroughgoing manner; and he had established allover configurations in paintings of 1946, some painted directly from the tube, with fingers, or with the palette knife. But only at the very end of that year were these components fused, resulting in the creation of his "classic" drip style.

The *Free Form,* painted in November or December 1946 in Springs, near East Hampton, Long Island, was an important turning point in Pollock's development. Believed by Clement Greenberg to be the first picture made in the artist's mature drip technique,[104] it is also one of the smallest. The openness and transparency of its black and aluminum webs, their linear variety, and their relation to the frame anticipate the more fully developed, larger works that Pollock would realize in 1947–1950.

The *White Light* is one of the relatively few works that Pollock completed in his last years; from 1954 until his death in 1956, he painted very little. Although eight years later than the *Free Form,* it reverts to the tube-drawn paintings of 1946 that preceded the drip pictures, such as the Museum's *Sounds in the Grass: Shimmering Substance,* whose very title implies the Impressionist intent of the Janis picture. The *White Light* also shares with that group the heavy impasto and the feathery or blurred effects of Pollock's first allover paintings. Most of the pigment, even that of the lines, remains at tube consistency, substituting for the transparent and lyrical arabesques of the drip paintings a more opaque web, slashed by rectilinear accents.

These two paintings add to the scope and variety of the Museum's impressive collection of Pollocks, which includes the *She-Wolf,* 1943, and several major drip paintings, the greatest of which is *One* (page 207).

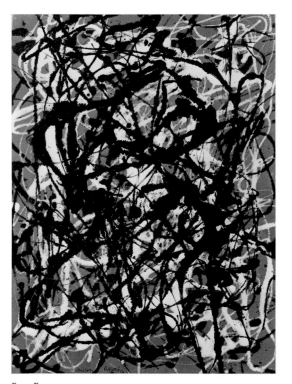

Free Form

White Light

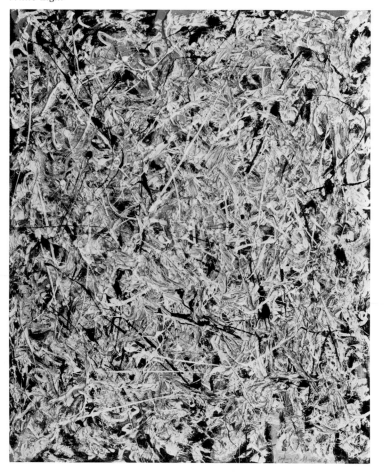

WILLEM DE KOONING American, born the Netherlands 1904

September Morn. 1958. Oil on canvas, 62 $^7/_8$ × 49 $^3/_8$ inches
A Tree in Naples. 1960. Oil on canvas, 6 feet 8 $^1/_4$ inches × 70 $^1/_8$ inches

Both the *September Morn* and *A Tree in Naples* are among the series of suburban or rural landscapes that Willem de Kooning painted in response to his surroundings at East Hampton, Long Island, where he was spending more and more time in the late 'fifties, and which became his principal home about 1960. These works, however, record no specific place; rather, they are distillations of landscape that reflect a manner of seeing and experiencing a locale. In these paintings, de Kooning's palette becomes less mordant and expressionist than it had been in the 'forties; the colors tend to be more decorative, and there is a new character to the light. There is a notable relaxation in the larger, less fragmented surfaces. This feeling of relaxation, apparent in such pictures as the *September Morn* and *A Tree in Naples,* derives also from the marked frontality of the planes, which are larger in size and fewer in number than in de Kooning's tense compositions of a decade before.

The broad, gestural brushstrokes characteristic of the landscape series have affinities with the manner of Franz Kline (page 125), who had himself been influenced by de Kooning in the late 'forties. In the large, slashing passages within these paintings, however, de Kooning created edges that cut into the picture plane in a way quite alien not only to Kline, but also to the host of de Kooning imitators who had turned the linear electricity of his earlier style into a mannerism.

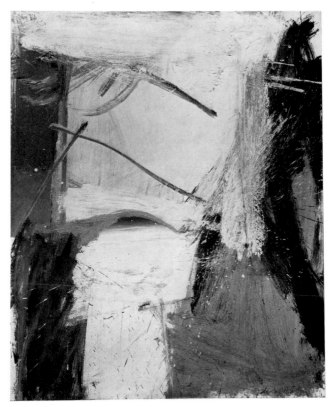

September Morn

A Tree in Naples

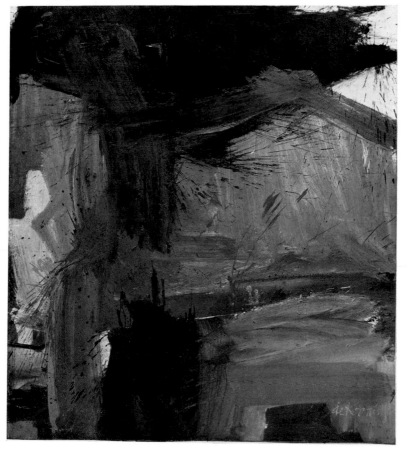

WILLEM DE KOONING

Woman, XI. 1961. Oil and pastel on paper mounted on canvas, 29 × 22 ³/₈ inches

As though to counterbalance his involvement with landscape themes during much of the previous decade, in 1960 de Kooning reverted to the subject of Woman, which he had explored intermittently in the 'forties and, with greater vehemence, in a series begun in the early 'fifties (coincidentally, at the same time that Dubuffet became preoccupied with his Corps de Dame series, page 103). When the *Woman, I,* 1950–1952 (page 191) was first exhibited, the art world saw in it, as in Pollock's black pictures of approximately the same date, indications of the avant-garde's return to figurative painting. But de Kooning had never entirely left it; he merely reorganized the fragmented particles of his black paintings of the late 'forties back into a coherent, readable figure instead of a primarily abstract one—much as the Cubists, in their post-1912 pictures, had "synthesized" the atomized, fragmented elements of their late Analytical phase into the more simplified and legible icons of their Synthetic period. The Cubists, however, always regarded the figure more as "motif" than as subject, whereas for de Kooning the female body has invariably been an expressive subject of great importance.

Among the other ambiguities evident in the *Woman, I* is the involvement of a figure with its environment. De Kooning is quoted as having said at the time that the woman's form reminded him strongly of "a landscape—with arms like lanes and a body of hills and fields, all brought up close to the surface, like a panorama squeezed together."[105] In fact, it was the enlargement of certain passages in his first Woman paintings of the very early 'fifties that eventually led him to the landscape series he began toward the end of that decade (an unfinished painting of 1955, in a private collection, actually bears the title *Woman as Landscape*). In turn, in the later Woman series, figure and landscape become even more interchangeable. But in contrast to the tension and anxiety evident in the earlier group, these works—such as the Janis collection *Woman, XI* of 1961—display the greater relaxation typical of de Kooning's later style.

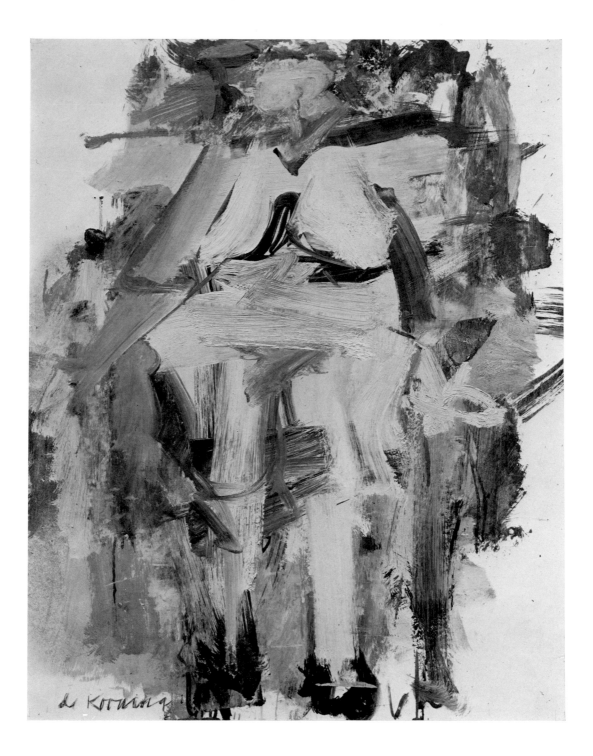

FRANZ KLINE American, 1910–1962

Two Horizontals. 1954. Oil on canvas, 31 $^1/_8$ × 39 $^1/_4$ inches
Le Gros. 1961. Oil on canvas, 41 $^3/_8$ × 52 $^5/_8$ inches

The *Two Horizontals* and *Le Gros* suggest the direction of Franz Kline's development during the final decade of his life. While the *Chief,* 1950 (The Museum of Modern Art) retains the heavy curves and complicated linear network characteristic of his work of the early 'fifties, the *Two Horizontals* displays a more architectonic structuring, and a robustness and directness that appear deceptively spontaneous. The four major forms are so assertive that the detail and subtleties of the under- and overpainting are at first unnoticed. *Le Gros,* painted a year before Kline's death, is less forthright. The attenuation of the black forms within a taut space and the subtly variegated handling of the paint reflect a gradual refinement that is echoed in other of the artist's late works.

Despite their unquestionably graphic quality, these canvases record—if at a considerable psychic distance—a response to observed phenomena, as well as to the act of painting itself, rather than simply to drawing. Kline did not paint black *on* white so much as black *and* white, or even black *in* white.[106] Although his work has sometimes been compared to Oriental calligraphy, it is, as Kline himself has pointed out, firmly based on Western tradition, "the tradition of painting the areas which, I think, came to its reality here through the work of Mondrian—in other words, everything was equally painted—I don't mean that it's equalized, but I mean the white or the space is painted. . . ."[107]

Two Horizontals

Le Gros

CLYFFORD STILL American, born 1904

Painting. Oil on canvas, 8 feet 8 $^1/_4$ inches × 7 feet 3 $^1/_4$ inches

Although Clyfford Still was one of the major innovators among the Abstract Expressionists, often known as the "New York School," he did not settle in New York until 1950; however, from about 1945 on, he was already widely influential among his fellow artists there, through exhibitions and brief sojourns. He developed his basic style in the latter half of the 'forties on the West Coast, where he taught at the California School of Fine Arts in San Francisco. More programmatically than any other of the Abstract Expressionists, Still consciously sought to expunge from his painting any traces of modern European movements—especially Cubism—and, by freeing himself from all such influences, to evolve a completely new art appropriate to the New World.

The Janis collection *Painting* is a particularly powerful example of Still's early mature style. It presents a variegated surface that negates illusionistic space and concentrates attention on itself. The wide expanse of tarry black impasto is enlivened with knife marks and cut across by a jagged red line that rushes horizontally across the upper part of the canvas, to be intersected by two irregular, pointed, vertical shapes descending from above, before it plunges downward to the bottom edge at the right. The elements of this composition, the way in which it fills the entire surface without reference to a surrounding frame or central scaffolding, and the unusually large size for a painting of this period, are all indicative of Still's originality and his masterly command of a new kind of abstraction, free from any decipherable symbols or references to nature. Although many critics have read into Still's works a vision of the broad, romantic Western landscape, he himself has rejected such allusions, believing that the impact of his work could only be diminished by such associations on the part of the viewer.

William Rubin has characterized Still's paintings as "Gothic," with reference to their pointed, vertical forms, which are arranged in relation to one another and to the frame in a totally anticlassical way. An even greater emphasis on soaring verticality, combined with a similar spatial breadth and monumental scale, appears in the Museum's later *Painting* by Still, which dates from 1951.

MARK ROTHKO American, born Latvia. 1903–1970

Horizontals, White over Darks. 1961. Oil on canvas, 56 $^1/_2$ × 7 feet 9 $^3/_8$ inches

Generally, as Elaine de Kooning once noted, Mark Rothko's paintings are "vertical though retaining their horizontal souls."[108] For the *Horizontals, White over Darks*, he chose the atypical horizontal format—one that he had probably begun to explore in 1958–1959 for a large dining room in a Park Avenue building.[109] Here the usual compression is absent, the principal forms are narrower, and the soft-edged, expansive rectangles float freely.

The chief experience offered by Rothko's work from the late 'forties until his death in 1970 is that of color-light, which creates an absorbent, enveloping space of its own. Rectangular forms hold the pictures near the surface of the canvas, so that the spectator has the sense of an encounter rather than of simply being drawn into an amorphous cloud of color.

Although Rothko has been classified with the Abstract Expressionists, he did not share all the attitudes associated with members of that movement. Completely uninhibited self-expression appealed to him not at all: "There are some artists who want to tell all, but I feel it is more shrewd to tell little. My paintings are sometimes described as façades, and indeed, they are façades."[110] He nevertheless once stated that the painter's goal should be "toward clarity: toward the elimination of all obstacles between the painter and the idea, and between the idea and the observer.... To achieve this clarity is, inevitably, to be understood."[111]

BARNETT NEWMAN American, 1905–1970

The Voice. 1950. Egg tempera and enamel on canvas, 8 feet $^{1}/_{8}$ inch × 8 feet 9 $^{1}/_{2}$ inches

In the last two decades of his life, Barnett Newman restricted himself to a single image: that of a band or bands, usually vertical but occasionally horizontal, dividing an expansive color field. Like his *Abraham*, 1949, and *The Wild*, 1950, both in the Museum's collection, *The Voice* adheres to this scheme. In this work, a pale, painted stripe the color of raw canvas crosses a ground of faintly modulated bone white. The paint is applied thinly, without virtuoso treatment, its slight brushiness suggesting an ambiguous but distinctly shallow depth. In this respect, *The Voice* relates to some of Jackson Pollock's paintings, in which the effect is that of a single surface backed by indefinable space but totally without the coordinates of traditional illusionism. In its mood of mystical calm, *The Voice* anticipates Newman's Stations of the Cross series, completed in 1966. Among the several white canvases in that series, the *Fourteenth Station* in particular recalls this much earlier work.[112]

Newman declared that he wished to work with the whole space and denied that his painting had anything to do with geometry: "It is precisely . . . the grip of geometry that has to be confronted . . . only an art of no-geometry can be a new beginning."[113] In fact, his spirit is closer to Monet's than to that of Mondrian. As William Rubin has pointed out: "More than any other painter of his generation, Newman was responsible for establishing what is now called 'color-field' painting. The large size of certain of his pioneering canvases, the purity and drama of his color, and above all the immediate and simple splendor of his art especially recommended it to the younger abstract painters, such as Frank Stella and Larry Poons, who were finding their own styles in the later 1950s. They were naturally most interested in those aspects of Newman's art which fit their own needs; the formal daring—the flatness and pictorial economy—of the whole. The more poetic, visionary aspect of Newman's enterprise belongs rather to the spirit of Abstract Expressionism and links him more closely to contemporaries such as Pollock and Rothko."[114]

YVES KLEIN French, 1928–1962

Blue Monochrome. 1961. Oil on cotton cloth over plywood, 6 feet 4⁷/₈ inches × 55¹/₈ inches

Any group of "identical" paintings from Yves Klein's *époque bleue* is devoid of obvious gestural or textural differences; the paint was often applied with a roller to divest the works of any superficially personal touch. Nevertheless, the great variety of intensities and mutations in these richly sensitive surfaces is apparent when several are hung together. Klein's work was especially admired by Harriet Janis, who shared his interest in jazz and was attracted by his extraordinarily complex and original mind, which found expression not only in painting but also in immaterial sculptures of fire, steam, and water, in esoteric writings, and in monotonal and silent music, predating that of John Cage.

"Yves le monochrome," as Klein called himself, began making one-color, one-surface paintings in 1949 at the age of twenty-one but abandoned the idea a year later for a period of highly individual education and travel. He resumed monochromes in 1952, the year in which he went to Japan to master judo and complete his program of self-enlightenment. In 1957 he began to concentrate on "International Klein Blue," which became his trademark and his obsession. He called his monochrome painting "color realism," choosing the same term as Kasimir Malevich, whose *Suprematist Composition: White on White,* 1918 (The Museum of Modern Art) is the major historic precedent for recent monochrome. As Klein himself noted, however, Malevich's primary concern had been with the form of the square, rather than with color.

There has been a resurgence of one-color painting in the United States, but Klein differs in emphasis from "color-field" painters, such as Barnett Newman (page 131), who, as Sidney Simon has observed, concentrated on expansive scale and tangible presence, whereas Klein concentrated on a closed but transpersonal aura. Simon points out that in Newman's work, color is a form of pure visibility, "an image of the 'sublime'"; in the case of Klein, however, the viewer carries away with him "not an image at all but the experience of the 'void' . . . a painting by Klein . . . is something to be *looked into,* an entity of matter, concentrating a sum of energy, sufficient to cause . . . a vast explosion in the mind."[115]

AUGUSTE HERBIN French, 1882–1960

Composition on the Word "Vie," 2. 1950. Oil on canvas, 57 ¹/₂ × 38 ¹/₄ inches

The art of Auguste Herbin is independent of the world of appearances. Art for him was a means of paralleling, rather than dominating, the forms of nature. A Cubist from 1909 on, he introduced geometric elements into his work in 1913, made polychromed constructions for several years, and, after a brief period devoted to configuration, from 1926 until his death refined a totally nonobjective and systematic style, which reached its apogee in the last decade of his life.

Like Josef Albers (page 136), Herbin employed a geometric framework for an art based primarily on color (at one point, recalling an earlier movement, he called his work "synchromies"; see page 20). His compositional intricacy, however, was closer to the balanced planes constructed by Victor Vasarely (page 143). Herbin saw life as a tension between opposing forces, an eternal, reciprocal movement from light to darkness, sleep to waking, peace to war. The vocabulary of color he evolved to express these forces is symbolic rather than scientific; thus yellow represents light; blue, shadows; and green, the permanence of the plant kingdom. He excluded gray from his palette because it is "anti-painting. Color is a living thing."[116] With this elaborate philosophy, he established an aesthetic of bright colors contained within severely geometric, two-dimensional forms—reducing Cézanne's cylinder, cone, and sphere to the flat shapes of rectangle, triangle, and disc.

The *Composition on the Word "Vie,"* 2 reflects this philosophy. It is one of a series that, like all of Herbin's series, was initially inspired by a single word (in this case, *vie*—"life"). The composition of his paintings was determined by the application of a complex "color alphabet" within a strictly delimited geometric framework.[117] He began each series with diagrams that led to a large group of researches carried out in gouache, from which the final oils were derived. Another composition on the word *"Vie,"* very similar to this one (Albright-Knox Gallery of Art, Buffalo), was included in the Sidney Janis Gallery's exhibition "The Classic Spirit in 20th Century Art" in 1964.

RICHARD J. ANUSZKIEWICZ American, born 1930

Radiant Green. 1965. Synthetic polymer paint on composition board, 16 × 16 inches

Richard Anuszkiewicz was a student of Josef Albers at Yale University in 1954–1955. While in the *Radiant Green* of 1965, as in many other works, he has adopted the basic format of Albers' Homage to the Square series, Anuszkiewicz goes beyond Albers' demonstration of the subtle interaction of color to assault the eye with a barrage of dizzying optical effects. By imposing striated diamonds over a classically stable, square composition, he has succeeded here in breaking up the close-valued color elements into rays that, in their effect on the retina, suggest actual light. The *Fluorescent Complement* of 1960 in the Museum's collection is rougher and freer in effect. Its forms remain discrete and distinguishable, whereas the shimmering intensity of colors in the *Radiant Green* finally dematerializes both surface and form.

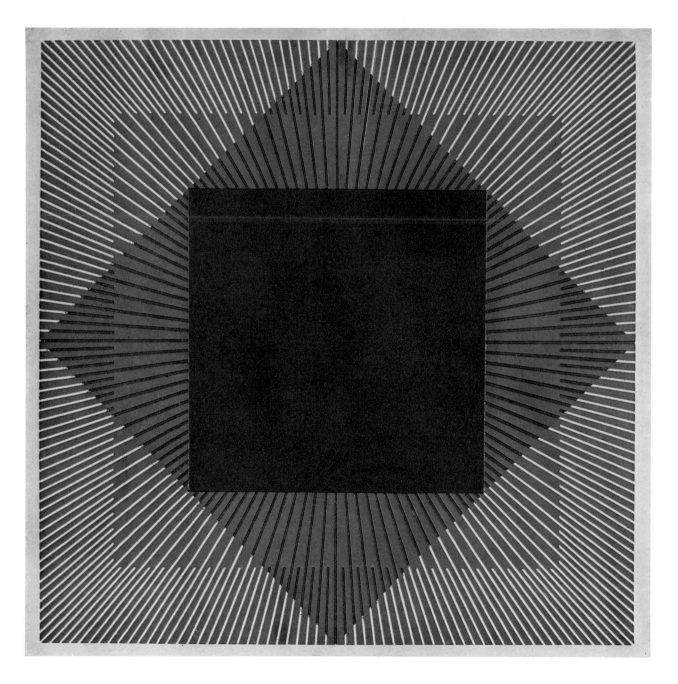

ELLSWORTH KELLY American, born 1923

Spectrum, III. 1967. Oil on canvas in thirteen parts, overall 33 ¼ inches × 9 feet ⅝ inch

This is one of six related paintings by Ellsworth Kelly on the color scale, the earliest of which dates from 1953.[121] In *Spectrum, III* he traces thirteen subtle changes from modules of yellow, green, blue, and violet, and back again through red, orange, and yellow. Instead of dividing a single canvas into thirteen sections, he has used a separate panel for each hue, joining them together across the back of the stretcher. Each color contributes specifically to the appearance of the two adjacent to it and also modifies those farther removed, none of which would look the same if seen in isolation.

Kelly uses these panels as Josef Albers does his squares—as formal, neutral vehicles for a statement in which the emotional content resides entirely in the color, rather than in other formal components such as drawing and shaping, or in subject matter.[122] It was while living in Paris in the late 'forties that, under the influence of Victor Vasarely's patterned illusions, Kelly first became interested in color and reductive geometry. About 1950, he began to work serially and to hang separate solid-color canvases together as a single painting; for example, his *Colors for a Large Wall*, 1951 (in the Museum's collection), consists of sixty-four joined panels, eight across and eight high. After returning to New York in 1954, he developed a new idiom, in which a single shape is contrasted with a ground of another strong color, as for example in the Museum's *Running White* of 1959. Later, he began to work again with monochromatic panels; but in more recent works, such as the *Spectrum, III*, the scale is much larger than in the paintings made earlier in Paris.

VICTOR VASARELY French, born Hungary 1908

Capella 4B. 1965. Tempera on composition board in two parts, overall 50$^5/_8$ × 32$^3/_4$ inches

Whereas the paintings by Josef Albers, Richard Anuszkiewicz, and Ellsworth Kelly in the Janis collection (pages 137, 139, and 141) are concerned with color relationships, the *Capella 4B* depends upon black and white alone to activate vision. Victor Vasarely has been the foremost innovator in optical painting of this kind; not only his art but also his researches and theoretical writings have "at the second or third remove . . . affected painters who were barely aware of his influence."[123] Born in Hungary, he studied at the Mühely Academy—the Bauhaus of Budapest—where he took courses with László Moholy-Nagy before going to Paris in 1930. He has won increasing renown ever since his first one-man show of geometric abstractions, held in 1944 at the Galerie Denise René, of which he was co-founder.

The *Capella 4B* is one of the numerous tempera studies for an oil, *Capella 4,*[124] in a series of paintings executed between 1963 and 1965 that deal with "the mystery of the Stars and the Galaxy." Vasarely states that, on a formal level, the series is concerned with "the introduction of light and shade into geometric abstraction."[125] Here he has taken the square and the circle—the ancient and universal symbols of heaven and earth—as the starting point for an exercise in the harmony of opposites. Not only are the two concentric forms contrasted in shape, but the shutterlike bars over them are reversed in direction, one set opening toward the center, the other closing. By this systematic fragmentation of forms, alternately compressed and released, the white circle seems to force its way from the picture plane, while the black square recedes, producing an illusion equivalent to chiaroscuro.

This painting is a notable addition to others by Vasarely owned by the Museum, ranging from an early work, *Yllam,* 1949–1952, through the *Yarkand,* 1952–1953 of his so-called "Crystal" period, and the *Ondho,* 1956–1960 (the first syllable of its title being derived from *ondulatoire* and referring to the artist's interest in the wave theory of physics), to the *CTA-104-E,* of 1965, a painting of the same date as the *Capella 4B,* and with a title relating to cosmic rays.

True to Bauhaus tradition, Vasarely has worked in many mediums: paintings, prints, sculpture, and murals, and has also advocated collaboration, art teams, scientific procedure, and industrial-design techniques as means to rid art of its egocentric basis. He is particularly interested in the application of his principles to architecture. Vasarely believes that we are now "at the stage of concepts. . . . Only teams, groups, entire disciplines will henceforth be capable of creating; cooperation among scientists, engineers and technicians, manufacturers, architects and technicians will be the work's prime condition. More and more numerous are the contacts with extra-pictorial circles to concretize investigations. The art-idea is abandoning its centuries-old mist to flourish in the sunlight in the immense modern network that is being woven round the globe."[126] Like many of Vasarely's ideas, these words, written in 1965, have already been proved prophetic by younger artists throughout the world.

ÖYVIND FAHLSTRÖM Swedish, born Brazil 1928

Eddie (Sylvie's Brother) in the Desert. 1966. Variable collage:
fifteen movable serigraphed paper cutouts over serigraphed cutouts
pasted on painted wood panel, $35\,^{1}/_{4} \times 50\,^{1}/_{2}$ inches

In Öyvind Fahlström's own words, the variable collage *Eddie (Sylvie's Brother) in the Desert* is an "erotical-political parable on USA and the world."[128] Although he has identified Eddie as a French pop composer and bandleader, brother of the singer Sylvie Vartan, the precise symbolism of the work is elusive. First shown in Fahlström's one-man show at the Sidney Janis Gallery in 1967, it is closely related to a silkscreen print of the same title, published by Tanglewood Press in their 1966 portfolio "New York International" (a copy of which is in the Museum's collection) and a drawing of the same title (also in the Museum's collection). Many of the images, though differently arranged, are repeated in the print, which in turn is a near replica of a static painting in tempera on board, also of 1966 (Collection Fredric Ossorio, Greenwich, Connecticut).[129] The print and the tempera painting perhaps represent the "ideal" arrangement of the collage, which, however, is always to be regarded as subject to chance and the caprice of its owner. Fifteen of its images are mounted on a spongy material and are held in place only by the pressure of the protective plexiglas glazing. They can be moved at will simply by removing the plexiglas.

International by birth, education, travel, orientation, and renown, Fahlström has been active not only in the visual arts but also as a writer of poetry and prose, in the theater and happenings, as well. His first variable game painting was executed in 1962, a year after he came to the United States. He conceives of this medium as related to "puppet theater and psychodrama," and declares, "The isolated elements are thus not paintings but machinery to make paintings. Picture-organs."[130] He further explains, "A game structure means neither the one-sidedness of realism nor the formalism of abstract art, nor the symbolic relationship in surrealistic pictures, nor the unbalanced relationship in 'neo-dadaist' work."[131] His game structures have been related to novels by William Burroughs, their dispersive space, fragmentation, and comic-book harshness of line having similarly sinister overtones.

Fahlström has explored the scenario potential of his variables in actual theater events and happenings. The faces of Mao Tse-tung and the rocket-blimp-fish found in *Eddie (Sylvie's Brother) in the Desert* also appeared in his contribution to "Nine Evenings of Art and Technology" presented in New York in 1966—the content of both performance and collage being strongly antiwar.

JASPER JOHNS American, born 1930

0 through 9. 1961 (plaster; this cast 1966). Cast aluminum, $26 \times 19\,^7/_8 \times\,^7/_8$ inches, irregular

The four major themes of Jasper Johns's early career—numbers, alphabets, flags, and targets—all appeared in his first one-man show, which was held in 1958 and included works dating back to the winter of 1954/55. His choice of banal images has since come to be recognized as a decisive influence on the development of Pop art, while his repetition of single motifs anticipated some of the serial painting of the later 'sixties. The immediate impact of these works when they were first exhibited, however, was due to the manner in which they presented familiar, recognizable forms in a "painterly" technique directly—and most immediately—derived from Abstract Expressionism, to which they nevertheless posed an arresting challenge. By selecting motifs that were in themselves flat and identifying their edges with the shape of the canvas, Johns also departed significantly from previous representational painting. Instead of being portrayed *within* a space, the depicted objects themselves established the entirety of the pictorial space.

The *0 through 9* relief is one of the many number images that have occupied Johns intermittently since 1955. He has developed the theme in numerous paintings, among them *White Numbers*, 1957, and the 0 through 9 series of lithographs, 1960—1963 (both in the collection of The Museum of Modern Art), as well as in other lithographs and sculptures. In this cast-aluminum relief, the digits are superimposed, and, to an even greater degree than in the prints, the underlying figures are implied rather than legible. The work was derived from a sculpmetal relief of the same year and title (Collection Carl Fredrik Reuterswärd, Stockholm) by making a gelatin mold from which a plaster impression was taken and extensively reworked before being cast in aluminum.

JIM DINE American, born 1935

Five Feet of Colorful Tools. 1962. Oil on canvas surmounted by a board
 on which thirty-two tools hang from hooks; overall $55\,^5/_8 \times 60\,^1/_4 \times 4\,^3/_8$ inches

Jim Dine shares with Jasper Johns a debt to both Marcel Duchamp and the Abstract Expressionists. There has in fact been a certain interplay between the two younger artists, although Johns matured considerably earlier. In Dine's *Five Feet of Colorful Tools,* there are cross references not only to other of his works with palettes and spectrums but also to Johns's paintings that label (or mislabel) colors, as well as to Duchamp's Readymades, especially the snow shovel called *In Advance of the Broken Arm,* 1915 (replica, Yale University Art Gallery, New Haven, Connecticut). The *Five Feet* is also reminiscent of Duchamp's last painting, *Tu m',* 1918 (Yale University Art Gallery, New Haven), which is dominated by the shadows of a bicycle wheel, hat rack, and corkscrew, and includes real safety pins to close a painted opening. Dine has made his tools—saws, hammers, pliers, screwdrivers, cramps, braces, and nuts—both realities and illusions, three-dimensional and "painted." Despite all this, plus the visual pun made by combining colors and shadows with actual objects, the configuration of this work has less to do with Dada than with Abstract Expressionism—especially those paintings by Clyfford Still in which jagged, irregular forms anchored at the edge cut into the field of the pictures (see pages 126–127).

The *Five Feet of Colorful Tools* was shown in the "New Realists" exhibition in 1962, which was installed in the Sidney Janis Gallery and a Fifty-seventh Street store one block away. The first group show in New York to juxtapose American Pop art and its European counterparts (including many works that had been seen the previous year in The Museum of Modern Art's exhibition "The Art of Assemblage"), it marked the end of Pop's underground phase and the beginning of its public triumph.

ROY LICHTENSTEIN American, born 1923

Modern Painting with Bolt. 1966. Synthetic polymer paint and oil
partly silkscreened on canvas, 68 $^{1}/_{4}$ × 68 $^{3}/_{8}$ inches

Roy Lichtenstein's Modern Painting series, to which this work belongs, began in the autumn of 1966 with a poster for the fourth New York Film Festival at Lincoln Center (a copy is in the Museum's collection). Like most of Lichtenstein's work, it is art about art—in this case, the ubiquitous Hollywood–New York *moderne* décor of the 'thirties, which dominated fashion, architecture, interior design, illustration, and the movies in the artist's youth, and which has also been parodied in Claes Oldenburg's *Bedroom Ensemble,* first shown at the Sidney Janis Gallery in 1964. The flat, hard-edge forms, the benday screen patterns, and even the bolt in this painting are all holdovers from Lichtenstein's earlier comic-strip series, but the narrative element is missing, and the subject matter is more generalized than in his Landscapes of 1964 and Brushstrokes of 1965.

In the Modern Painting series and sculpture related to it, Lichtenstein moved closer to the formal abstraction that permeated even his hard-core Pop art. These works may also be satiric comments on the influence of earlier geometric abstraction on more recent mannerist abstraction. The primary colors are those of Mondrian (Lichtenstein had made a benday version of a Mondrian in 1964), but the chevrons at the right and the halved circle at the center might be allusions to paintings by Kenneth Noland and Frank Stella, as well as re-calling the geometric elements in 'thirties décor.

The parodic references in the *Modern Painting with Bolt* can be extended to the entire range of classical or neoclassical art (the antithesis of Pop). The inclusion of motifs such as the wing, bolt of lightning, sea, and chariot wheels (or shields or suns) may be a dig at the conventionally heroic pose of "public" art and artists—a counterpart to Lichtenstein's sati-rizing of Abstract Expressionism in his Brushstroke series.

JAMES ROSENQUIST American, born 1933

Marilyn Monroe, I. 1962. Oil and spray enamel on canvas, 7 feet 9 inches × 6 feet $^{1}/_{4}$ inch

James Rosenquist's portrait of Marilyn Monroe was painted soon after her death. In choosing the format of an immense, fragmented close-up, Rosenquist was calling both on his experience as a painter of billboards and on the sequential, large-screen imagery of the movies. The combination is well suited to representing a film star of Marilyn Monroe's ambiguity and symbolic presence. Her countenance appears inverted, entrapped behind the tinseled symbol of stardom—her name partially spelled out in huge silvery letters, across which a smoky white "Coca-Cola" is traced in skywriting, placing her firmly in the domain of established Americana. The extent to which she has continued to haunt the imagination of artists both in the United States and abroad was manifested in the exhibition "Homage to Marilyn Monroe" held at the Sidney Janis Gallery in 1967.

Rosenquist's "painted collage" composition has indirect connections with Surrealism and its analogues, for example, the compartmented realism of René Magritte in pictures such as *The Palace of Curtains, III* (page 57). Rosenquist, however, deploys a space and scale that could only have become possible after the accomplishments of the Abstract Expressionists.

One of Rosenquist's finest paintings, the *Marilyn Monroe, I* was purchased from the artist by Sidney Janis soon after it was painted and was among his first acquisitions of Pop art.

TOM WESSELMANN American, born 1931

Mouth 7. 1966. Oil on shaped canvas, 6 feet 8 $\frac{1}{4}$ inches × 65 inches

A possible prototype of Tom Wesselmann's *Mouth 7* may be Man Ray's Surrealist painting *Observatory Time—The Lovers,* 1932–1934 (page 204), which depicts a giant pair of lips floating above a landscape. Its immediate progenitors, however, are found in the blatantly sexual billboard and advertising art that directly inspired James Rosenquist and that had earlier led Willem de Kooning to make one of his 1950 oils of the Woman series into a collage by affixing onto it a mouth from a cigarette advertisement in a magazine.[132]

Wesselmann's Great American Nude series (of which The Museum of Modern Art owns an early example) was begun in 1960 and was a fusion of influences from Matisse and contemporary commercial art. Subsequently, he has concentrated on the Nude's erogenous zones—torso, breasts, and mouth—and has made plastic reliefs of the same subjects for mass production. The Mouth series also appropriates the identification of painted image with the contours of the support, as developed by proponents of the abstract shaped canvas. Here the vulgarity of lips over six-and-a-half feet across is enhanced by Wesselmann's use of a shaped canvas to contour the open mouth—adopting for his own purposes a technique developed with more formal intent by Frank Stella.

The Museum of Modern Art also owns another shaped canvas of this series, *Smoker 1 (Mouth 12),* 1967, and two related drawings, Study for *Mouth 8,* 1966, and Study for *Smoker 4 (Mouth 18),* 1968.

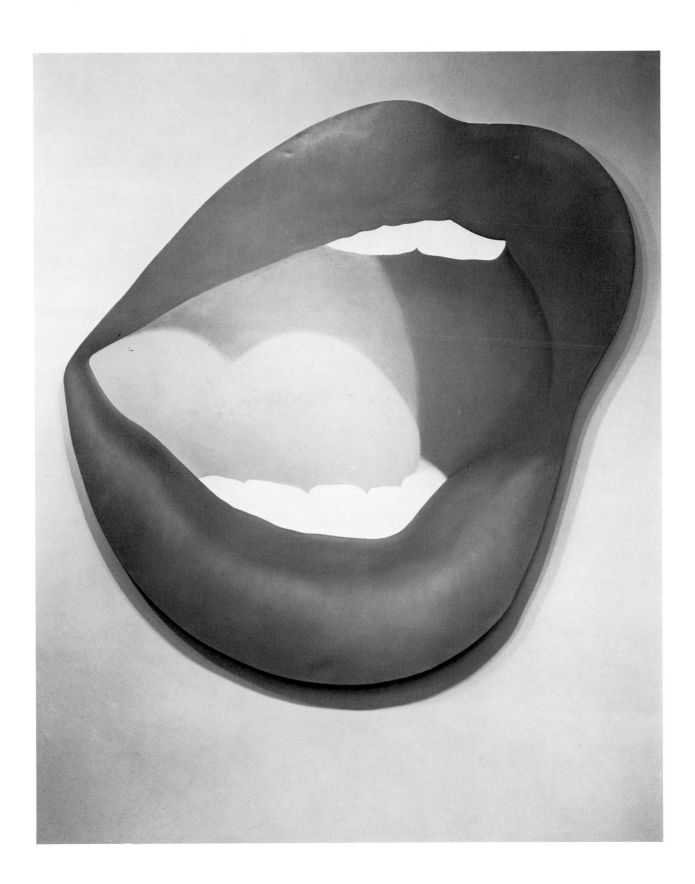

CLAES OLDENBURG American, born Sweden 1929

Pastry Case, I. 1961–1962. Nine painted plaster sculptures in glass showcase,
 20³/₄ × 30¹/₈ × 14³/₄ inches
Giant Soft Fan. 1966–1967. Vinyl filled with foam rubber, wood, metal, and plastic
 tubing, 10 feet × 59 × 62 inches, variable; plus cord and plug, 24 feet 3¹/₄ inches

Though made five years apart and representing different phases of his art, the two works by Claes Oldenburg in the Janis collection both manifest his characteristic metamorphosis of form. Oldenburg constantly challenges our acceptance of the everyday world by rendering hard objects as soft, or vice versa, or by exaggerating scale. But, as Barbara Rose has pointed out, "The initial shock of recognition, the secondary appreciation of witty analogies between one configuration and another, does not obviate nor transcend the appeal of surface, silhouette, form, and color. . . ."[133]

The Pastry Case, I, which Sidney Janis bought from Claes Oldenburg's first one-man show in uptown New York, held at the Green Gallery in 1962, belongs to his Store period, as do two other examples in the Museum's collection—*Red Tights,* 1961, and *Two Cheeseburgers, with Everything (Dual Hamburgers),* 1962; all three were included in the Museum's exhibition "Americans 1963." In the winter of 1962/63, Oldenburg had opened The Store in his store-front studio on East Second Street in New York. There he displayed and offered for sale unlikely metaphors (mostly made of fabric laid over wire frames, soaked in plaster, and painted) of the signs, foodstuffs, clothing, and other articles found in Lower East Side shops. *Pastry Case, I* (a second version is in the collection of Mr. and Mrs. Morton G. Neumann, Chicago) exemplifies Oldenburg's retention, almost unique among "cool" Pop artists, of both Surrealist and Abstract Expressionist elements. The pastry case itself and the dishes are Duchampian Readymades, while the pastries are transformations both of real ones and of the fake replicas made for display in restaurant vitrines. What differentiates Oldenburg's objects from their commercial prototypes are the irregular surface modeling, the painterly brushwork, and the bright color—qualities he took over from Abstract Expressionism.

It is precisely these qualities that are eliminated in the smooth, impersonal vinyl surfaces of the *Giant Soft Fan*—Oldenburg's "soft" version of the hard-edge aesthetic of the 'sixties. In this work, commissioned for the United States Pavilion at Expo '67 in Montreal, Oldenburg's humor resides in the dissociation of scale (a small household appliance enlarged to the colossal size of a monument) and in the transformation of what we know to be a hard machine into a collapsible object, which, like Dali's limp watches, has a not too elliptical sexual connotation. Particularly illuminating are the notes that Oldenburg wrote for his one-man show at the Sidney Janis Gallery in the spring of 1967, in which the related all-white *Giant Ghost Fan —Soft Version* (Museum of Fine Arts, Houston) was displayed: "The Banana Monument for Times Square leads into the Fan [conceived of as a giant monument for Bedloe's Island, site of the Statue of Liberty]. . . . When you peel the banana you get the four wings of the Fan (leaves). The Fan replaces the Statue of Liberty. This is to make you *feel* the large version of the object—i. e. *feel* the Fan the way one feels the Statue of Liberty. It's that heavy, that tall. . . . You can also think of the Fan as sort of a substitute image of America. . . . The Giant Fan is going to hang in the U.S. Pavilion in Montreal, which may make it a representative object. 'Fan' means Satan in Swedish—there is that area to explore. There is a black fan and a white one—a working of the theme of opposites in the context of superstition. I have a shiny black fan and a dry white fan—like the two angels . . . that walk beside you—the white angel and the black angel. . . . If people want to find things, they are probably there."[134]

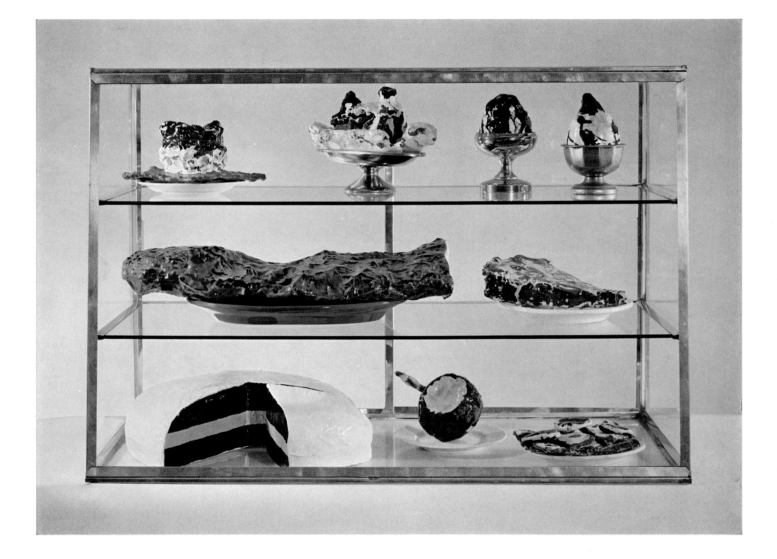

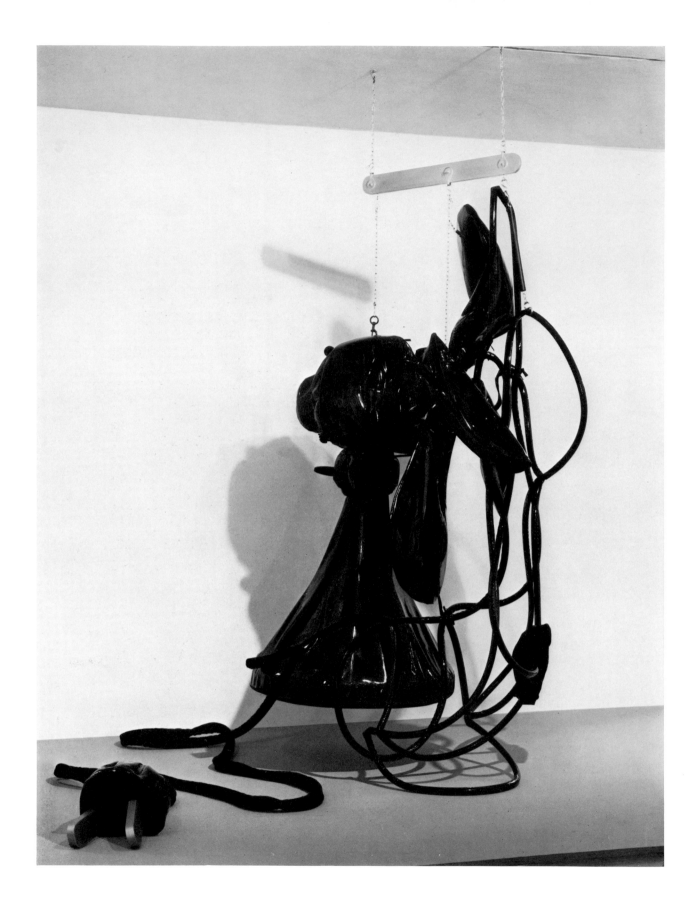

As always with Oldenburg, his preoccupation with subject matter never obscures his concern with the formal qualities of his art. His notes go on to explain: "The Fan was first made soft in 1965 and the interest has always concentrated for me on the cage—softening such a structure. . . . Removal of the planes (which is what cage is about) results in marvelous spatial confusion, since line only thing left—has no dimensions."[135] Oldenburg's penchant for "confusion" and the combining of opposites appears in his "Instructions for the Hanging of the Giant Soft Fan"; after a series of explicit directions for assembling and suspending the various parts, he countermands this firm control of the object by introducing the Surrealist element of automatism: "So final position: Fan hangs from hanger horizontal, cord falls, plug on floor like Anchor. Cord droops however it will. Blades twist and drop however they will."[136]

Giant Soft Fan, as installed in Buckminster Fuller's U.S. Pavilion, Expo '67, Montreal

ANDY WARHOL American, born 1925

Self-Portrait. 1966. Synthetic polymer paint and enamel silkscreened on six canvases,
each 22⅝×22⅝ inches
Seven Decades of Janis. 1967. Synthetic polymer paint silkscreened on eight joined
canvases, each 8⅛×8⅛ inches; overall 16¼×32⅜ inches
Sidney Janis. 1967. Photosensitive gelatin and tinted lacquer on silkscreen
on wood frame, 7 feet 11⅛ inches×6 feet 4⅛ inches

Andy Warhol creates modern-day icons, apotheosizing either common objects from the
everyday world, such as Campbell Soup cans, or celebrities. In the *Self-Portrait,* the *Seven
Decades of Janis,* and the *Sidney Janis,* he has given his subjects the same superstar treatment
that he has accorded to Marilyn Monroe, Elvis Presley, Jackie Kennedy, and other culture
heroes of our time. The hallmarks of his style are large format, repetitive images, and tech-
niques adapted from commercial art and used even more literally than by Roy Lichtenstein or
Robert Rauschenberg.

Warhol's silkscreens are made commercially from extant photographs, occasionally from
those taken by automatic candid cameras in subway booths. He hires an assistant to print
and sometimes even to color the resulting image. His repetitive formats and mechanical ex-
ecution both honor the mass-production concept sacred to American industry and deper-
sonalize his subjects, even while asserting their identity. He has expressed the belief that "it
would be terrific if everybody was alike," adding, "The reason I'm painting this way is be-
cause I want to be a machine."[137] In thus negating the significance either of the subject's
individuality or of the intervention of the artist's hand in creating the finished work, Warhol
has gone beyond one of Marcel Duchamp's ideas. Whereas Duchamp took a manufactured
object and called it art, Warhol makes art a manufactured object. The huge single portrait of
Sidney Janis is not even a silkscreen print, but the screen itself. Nevertheless, each of these
paintings is signed on the back, thus repersonalizing the depersonalized art object.

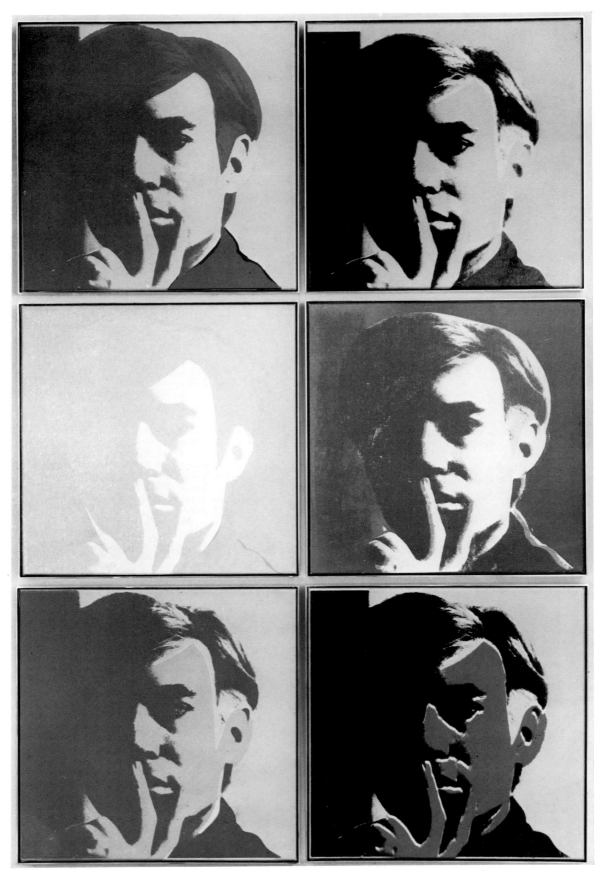

Self-Portrait

Seven Decades of Janis

Sidney Janis

GEORGE SEGAL American, born 1924

Portrait of Sidney Janis with Mondrian Painting. 1967. Plaster figure with
Mondrian's *Composition,* 1933, on an easel; figure, 66 inches high;
easel, 67 inches high

George Segal's approach to portraiture is much more personal and traditional than that of
Andy Warhol. His detachment is apparent only in the frozen white of his medium and in the
partial use of a quasi-mechanical process—the making of a life cast in plaster—as a point of de-
parture. Segal's aesthetic is that of a creative photographer. "The human being is capable
of an infinity of gestures and attitudes," he has said. "My biggest job is to select and freeze
the gestures that are most telling so that if I'm successful . . . I hope for a revelation, a per-
ception."[138]

In the *Portrait of Sidney Janis with Mondrian Painting,* Mr. Janis has been posed with
a picture for which he holds a particular affection—Mondrian's *Composition,* 1933 (page 31).
This is the first Mondrian that Mr. Janis bought; he recalls having selected it in Paris during a
visit to the artist's studio in 1932, and having to wait a year for Mondrian to complete the
picture and deliver it to him (see page 211). Through the informal stance, the hand on the
frame, the careful scrutiny of the picture, Segal has conveyed Mr. Janis's fondness for this
painting, his connoisseurship, and his possessiveness as a collector, together with his show-
manship. He has thus subtly delineated the complex relationship between a collector-dealer
and the art and artists of his stable.

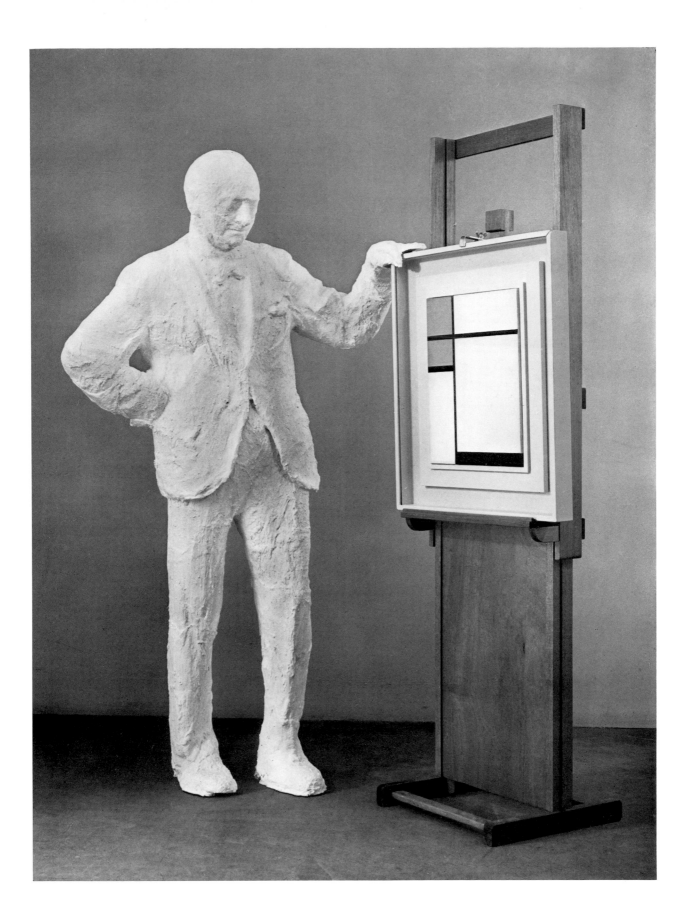

MARISOL (Marisol Escobar) Venezuelan, born France 1930

Portrait of Sidney Janis Selling Portrait of Sidney Janis by Marisol, by Marisol.
 1967–1968. Mixed media on wood, 69 × 61 $^1/_2$ × 21 $^5/_8$ inches

Marisol's portrayal of Sidney Janis is a far more satiric rendering of the subject than either Andy Warhol's impersonal approach or George Segal's perceptive interpretation. The "real" Sidney Janis (distinguished as such because he holds real spectacles in his hand and stands on a section of real carpet) rests one foot on the pedestal of the sculptured portrait of himself that he is selling. If the art dealer is thus neatly caught in the vise of Marisol's clever wit and shown as forever selling himself, she too may not be excluded from her own mockery; for here, instead of depicting herself, as she so frequently does, she has employed the kind of self-quotation so frequent in Pop art and incorporated into the work what is ostensibly one of her own sculptures.

In executing this portrait, Marisol worked from a photograph (see page 231), as she did in two other pieces in The Museum of Modern Art, *The Family*, 1962, and *LBJ*, 1967.

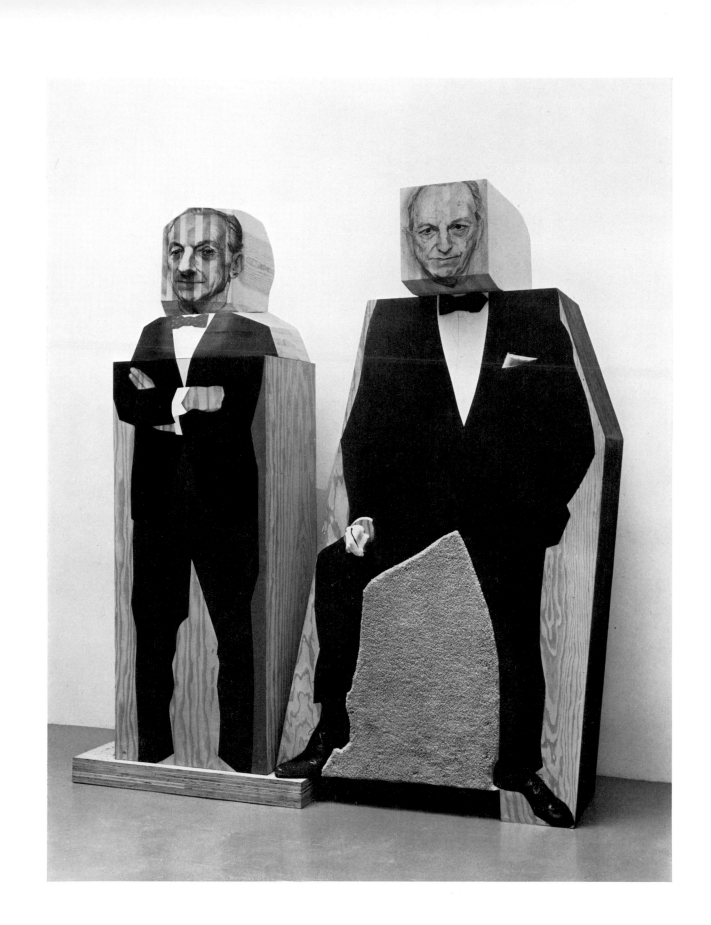

NOTES

1 From a 1913 lecture delivered by Léger at the Académie Wassilieff, "Les Réalisations picturales actuelles," published in *Soirées de Paris*, June 15, 1914, pp. 349–54; quoted in Edward F. Fry, *Cubism* (London: Thames and Hudson, 1966), p. 139.

2 The date 1908 was adopted by Douglas Cooper in *Fernand Léger et le nouvel espace* (Geneva: Éditions des Trois Collines, 1949), p. 35, and the "summer of 1909" by John Golding in *Cubism: A History and an Analysis, 1907–1914* (New York: George Wittenborn, 1959), p. 144; the Sidney Janis Gallery gave 1909–1910 in its catalogue for the exhibition "Léger: Major Themes" in 1957, and Alfred H. Barr, Jr., gave 1910 in *Cubism and Abstract Art* (New York: The Museum of Modern Art, 1936), p. 42, fig. 32.

3 A contrary opinion was offered by Sidney Janis in the catalogue for the 1957 exhibition "Léger: Major Themes"; since the label that Léger attached to the back of the painting was marked "# 1," he believed this to be Léger's first Cubist work.

4 Quoted without source in Katharine Kuh, *Léger* (Chicago: The Art Institute of Chicago, 1953), p. 53.

5 Reproduced in catalogue of the exhibition "Léger: Major Themes," Sidney Janis Gallery, New York, January 2–February 2, 1957, cat. no. 5.

6 *Juan Gris: His Life and Work*, translated from the French original (*Juan Gris, sa vie, son œuvre, ses écrits*, Paris: Gallimard, 1946) by Douglas Cooper (New York: Curt Valentin, 1947), p. 172.

7 "Picasso and the Coronation of Alexander III: A Note on the Dating of Some *Papiers Collés*," *Burlington Magazine* (London), vol. 113, October 1971, pp. 604–607.

8 Other examples of the double-head imagery include *The Sculptress*, 1925 (*La Statuaire*, Zervos VII, no. 1), in which a pale front face is juxtaposed on a dark profile; the 1922–1925 etchings for the ballet *Mercure*; some monstrously distorted portraits of about 1940; and the *Harlequin*, 1926 (Zervos V, no. 45) and the *Seated Woman* of 1926–1927 (Art Gallery of Ontario), both of which are related to the Janis picture, although lacking its harshness of expression.

9 "The Evolution of the Double Head in the Art of Picasso," *Horizon* (New York), vol. 5, 1942, p. 343.

10 In Alfred H. Barr, Jr., *Cubism and Abstract Art* (New York: The Museum of Modern Art, 1936), opposite fig. 88.

11 Reproduced in Ethel K. Schwabacher, *Arshile Gorky* (New York: Macmillan, 1957), fig. 16, p. 53.

12 "Die Ausstellung des modernen Bundes im Kunsthaus Zürich," *Die Alpen* (Berne), vol. 6, August 1912, p. 700.

13 Interview, June 1967.

14 Issued in Milan, April 11, 1910, by Boccioni, Carlo Carrà, Luigi Russolo, Giacomo Balla, and Gino Severini; English translation quoted by Joshua Taylor in *Futurism* (New York: The Museum of Modern Art, 1961), p. 125.

15 "Toward the True Vision of Reality," 1942, in *Plastic Art and Pure Plastic Art, 1937 and Other Essays, 1941–1943*, The Documents of Modern Art (New York: George Wittenborn, 1945), p. 10.

16 Quoted in James Johnson Sweeney, "Piet Mondrian," *Museum of Modern Art Bulletin* (New York), vol. 12, Spring 1945, p. 4.

17 "Toward the True Vision of Reality," p. 10.

18 Ibid.

19 "Liberation from Oppression in Art and Life," 1937, in *Plastic Art and Pure Plastic Art*, p. 60.

20 "Toward the True Vision of Reality," p. 10.

21 Ibid., p. 13.

22 Two other paintings from this series are in the Gemeentemuseum, The Hague, and the Rijksmuseum Kröller-Müller, Otterlo; a gouache study for a third was included in the second Mondrian show at the Sidney Janis Gallery in 1951.

23 "Toward the True Vision of Reality," p. 13.

24 Camilla Gray, *The Great Experiment: Russian Art 1863–1922* (New York: Harry N. Abrams, 1962), p. 248.

25 Translated by Sophie Lissitzky-Küppers, *El Lissitzky: Life, Letters, Texts* (Greenwich, Connecticut: New York Graphic Society Ltd., 1968), facing Plate 80.

26 *Klee (1879–1940)*, with an introduction and notes by Andrew Forge (London: Faber and Faber, 1954), vol. 2, p. 12.

27 *Paths of the Study of Nature (Wege des Naturstudiums)*, originally published in *Staat-*

liches Bauhaus in Weimar 1919–1923 (Munich-Weimar: Bauhausverlag, 1923), p. 24; quoted in English translation by Sibyl Moholy-Nagy in her introduction to Paul Klee, *Pedagogical Sketchbook* (New York: Frederick A. Praeger, 1953), p. 7.

28 Will Grohmann, *Wassily Kandinsky: Life and Work* (New York: Harry N. Abrams, 1958), no. 252.

29 Ibid., no. 246.

30 Ibid., no. 376.

31 Ibid., no. 399.

32 Suggested by Daniel Robbins in a letter to Lucy Lippard, February 12, 1968.

33 *Memorie della mia vita*, quoted in English translation from the Italian original (Rome: Astrolabio, 1945) by James Thrall Soby, *Giorgio di Chirico* (New York: The Museum of Modern Art, 1955), p. 110. Soby suggests that these delicacies were probably forbidden the artist, who was suffering from a nervous gastric condition, and probably therefore appealed especially to his fantasy.

34 Soby, ibid., p. 112. Virtually all de Chirico's Ferrarese paintings contain similar elements. The central image of a 1916 painting, *The Regret* (Munson-Williams-Proctor Institute, Utica, New York), is composed of cookies, but this is but one of many paintings of that year containing this motif. Two other still lifes, the *Politics* (Collection Gordon Onslow-Ford, Mill Valley, California) and *The Melancholy of Departure* (Collection Sir Roland Penrose, London), both of 1916, contain maps.

35 The analysis that follows is condensed from the detailed discussion of this painting in William S. Rubin, *Dada and Surrealist Art* (New York: Harry N. Abrams, 1969), pp. 226–27.

36 James Thrall Soby, *Salvador Dali* (New York: The Museum of Modern Art, 1941), p. 15.

37 Variants of this motif, which symbolized to Dali both castration and masturbation, appear in *The Lugubrious Game*, 1929 (Private collection, Paris; reproduced in color in Rubin, *Dada and Surrealist Art*, Plate XXXII, p. 219).

38 This observation, made by William S. Rubin in *Dada, Surrealism, and Their Heritage* (New York: The Museum of Modern Art, 1968), p. 113, is based on remarks by Meyer Schapiro concerning small scale in the work of Paul Klee.

39 Reproduced in color in catalogue of the exhibition "Salvador Dali 1910–1965," Gallery of Modern Art, New York, December 18, 1965–February 28, 1966, p. 42.

40 "L'Âne pourri," *Le Surréalisme au service de la révolution*, vol. 1, July 1930, pp. 11–12: "Il convient de dire, une fois pour toutes, aux critiques d'art, artistes, etc., qu'ils n'ont à attendre des nouvelles images surréalistes que la déception, la mauvaise impression et la répulsion."

41 It had originally appeared in the last issue of *La Révolution surréaliste*, vol. 5, December 15, 1929.

42 "Les Mots et les images," *La Révolution surréaliste*, vol. 5, December 15, 1929, pp. 32–33; English translation by E. L. T. Mesens in exhibition catalogue, "Magritte: Word vs Image," Sidney Janis Gallery, New York, March 1–20, 1954.

43 In catalogue of the exhibition "Magritte: Word vs Image."

44 Illustrated in *Arp*, edited with an introduction by James Thrall Soby (New York: The Museum of Modern Art, 1958), pp. 72 and 70.

45 Reproduced in Jean Cathelin, *Jean Arp*, translated from the French by Enid York (New York: Grove Press, 1959), fig. 35.

46 Reproduced in Eduard Trier, *Jean Arp: Sculpture—His Last Ten Years* (New York: Harry N. Abrams, 1968), fig. 199.

47 Quoted in catalogue of the exhibition "Kurt Schwitters," UCLA Art Galleries, Los Angeles, March–April 1965, p. 9.

48 "Kurt Schwitters," *Los Angeles County Museum Bulletin*, vol. 14, no. 2, 1962, p. 6.

49 Interview, June 1967. Mr. Janis remarked that he had bought many of these small works at auction, when they were still selling for under $100.

50 The booklet was subsequently published in French as Hans Bellmer, *La Poupée*, translated by Robert Valency (Paris: G. L. M., 1936).

51 Hans Bellmer, *Les Jeux de la poupée* (Paris: Les Éditions Premières, 1949). Although not published until 1949, Bellmer's constructions and photographs for this book date from 1936 and 1937, and Éluard's text was written in December 1938.

52 "Le jeu appartient à la catégorie 'poésie expérimentale.' Si l'on retient essentiellement la méthode de provocation, le jouet se présentera sous forme d'objet provocateur."

53 *Hans Bellmer*, translated by Bernard Frechtman (Chicago: William and Noma Copley Foundation, 1961).

54 "An Informal Life of M. E. (as told by himself to a young friend)," in *Max Ernst*, edited by William S. Lieberman (New York: The Museum of Modern Art, 1961), p. 8.

55 The critic Lucy Lippard believes that this painting may actually date from 1924 rather than two years later.

56 "Journey into a Painting by Ernst," *View* (New York), ser. 2, April 1942 (special Ernst issue), pp. 10–12.

57 Le Fantastique en peinture, au théâtre," *VVV* (New York), nos. 2–3, 1943–1944; quoted in English translation by Lucy R. Lippard in *Surrealists on Art* (Englewood Cliffs, New Jersey: Prentice-Hall, 1970), pp. 67–68.

58 In another drawing of the same period, the head is treated as a pitcher, as Dali too had seen it (see page 54). Various other motifs in the *Nude and Spectral Still Life* occur in other of Brauner's works of about the same date: for example, the curlicues rising like wings behind the shoulder of the nude appear as "handles" on the hips of a nude in a 1937 drawing; and the double waking-sleeping head, the hazy aura, and triangular "vertebrae" may be found in other paintings of about 1939, among them *La Magie de la nuit*, *La Chimère*, and the *Pierre philosophale* (all Private collections). In 1951, Brauner returned briefly to similar themes in his *Être rétracté réfracté espionné par sa conscience* (Collection Alexandre Iolas, Paris).

59 "School of Paris Comes to U.S.," *Decision* (New York), vol. 2, November–December 1941, p. 95.

60 Reply to a questionnaire in the Collection files of The Museum of Modern Art, 1967.

61 "Prolegomena to a Third Manifesto of Surrealism or Else," *VVV* (New York) no. 1, June 1942, p. 25.

62 "Arshile Gorky," essay written in 1945 and included in the revised edition of *Le Surréalisme et la peinture* (New York: Brentano's, 1945), p. 198.

63 William Schack, *And He Sat among the Ashes* (New York: American Artists Group, 1939), p. 210.

64 Quoted in "The Discovery of Louis Eilshemius," *The Arts* (New York), vol. 1, December 1926, p. 316.

65 From the poem "Lines," in Eilshem[i]us, *Songs of Southern Scenes* (New York: Eastman Lewis, 1904), p. 29.

66 Included in *Collection of the Société Anonyme: Museum of Modern Art 1920* (New Haven, Connecticut: Yale University Art Gallery, 1950), p. 154.

67 *Sky Hooks: The Autobiography of John Kane* (Philadelphia and New York: J. B. Lippincott, 1938), p. 30.

68 Ibid., pp. 102 and 101.

69 Sidney Janis, *They Taught Themselves: American Primitive Painters of the 20th Century* (New York: Dial Press, 1942), p. 54.

70 Quoted in ibid., p. 56.

71 Quoted in ibid., p. 57.

72 Sullivan's theme for *The Fourth Dimension*, quoted in full, ibid., p. 70.

73 Interview, June 1967.

74 *They Taught Themselves*, pp. 46–47.

75 "My Life Biography," included in the chapter "Morris Hirshfield," Sidney Janis, *They Taught Themselves*, p. 18.

76 *They Taught Themselves*, pp. 14–38.

77 "The Paintings of Morris Hirshfield," The Museum of Modern Art, New York, June 23–August 1, 1943.

78 Maude Riley, "Tailor-Made Show Suits Nobody," *Art Digest* (New York), vol. 17, July 1, 1943, p. 19.

79 Howard Devree, "To Show Paintings by M. Hirshfield," *The New York Times*, June 23, 1943.

80 Interview, June 1967.

81 *They Taught Themselves*, pp. 20 and 24.

82 Ibid., p. 25.

83 Ibid., p. 26.

84 Ibid., p. 16.

85 Ibid., p. 28.

86 In his interview, June 1967, Mr. Janis recalled that Hirshfield once took him aside confidentially to tell him that the "naked lady" in the "large picture with a lot of shrubs and animals in it" was "swollen" and offered to correct it.

87 *They Taught Themselves*, p. 33.

88 *Five Primitive Masters*, translated from the original German *Fünf primitive Meister* (Zürich: Atlantis Verlag, 1947) by Ralph Thompson (New York: Quadrangle Press, 1949), pp. 54 and 53.

89 *Prospectus aux amateurs de tout genre* (Paris: Gallimard, 1946), p. 43, quoted in English translation in Peter Selz, *The Work of Jean Dubuffet* (New York: The Museum of Modern Art, 1962), p. 37.

90 "Portraits à ressemblance extraite, à ressemblance cuite et confite dans la mémoire, à ressemblance éclatée dans la mémoire de M. Jean Dubuffet, peintre," Galerie René Drouin, Paris, October 7–31, 1947; quoted in English

translation in Selz, *The Work of Jean Dubuffet*, p. 31.

91 Information provided by the artist in a questionnaire in the Collection archives of The Museum of Modern Art.

92 "Notes du Peintre—Portraits," in "Tableau bon levain à vous cuire la pâte" (Paris: Galerie René Drouin, 1953), pp. 94–95; quoted in English translation in Selz, *The Work of Jean Dubuffet*, p. 48.

93 "Empreintes," *Les Lettres nouvelles* (Paris), no. 48, April 1957, p. 508; quoted in Selz, *The Work of Jean Dubuffet*, p. 19.

94 "Landscaped Tables, Landscapes of the Mind, Stones of Philosophy," translated by the artist and Marcel Duchamp (New York: Pierre Matisse Gallery, 1952); reprinted in Selz, *The Work of Jean Dubuffet*, p. 63.

95 "Landscaped Tables, . . ."reprinted in Selz, *The Work of Jean Dubuffet*, p. 72.

96 Jean Dubuffet, "Memoir on the Development of My Work from 1952," quoted in English translation by Louise Varèse in Selz, *The Work of Jean Dubuffet*, p. 110.

97 "A Letter from Alberto Giacometti to Pierre Matisse, 1947," first published in catalogue of the exhibition "Alberto Giacometti: Sculptures, Paintings, Drawings," Pierre Matisse Gallery, New York, January 19–February 14, 1948; quoted in *Alberto Giacometti* (New York: The Museum of Modern Art, 1965), p. 28.

98 Interview, June 1967.

99 *Dada, Surrealism, and Their Heritage*, pp. 174–76.

100 Quoted by William C. Seitz, *Arshile Gorky: Paintings, Drawings, Studies* (New York: The Museum of Modern Art, 1962), p. 34.

101 Ibid., p. 39.

102 Catalogue of the exhibition "Mark Tobey," New York, Willard Gallery, April 4–29, 1944.

103 William C. Seitz, *Mark Tobey* (New York: The Museum of Modern Art, 1962), p. 27.

104 Mr. Greenberg wrote a letter attesting this point on April 19, 1961; the Sidney Janis Gallery has a record of this letter, although the original has been lost. Mr. Janis also recalls that it was he, rather than Pollock, who gave the title *Free Form* to this painting.

105 Thomas B. Hess, "De Kooning Paints a Picture," *Art News* (New York), vol. 52, March 1953, p. 67.

106 In his interview, June 1967, Mr. Janis observed, "We think about Franz Kline as black forms on white, but he'd talk about these white areas as 'cutting into' the black. It's rather interesting, because years ago I knew some sign painters, and 'cutting in' is part of their description of making letters out of a background; if you have a white paper that you're working on, you 'cut out' the letters with black paint, and the white letter remains. Here Kline cut out the black with the white, in his terminology, and he spoke many times about the fact that the white juts into the black and creates tension."

107 From an interview with David Sylvester published in *Living Arts* (London, vol. 1, Spring 1963); quoted by Maurice Tuchman in catalogue of the exhibition "New York School: The First Generation," Los Angeles County Museum of Art, July 16–August 1, 1965, pp. 18–19.

108 In introduction to catalogue of the exhibition "Mark Rothko," Contemporary Arts Museum, Houston, September 5–October 6, 1957.

109 The murals for that room were never delivered, because Rothko decided that their somber, almost religious intimations did not suit the setting. Since 1970 they have been installed in the Tate Gallery, London, the gift of the American Federation of Arts.

110 From a lecture given at Pratt Institute, Brooklyn, in 1958; excerpted by Dore Ashton, "Letter from New York," *Cimaise* (Paris), sér. 6, December 1958, pp. 38—39, and quoted in catalogue of the exhibition "New York School: The First Generation," Los Angeles County Museum of Art, July 16–August 1, 1965, p. 30.

111 *Tiger's Eye* (New York), vol. 1, October 1949, p. 114; reprinted in *15 Americans*, edited by Dorothy C. Miller (New York: The Museum of Modern Art, 1952), p. 18.

112 The *Fourteenth Station* is illustrated in Thomas B. Hess, *Barnett Newman* (New York: The Museum of Modern Art, 1971), p. 102.

113 Statement, 1958, in catalogue of the exhibition "The New American Painting: As Shown in Eight European Countries 1958–1959," The Museum of Modern Art, New York, May 28–September 8, 1959, p. 60.

114 Introductory panel to the exhibition "Barnett Newman Memorial," The Museum of Modern Art, New York, July 21–September 8, 1970.

115 "Yves Klein," *Art International* (Zürich), vol. 11, October 20, 1967, p. 23.

116 Quoted in "Intransigeance d'Auguste Herbin," *Art d'Aujourd'hui* (Paris), sér. 4, no. 8, December 1953, p. 21.

117 In his book *L'Art non-figuratif, non-objectif* (Paris: Lydia Conti, 1949), p. 68, Herbin explains his symbolic use of color and of geometric forms to express in pictorial terms the profound laws of nature.

118 "On My 'Homage to the Square,'" quoted in catalogue of the exhibition "Josef Albers: Homage to the Square," organized and circulated by The International Council of The Museum of Modern Art, 1964–1965, n. p.

119 *Interaction of Color* (New Haven and London: Yale University Press, 1963), p. 13.

120 For the inscription on the reverse of the *Broad Call*, see page 176.

121 *Spectrum, I*, 1953 (Collection of the artist), measuring 5 feet square, and the smallest of the series, is a single panel; *Spectrum, II*, 1966 (The St. Louis Art Museum), is in thirteen panels, 6 feet 8 inches by 22 feet 9 inches overall; *Spectrum, IV*, 1967 (Collection Irving Blum, Los Angeles), is also in thirteen panels but resembles *Spectrum, I* in its square dimensions, though twice its size—10 feet square; *Spectrum, V*, 1969 (The Metropolitan Museum of Art, New York), in thirteen discrete panels, measures 7 feet by 36 feet 11 inches overall and is paler in color than the earlier Spectrums (in conversation the artist noted that the softer hues of this work came about after he had designed costumes for the Paul Taylor dancers based on the Spectrum series. In making the sketches he found his usual palette too bright for the stage and added more gouache to the paint; he liked the results so much that he decided to do a painting based on them). *Spectrum, VI*, 1969 (Private collection, New York), is a smaller version of *Spectrum, V*.

122 In his interview, June 1967, Mr. Janis recalled that Albers attended the opening of Kelly's one-man show at the Sidney Janis Gallery in March 1967 and spent over an hour discussing color with Kelly, especially that in *Spectrum, II*, "pointing out how the colors within each panel changed as it came in proximity with another color, depending upon after-images and optical dynamics. Kelly had hit upon it rather unconsciously, whereas Albers over the years has really studied it and refuted the long-accepted theories of Chevreul, the great nineteenth-century discoverer of the interaction of color."

123 William C. Seitz, *The Responsive Eye* (New York: The Museum of Modern Art, 1965), p. 30.

124 The *Capella 4* was reproduced on the cover of the catalogue of Vasarely's one-man show at the Sidney Janis Gallery in January 1966.

125 From the artist's reply to a questionnaire in the Collection archives of The Museum of Modern Art.

126 "Planetary Folklore," *Vasarely*. Plastic Arts of the 20th Century. (Neuchâtel: Editions du Griffon, 1965), p. 157.

127 Saul Steinberg, *The Passport* (New York: Harper & Brothers, 1954), n. p.

128 From the artist's response to a questionnaire in the Collection archives of The Museum of Modern Art.

129 Both print and painting are illustrated in *Öyvind Fahlström*, Texts and Manifestoes by Torsten Ekbom, Robert Rauschenberg, and Öyvind Fahlström (privately printed for the authors by Stenström and Bartelson, Malmö, Sweden, 1967), n. p.

130 "A Game of Character," *Art and Literature* (Lausanne), no. 3, Autumn/Winter 1964, p. 225.

131 Ibid.

132 Thomas B. Hess, *Willem de Kooning* (New York: The Museum of Modern Art, 1968), pp. 77–78, 83, illus.

133 *Claes Oldenburg* (New York: The Museum of Modern Art, 1970), p. 13.

134 "Some Program Notes about Monuments, Mainly," in mimeographed supplement to catalogue of the exhibition "New Work by Claes Oldenburg," Sidney Janis Gallery, New York, April 26–May 27, 1967 (subsequently published in *Chelsea* magazine, New York, June 1968, p. 6).

135 "From Notes while Working—1967," ibid., pp. 7–8.

136 "Instructions for the Hanging of the Giant Soft Fan in U.S. Pavilion at Montreal," ibid., p. 7.

137 Quoted in catalogue of the exhibition "Andy Warhol," Stockholm, Moderna Museet, 1968, n. p.

138 Quoted by John Gruen, "Art: A Quiet Environment for Frozen Friends," *New York Herald Tribune*, March 22, 1964, p. 32; reprinted in Lucy R. Lippard, *Pop Art* (New York and Washington: Frederick A. Praeger, 1966), p. 102.

CATALOGUE RAISONNÉ

and Theory 1909–1915, Oxford: Clarendon Press, 1968, pp. 157–61, 169–70, 171, fig. 124. — Aldo Palazzeschi, *L'Opera completa di Boccioni*, Milan: Rizzoli, 1969, fig. 171 A–B.
Page 23

VICTOR BRAUNER. Rumanian, 1903–1966. Lived in Paris from 1930.

9 *Nude and Spectral Still Life*. (1939). 581.67
Oil on canvas, 36 1/8 × 28 5/8 inches.
PROVENANCE: Acquired from Julien Levy, 1942.
ALTERNATE TITLE: *La Vie intérieure*.
EXHIBITIONS: "Selected Works from 2 Generations of European & American Artists: Picasso to Pollock," SJG, January 3–27, 1967, cat. no. 39, illus. — "El Arte del Surrealismo," cat. p. 28, illus. (see no. 5 for tour).
BIBLIOGRAPHY: Sarane Alexandrian, *Victor Brauner, l'illuminateur*, Paris: Éditions Cahiers d'Art, 1954, pp. 34, 39–40; illus. p. 25.
Page 73

10 *Talisman*. 1943. 582.67
Tallow on wood, 6 3/8 × 10 7/8 inches.
Incised in wax lower right: "Victor Brauner 1943"; signed on back: "À Sidney Janis cette image/Talisman/en signe d'amitiée/Victor Brauner 30 III, 1946."
PROVENANCE: Acquired in Paris from the artist, 1946.
EXHIBITION: "Dada, Surrealism, and Their Heritage," MOMA, March 27–June 9, 1968, cat. no. 31, illus.; Los Angeles County Museum of Art, July 16–September 8, 1968; The Art Institute of Chicago, October 19–December 8, 1968.
BIBLIOGRAPHY: William S. Rubin, *Dada, Surrealism, and Their Heritage*, New York: The Museum of Modern Art, 1968, p. 136, illus. — Idem, *Dada and Surrealist Art*, New York: Harry N. Abrams, 1969, p. 313, fig. 315.
Page 73

GIORGIO DE CHIRICO. Italian, born Greece 1888. Worked in Paris 1911–1915, 1925–1939.

11 *Evangelical Still Life*. 1916. 583.67
Oil on canvas, 31 3/4 × 28 1/8 inches, irregular.
Signed lower center in black oil: "G. de Chirico/ 1916."
PROVENANCE: Serge Lifar, Paris; acquired from Julien Levy, New York, 1930.
EXHIBITIONS: "Chirico," Paul Guillaume, Paris, June 4–12, 1926, cat. no. 4 (the catalogue gives neither date nor dimensions, so the work shown may possibly be the 1917 *Evangelical Still Life*). — "Modern Works of Art, Fifth Anniversary Exhibition," MOMA, November 20, 1934–January 20, 1935, cat. no. 57, illus. — "Sidney Janis Collection of Modern Paintings" The Arts Club of Chicago, April 5–24,

1935, cat. no. 8. — "Summer Exhibition: The Museum Collection and a Private Collection on Loan," MOMA, June 4–September 24, 1935. — "Sidney Janis Collection: Twentieth Century Painters," The University Gallery, University of Minnesota, Minneapolis, October 21–November 5, 1935, cat. no. 8. — "Giorgio de Chirico," Pierre Matisse Gallery, New York, November 19–December 21, 1935, cat. no. 15. — "Cubism and Abstract Art," MOMA, March 2–April 19, 1936, cat. no. 41, fig. 192; San Francisco Museum of Art, July 27–August 24, 1936; Cincinnati Art Museum, October 19–November 16; Minneapolis Institute of Arts, November 29–December 27; Cleveland Museum of Art, January 7–February 7, 1937; Baltimore Museum of Art, February 17–March 17; Rhode Island School of Design, Providence, March 24–April 21; Grand Rapids Art Gallery, April 29–May 26. — "Sidney Janis Collection," Brooklyn Museum, Summer 1937. — "Pioneers," Institute of Modern Art, Boston, March 28–April 30, 1944, cat. no. 12. — "Pioneers of American and European Contemporary Art," Nierendorf Gallery, New York, December 1–14, 1944. — "Paintings from New York Private Collections," MOMA, July 2–September 22, 1946. — "Illusionism and Trompe l'Oeil," California Palace of the Legion of Honor, San Francisco, May 3–June 12, 1949, cat. p. 72. — "20th Century Old Masters," SJG, February 27–March 25, 1950. — "Giorgio de Chirico," MOMA, September 6–October 30, 1955, illus. p. 221. — "2 Generations: Picasso to Pollock," SJG, March 3–April 4, 1964. — "El Arte del Surrealismo," cat. p. 28, illus. p. 11 (see no. 5 for tour).
BIBLIOGRAPHY: Julien Levy, *Surrealism*, New York: Black Sun Press, 1936, pl. 45. — James Thrall Soby, *The Early Chirico*, New York: Dodd, Mead, 1941, pp. 68, 81, pl. 59. — Sidney Janis, *Abstract & Surrealist Art in America*, New York: Reynal & Hitchcock, 1944, p. 25, illus. — James Thrall Soby, *Giorgio de Chirico*, New York: The Museum of Modern Art, 1955, pp. 112–13, illus. p. 221 (New York: Arno reprint for The Museum of Modern Art, 1966). — William S. Rubin, *Dada and Surrealist Art*, New York: Harry N. Abrams, 1969, p. 95, fig. 119.
Page 51

SALVADOR DALI. Spanish, born 1904. Active in Paris 1929–1939, and in New York since 1934. Works in Spain and New York.

12 *Illumined Pleasures*. (1929). 584.67
Oil and collage on composition board, 9 3/8 × 13 3/4 inches.
PROVENANCE: Louis Aragon, Paris; acquired from Julien Levy, New York, 1930.
EXHIBITIONS: "Salvador Dali," Galerie Goemans,

Paris, November 20–December 5, 1929. — "Modern Works of Art, Fifth Anniversary Exhibition," MOMA, November 20, 1934–January 20, 1935, cat. no. 60, illus. — "Sidney Janis Collection of Modern Paintings," The Arts Club of Chicago, April 5–24, 1935, cat. no. 16. — "Summer Exhibition: The Museum Collection and a Private Collection on Loan," MOMA, June 4–September 24, 1935. — "The Art of Today," Albright Art Gallery, Buffalo, January 3–31, 1936, cat. no. 28. — "Fantastic Art, Dada, Surrealism," MOMA, December 9, 1936–January 17, 1937, cat. p. 156, illus. — "Sidney Janis Collection," Brooklyn Museum, Summer 1937. — "Sources of Modern Painting," Institute of Modern Art, Boston, March 2–April 9, 1939, cat. no. 30, illus. — "Salvador Dali," MOMA, November 19, 1941–January 11, 1942, illus. cat. p. 34; Smith College Museum of Art, Northampton, Massachusetts, February 1–28; Cleveland Museum of Art, March 7–28; John Herron Art Institute, Indianapolis, April 5–May 6; California Palace of the Legion of Honor, San Francisco, May 16–June 14; College of William and Mary, Williamsburg, Virginia, October 24–November 7; Munson-Williams-Proctor Institute, Utica, New York, January 3–27, 1943; The Detroit Institute of Arts, March 22–April 12; Joslyn Art Museum, Omaha, April 26–May 17, 1943. — "Tenth Anniversary Exhibition: Dominant International Trends in Contemporary Art," San Francisco Museum of Art, January 18–February 5, 1945, cat. no. 8. — "Paintings from New York Private Collections," MOMA, July 2–September 22, 1946. — "Collage," MOMA, September 21–December 5, 1948. — "XX Century Painting," SJG, February 14–March 12, 1949. — "Illusionism and Trompe l'Oeil," California Palace of the Legion of Honor, San Francisco, May 3–June 12, 1949, cat. p. 72, illus. p. 47. — "Pictures within Pictures," Wadsworth Atheneum, Hartford, November 9–December 31, 1949, cat. no. 14, fig. 4. — "The Museum of Our Wishes," Moderna Museet, Stockholm, December 26, 1963–February 16, 1964. — "A Selection of 20th Century Art of 3 Generations," SJG, November 24–December 26, 1964, cat. no. 4, illus. — "Salvador Dali 1910–1965," Gallery of Modern Art, New York, December 18, 1965–February 28, 1966, cat. no. 27, repr. in color p. 40. — "50 Years of Modern Art," Cleveland Museum of Art, June 15–July 31, 1966, cat. no. 47, illus. — "Dada, Surrealism, and Their Heritage," MOMA, March 27–June 9, 1968, cat. no. 60, illus. (see no. 10 for tour). — "El Arte del Surrealismo," cat. p. 28, illus. p. 17 (see no. 5 for tour).

BIBLIOGRAPHY: *La Révolution surréaliste*, no. 12, December 15, 1929, illus. pp. 29, 64 (detail). — Julien Levy, *Surrealism*, New York: Black Sun Press, 1936, pl. 51 — *Brooklyn Museum Quarterly*, vol. 24, July 1937, pp. 144–46. — James Thrall Soby, *Salvador Dali*, New York: The Museum of Modern Art, 1941, p. 13, illus. p. 34. — Harriet Janis, "Paintings as a Key to Psychoanalysis," *Arts and Architecture* (Los Angeles), vol. 63, February 1945, pp. 38–40, 60. — A. Reynolds Morse, *Dali: A Study of His Life and Work*, Greenwich, Connecticut: New York Graphic Society, 1958, illus. p. 25. — Marcel Jean, *The History of Surrealist Painting*, trans. from the French by Simon Watson Taylor, New York: Grove Press, 1960, p. 200, illus. — Robert Descharnes, *The World of Salvador Dali*, New York: Harper and Row, 1962, repr. in color p. 155. — William S. Rubin, "Toward a Critical Framework: 1. Notes on Surrealism and Fantasy Art," *Artforum* (Los Angeles), September 1966, illus. p. 39. — H. H. Arnason, *History of Modern Art*, New York: Harry N. Abrams, 1968, p. 359, fig. 572. — Max Gérard, *Dali de Draeger*, Paris: Draeger, 1968, repr. in color,

Salvador Dali. *Imperial Monument to the Child-Woman.* c. 1929 (unfinished). Oil on canvas, 56 × 32 inches. Collection Mme Gala Dali, Paris

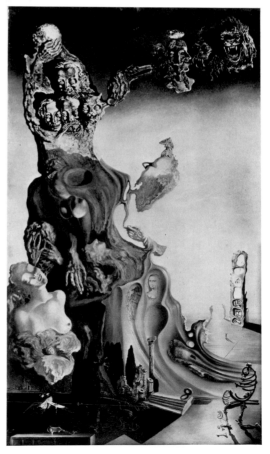

BIBLIOGRAPHY: *Catalogue des travaux de Jean Dubuffet*, fasc. II, "Mirobolus, Macadam et Cie (1945–1946)," Paris: J. J. Pauvert, 1966, p. 101, no. 152.
Page 101

19 *Portrait of Henri Michaux.* 1947. 591.67
Oil on canvas, 51 1/2 × 38 3/8 inches.
Signed and dated reverse, upper right, in black oil: "J. Dubuffet/1947"; inscribed reverse, upper right, in black oil: "Portrait of Henri Michaux"; on stretcher, in pencil, "Michaux gros cerne crème."
PROVENANCE: Michel Tapié, Paris; acquired from Galerie René Drouin, Paris, 1950.
ALTERNATE TITLE: *Michaux gros cerne crème.*
EXHIBITIONS: "Portraits," Galerie René Drouin, Paris, October 7–31, 1947, cat. no. 17. — "xxth Century Artists," SJG, October 3–November 5, 1960, cat. no. 12, illus. — "Jean Dubuffet at The Museum of Modern Art," MOMA, October 2–27, 1968. — "20th Century Portraits," Circulating exhibition organized by The Museum of Modern Art: The Society of the Four Arts, Palm Beach, Florida, January 7–February 6, 1972; Georgia Museum of Art, University of Georgia, Athens, April 2–May 7; Witte Memorial Museum, San Antonio, Texas, May 22–July 2; Krannert Art Museum, Champaign, Illinois, September 17–October 29; Arkansas Arts Center, Little Rock, Arkansas, November 20–December 31, 1972.
BIBLIOGRAPHY: *Catalogue des travaux de Jean Dubuffet*, fasc. III, "Portraits" (1946–1947), "Plus beaux qu'ils croient," Paris: J. J. Pauvert, 1966, p. 79, no. 112. — Cf. Georges Limbour, *Tableau bon levain à vous de cuire la pâte: L'Art brut de Jean Dubuffet*, New York: Pierre Matisse, 1953, pp. 91–92.
Page 101

20 *Corps de Dame: Blue Short Circuit.* (February) 1951. 593.67
Oil on canvas, 46 1/8 × 35 1/4 inches.
Signed and dated right edge, below center: "J. Dubuffet/51"; signed and dated reverse, upper left; "Court-circuit bleu/Corps de Dame/Février 51/J. Dubuffet."
PROVENANCE: Gabriel Giraud; acquired 1952.
EXHIBITIONS: "xxth Century Artists," SJG, October 3–November 5, 1960, cat. no. 13, illus. — "Jean Dubuffet, 1942–1960," Musée des Arts Décoratifs, Paris, December 16, 1960–February 25, 1961, cat. no. 78 — "The Work of Jean Dubuffet," MOMA, February 21–April 8, 1962, cat. no. 74; The Art Institute of Chicago, May 11–June 17; Los Angeles County Museum of Art, July 10–August 12. — "Jean Dubuffet at The Museum of Modern Art," MOMA, October 2–27, 1968.
BIBLIOGRAPHY: "Quelques introductions au Cosmorama de Jean Dubuffet, satrape," *Cahiers du Collège de 'Pataphysique* (Paris), nouvelle sér., dossiers 10–11, 1960, illus. p. 65. — Françoise Choay, "Les découvertes d'une rétrospective et la mythologie de la terre dans l'œuvre de Jean Dubuffet," *Art International* (Zurich), vol. 5, February 1961, p. 25, illus. — *Catalogue des travaux de Jean Dubuffet*, fasc. VI, "Corps de dames" (1950), Paris: J. J. Pauvert, 1965, p. 86, no. 118. — Cf. Georges Limbour, *Tableau bon levain à vous de cuire la pâte: L'Art brut de Jean Dubuffet*, New York: Pierre Matisse, 1953, pp. 92–93. — Peter Selz, *The Work of Jean Dubuffet*, New York: The Museum of Modern Art, 1962, pp. 48–53.
Page 103

21 *Façade.* (June) 1951. 1772.67
Watercolor on gesso on paper, 9 7/8 × 13 inches, irregular.
Signed and dated, bottom center, in pencil: "J. Dubuffet 51"; inscribed on backing in green ink: "avec l'amitié de/Jean Dubuffet/à Sidney Janis/Juin 51."
PROVENANCE: Gift of the artist, 1951.
Page 105

22 *Table aux souvenirs.* (March) 1951. 592.67
Oil and sand on canvas, 32 1/8 × 39 1/2 inches.
Signed and dated, upper left, in brown oil: "J. Dubuffet/51"; inscribed reverse in black oil: "Table aux souvenirs/Mars 51/J. Dubuffet"; inscribed on stretcher in black oil: "Mars 51."
PROVENANCE: Acquired from the artist in New York, 1952.
EXHIBITION: "European Artists from A to V," SJG, January 9–February 4, 1961, illus. in exhibition announcement.
BIBLIOGRAPHY: Lorenza Trucchi, *Jean Dubuffet*, Rome: De Luca, 1965, illus. p. 146. — *Catalogue des travaux de Jean Dubuffet*, fasc. VII, "Tables paysagées, paysages du mental, pierres philosophiques" (1951–1952), Paris: J. J. Pauvert, 1967, p. 25, no. 20. — Cf. Georges Limbour, *Tableau bon levain à vous de cuire la pâte: L'Art brut de Jean Dubuffet*, New York: Pierre Matisse, 1953, pp. 73–74. — Jean Dubuffet, "Landscaped Tables, Landscapes of the Mind, Stones of Philosophy," in Peter Selz, *The Work of Jean Dubuffet*, New York: The Museum of Modern Art, 1962, pp. 63–72.
Page 107

23 *Botanical Element: Baptism of Fire.* (September) 1959. 594.67
Assemblage of leaves on paper, 21 5/8 × 27 1/8 inches.
Signed and dated upper left in oil: "J. Dubuffet/59"; inscribed in red ink on backing: "Baptême du feu/Vence sept. 59."
PROVENANCE: Acquired from Cordier & Warren Gallery, New York, 1961.
EXHIBITIONS: "One Hundred Drawings of Jean Dubuffet," Cordier & Warren Gallery, New

York, December 8, 1960–January 5, 1961. — "Ways of Looking," MOMA, July 28–November 1, 1971.
Page 109

MARCEL DUCHAMP. American, born France. 1887–1968. Worked in U.S.A. 1915–1918, 1920–1923. In France until 1942. To U.S.A. 1942.

24 *Bicycle Wheel.* (1951; third version, after lost original of 1913). 595.67
Assemblage: metal wheel, diameter $25^{1}/_{2}$ inches, mounted on painted wood stool, $23^{3}/_{4}$ inches high, overall $50^{1}/_{2}$ inches high.
Signed on inner wheel in green oil: "Marcel Duchamp 1913/1959 (*sic*)."
PROVENANCE: Acquired from the artist, 1953.
EXHIBITIONS: "Climax in 20th Century Art, 1913," SJG, January 2–February 3, 1951, cat. no. 7, illus. — "The Art of Assemblage," MOMA, October 2–November 12, 1961, cat no. 74, illus. p. 46; Dallas Museum for Contemporary Arts, January 9, 1962–February 11, 1962; San Francisco Museum of Art, March 5–April 15. — "Marcel Duchamp, A Retrospective Exhibition," Pasadena Art Museum, October 8–November 3, 1963, cat. no. 52. — "A Selection of 20th Century Art of 3 Generations," SJG, November 24–December 26, 1964, cat. no. 7, illus. — "El Arte del Surrealismo," cat. p. 29, illus. p. 12 (see no. 5 for tour).
BIBLIOGRAPHY: Robert Lebel, *Marcel Duchamp*, trans. from the French by George Heard Hamilton, New York: Grove Press; London, Paris: Trianon Press, 1959; cat. no. 110. — William S. Rubin, *Dada and Surrealist Art*, New York: Harry N. Abrams, 1969, pp. 35, 36–37, 40, 263, 453, illus. p. 27. — Hugh Kenner, "Epilogue: The Dead-Letter Office," *Art in America* (New York), vol. 59, July–August 1971, illus. p. 106. — Cf. Walter Hopps, Ulf Linde, Arturo Schwarz, *Marcel Duchamp Ready-Mades, etc. (1913–1964)*, Paris: Le Terrain Vague, 1964, pp. 22–23, 24, 72, 79. — André Breton, "Crise de l'objet," *Art and Artists* (London), vol. 1, July 1966, pp. 12–15, illus. p. 12 (written in 1936 on the occasion of the "International Exhibition of Surrealism," Paris). — Arturo Schwarz, *The Complete Works of Marcel Duchamp*, Harry N. Abrams, 1969, pp. 442–43.
Page 49

LOUIS MICHEL EILSHEMIUS. American, 1864–1941.

25 *Samoa.* 1911. 596.67
Oil on cardboard, 10 × 8 inches.
Signed and dated lower right in black paint: "Eilshemius/1911."

PROVENANCE: Henry McBride, New York; acquired at auction, 1955.
BIBLIOGRAPHY: "Modern Paintings, Drawings and Prints, Property of Henry McBride & Estate of the Late Millicent A. Rogers," Parke-Bernet Galleries, New York, January 19, 1955, cat. no. 51.
Page 81

26 *Dancing Nymphs.* (1914). 597.67
Oil on composition board, $20^{1}/_{8} \times 20^{1}/_{4}$ inches.
Signed lower left: "Elshemus."
PROVENANCE: Acquired from the artist, 1934.
Page 81

27 *Nymph.* (1914). 598.67
Oil on composition board, $20^{1}/_{8} \times 19^{3}/_{4}$ inches.
Signed lower left: "Elshemus."
PROVENANCE: Acquired from the artist, 1934.
Note: Throughout his career, the artist signed his name variously as Elshemus, Eilshemius, and Eilsemus.
Page 81

MAX ERNST. French, born Germany 1891. To France 1922. In U.S.A. 1941–1950.

28 *Birds.* (1926). 599.67
Oil on sandpaper over canvas, $8^{1}/_{8} \times 10^{3}/_{8}$ inches.
Signed lower right in white and pink oil: "Max Ernst."
PROVENANCE: Acquired from the artist's stepdaughter Pegeen Vail (daughter of Peggy Guggenheim), c. 1957.
EXHIBITIONS: "A Selection of Paintings & Sculpture from the Gallery Collection," SJG, October 30–December 2, 1961, cat. no. 12, illus. — "2 Generations: Picasso to Pollock," SJG, March 3–April 4, 1964. — "Old Masters in xxth Century European Art," SJG, February 8–March 5, 1966, illus. in exhibition announcement. — "Selected Works from 2 Generations of European & American Artists: Picasso to Pollock," SJG, January 3–27, 1967, cat. no. 30.
BIBLIOGRAPHY: John Russell, *Max Ernst*, New York: Harry N. Abrams, 1967, p. 320, fig. 32.
Page 71

ÖYVIND FAHLSTRÖM. Swedish, born Brazil 1928. In Sweden 1939–1961. To U.S.A. 1961.

29 *Eddie (Sylvie's Brother) in the Desert.* (1966). 600.67
Variable collage: Fifteen movable serigraphed paper cutouts over serigraphed cutouts pasted on painted wood panel, $35^{1}/_{4} \times 50^{1}/_{2}$ inches.
PROVENANCE: Acquired from the artist, 1966.
EXHIBITIONS: "New Works by Öyvind Fahlström," SJG, February 1–25, 1967, cat. no. 10. — "The Artist as Adversary," MOMA, July 1–September 27, 1971, cat. no. 17.
Page 147

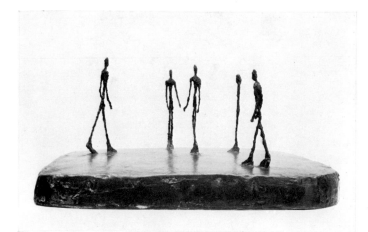

Alberto Giacometti. *City Square*. 1948. Bronze,
8 1/2 × 25 3/8 × 17 1/4 inches. The Museum of Modern
Art, New York. Purchase

ALBERTO GIACOMETTI. Swiss, 1901–
1966. Lived in Paris 1922–1942; 1945–1966.
Switzerland 1942–1945.

30 *Three Men Walking, I.* (1948–1949). 601.67
Bronze, 28 1/2 × 16 × 16 3/8 inches, including base,
10 5/8 × 7 3/4 × 7 3/4 inches. Cast 5/6.
Incised on base: "A. Giacometti."
PROVENANCE: Acquired from Galerie Maeght,
Paris, 1960.
ALTERNATE TITLES: *Group of Three Men, I; City
Square: Men Walking; Men Passing By; Three
Figures, I; Group.*
EXHIBITIONS: Documenta II, Kassel, July 11–Oc-
tober 11, 1959, cat. vol. 2, no. 1, p. 75. — "xxth
Century Artists," SJG, October 3–November 5,
1960, cat. no. 22, illus. — "European Artists
from A to V," SJG, January 9–February 4, 1961.
— "2 Generations: Picasso to Pollock," SJG,
March 3–April 4, 1964.
BIBLIOGRAPHY: Jacques Dupin, *Alberto Giaco-
metti*, Paris: Maeght, 1962, p. 245, illus. —
Raoul-Jean Moulin, *Giacometti: Sculptures*
(Little Art Library series), New York: Tudor,
1964, illus. no. 5.
Page 111

31 *The Artist's Wife.* (1954). 602.67
Pencil on paper, 16 5/8 × 11 3/4 inches, irregular.
Signed lower right in pencil: "Alberto Giaco-
metti."
PROVENANCE: Acquired from Galerie Maeght,
Paris, 1955.
Page 113

32 *Annette.* 1962. 603.67
Oil on canvas, 36 3/8 × 28 7/8 inches.
Signed lower right in black oil: "1962/Alberto
Giacometti."

PROVENANCE: Acquired from Galerie Maeght,
Paris, 1964.
EXHIBITIONS: "Alberto Giacometti," The Arts
Council of Great Britain/Tate Gallery, London,
July 17–August 30, 1965, cat. no. 148, pl. 58. —
"Selected Works from 2 Generations of Euro-
pean & American Artists: Picasso to Pollock,"
SJG, January 3–27, 1967, cat. no. 38, illus. —
"20th Century Portraits" (see no. 19 for tour).
Page 113

ARSHILE GORKY (Vosdanig Manoog
Adoian). American, born Turkish Armenia.
1904–1948. To U.S.A. 1920.

33 *Good Hope Road, II.* 1945. 604.67
Oil on canvas, 25 1/2 × 32 5/8 inches.
Signed lower left in black paint: "A Gorky/45."
PROVENANCE: Acquired from Mr. and Mrs. Jul-
ien Levy, 1966.
ALTERNATE TITLE: *Pastoral.*
EXHIBITIONS: "Connecticut Collects," Wadsworth
Atheneum, Hartford, Summer through Sep-
tember 9, 1962. — "Arshile Gorky," MOMA, De-
cember 19, 1962–February 12, 1963, cat. no. 76;
The Gallery of Modern Art, Washington, D.C.,
March 12–April 14. — "Selected Works from 2
Generations of European & American Artists:
Picasso to Pollock," SJG, January 3–27, 1967,
cat. no. 44, illus. — "The New American Paint-
ing and Sculpture: The First Generation," MOMA,
June 18–October 5, 1969, cat. no. 22. — "El Arte
del Surrealismo," cat. p. 29, illus. p. 24 (see no.
5 for tour).
Page 115

34 Study for *Summation.* 1946. 605.67
Pencil and colored crayon on paper, 18 1/2 × 24 3/8
inches.
Signed and dated lower right in ink: "A. Gorky/
46."
PROVENANCE: Acquired from Mrs. E. Roy, 1958.
EXHIBITIONS: "35 Selected Drawings from the
Late Work of Arshile Gorky," SJG, September
28–October 24, 1959, cat. no. 34, illus. — "Ar-
shile Gorky," MOMA, December 19, 1962–Feb-
ruary 12, 1963, cat. no. 91; The Gallery of Mod-
ern Art, Washington, D.C., March 12–April 14.
— "Arshile Gorky: Paintings and Drawings,"
The Arts Council of Great Britain/Tate Gallery,
London, April 2–May 2, 1965, cat. no. 77; Pa-
lais des Beaux Arts, Brussels, May 22–June 27;
Museum Boymans-van Beuningen, Rotterdam,
July 24–September 5, cat. no. 118, illus. —
"Drawings &," University Art Museum, Uni-
versity of Texas, Austin, February 6–March 15,
1966, cat. p. 18, illus. p. 48. — "The New Ameri-
can Painting and Sculpture: The First Genera-
tion," MOMA, June 18–October 5, 1969, cat. no.
23. — "El Arte del Surrealismo," cat. p. 30, illus.
p. 24 (see no. 5 for tour).

Arshile Gorky. *Impatience*. 1945. Oil, 24 × 48 inches.
Private collection, Los Angeles

Arshile Gorky. *Summation*. 1947. Oil, pastel, and
pencil on paper, 6 feet 7 5/8 inches × 8 feet 5 3/4
inches. The Museum of Modern Art, New York.
Mr. and Mrs. Gordon Bunshaft Fund

BIBLIOGRAPHY: H.C., "Reviews and Previews,"
Art News (New York), vol. 58, October 1959, p.
12, illus.
Page 115

AUGUSTE HERBIN. French, 1882–1960.
35 *Composition on the Word "Vie,"* 2. 1950. 606.67
Oil on canvas, 57 1/2 × 38 1/4 inches.
Signed bottom left in orange oil: "herbin 1950";
inscribed lower left corner in orange oil: "vie
no. 2."
PROVENANCE: Acquired from Galerie Denise
René, Paris, 1966.
EXHIBITIONS: "Herbin," Galerie Denise René, Pa-
ris, March 1–26, 1952, cat. no. 19 (dimensions
incorrectly listed). — "Recent Paintings by Her-
bin," SJG, December 29, 1952–January 17, 1953,
cat. no. 7. — "Paintings from the Galerie Denise
René," Städtisches Museum Schloss Morsbroich,
Leverkusen, West Germany, 1959. — "Art Con-
struit," Musée d'Ixelles, Brussels, January 31–
February 28, 1960, cat. no. 37. — "Hommage à
Herbin," Musée d'Art Wallon, Liège, April 2–
11, 1960, cat. no. 37. — "Herbin," Kunsthalle,
Berne, February 16–March 24, 1963, cat. no. 65.
— "Hard Edge," Galerie Denise René, Paris,
June–October, 1964, illus. — "Ways of Look-
ing," MOMA, July 28–November 1, 1971.
BIBLIOGRAPHY: Cf.: Julien Alvard, *Témoignages
pour l'art abstrait 1952*, Paris; Éditions "Art
d'aujourd'hui," 1952, pp. 147–150.
Page 135

MORRIS HIRSHFIELD. American, born
Russian Poland. 1872–1946. To U.S.A. 1890.
36 *Beach Girl*. (1937–1939; dated on canvas 1937).
2097.67
Oil on canvas, 36 1/4 × 22 1/4 inches.
Signed bottom left edge in oil: "M. Hirshfield/
1937."
PROVENANCE: Acquired from the artist, 1939.
EXHIBITIONS: "Contemporary Unknown Ameri-
can Painters," MOMA, October 18–November 18,
1939, cat. no. 18 (organized by the Advisory
Committee). — "Sidney Janis Collection," Al-
bright Art Gallery, Buffalo, Summer 1940. —
"They Taught Themselves," San Francisco Mu-
seum of Art, August 5–September 3, 1941;
Stendahl Art Galleries, Los Angeles, September
29–October 11, cat. no. 13. — "They Taught
Themselves," Marie Harriman Gallery, New
York, February 9–March 7, 1942, cat. no. 10. —
"The Paintings of Morris Hirshfield," MOMA,
June 23–August 1, 1943. — "Morris Hirshfield,
1872–1946, American Primitive Painter," SJG,
March 2–April 3, 1965, cat. no. 1, illus. — "Art
in the Mirror," Circulating exhibition organized
by The Museum of Modern Art, New York:
MOMA, November 21, 1966–February 5, 1967,
cat. no. 13; Mansfield Fine Arts Guild, Mans-

field, Ohio, March 10–April 2; San Francisco State College, April 21–May 14; Municipal Art Gallery, Los Angeles, June 27–July 23; Los Angeles Valley College, Van Nuys, California, September 22–October 15; Museum of Fine Arts, Houston, November 1–December 3; State University College, Oswego, New York, February 13–March 6, 1968. — "Ways of Looking," MOMA, July 28–November 1, 1971. — "Naive Paintings: A Selection from the Museum Collection," MOMA, January 7–February 24, 1972.

BIBLIOGRAPHY: Sidney Janis, *They Taught Themselves: American Primitive Painters of the 20th Century*, New York: Dial Press, 1942, pp. 20–24, illus. p. 21. — Sidney Janis, "The Paintings of Morris Hirshfield," *Bulletin of The Museum of Modern Art* (New York), vol. 10, May–June 1943, p. 13.

Page 89

37 *Angora Cat.* (1937–1939; dated on canvas 1937).
607.67

Oil on canvas, 22 1/8 × 27 1/4 inches.
Signed lower left: "M. Hirshfield/1937."
PROVENANCE: Acquired from the artist, 1939.
EXHIBITIONS: "Contemporary Unknown American Painters," MOMA, October 18–November 18, 1939, cat. no. 17 (organized by the Advisory Committee). — "Seven Centuries of Painting," California Palace of the Legion of Honor and the M. H. de Young Memorial Museum, San Francisco, December 29, 1939–January 28, 1940. — "They Taught Themselves," San Francisco Museum of Art, August 5–September 3, 1941; Stendahl Art Galleries, Los Angeles, September 29–October 11, cat. no. 12. — "They Taught Themselves," Marie Harriman Gallery, New York, February 9–March 7, 1942, cat. no. 8. — "Animal Kingdom in Modern Art," Circulating exhibition organized by The Museum of Modern Art: Vassar College, Poughkeepsie, New York, November 1–22, 1942; Art Institute of Zanesville, Ohio, December 1–22; University Museum of Fine Arts, University of Virginia, Charlottesville, Virginia, January 29–February 19, 1943; College of William and Mary, Williamsburg, Virginia, February 27–March 12; Chattanooga Art Association, Chattonoga, Tennessee, March 22–April 12; University of Texas, Austin, April 23–May 11; Wilmington Society of Fine Arts, Wilmington, Delaware, June 20–August 1. — "The Paintings of Morris Hirshfield," MOMA, June 23–August 1, 1943. — "Morris Hirshfield, 1872–1946, American Primitive Painter," SJG, March 2–April 3, 1965, cat. no. 2, illus. — "Naive Paintings: A Selection from the Museum Collection," MOMA, January 7–February 24, 1972.
BIBLIOGRAPHY: "Self Taught Artists in San Francisco," *Art Digest* (New York), no. 15, August 1, 1941, p. 14, illus. — *Newsweek*, August 18,

1941, p. 52, illus. (review of exhibition "They Taught Themselves," San Francisco Museum of Art). — Sidney Janis, *They Taught Themselves: American Primitive Painters of the 20th Century*, New York: Dial Press, 1942, pp. 15, 25–26, illus. p. 27. — *New York Times*, February 15, 1942, illus. (review by E. A. Jewell of exhibition "They Taught Themselves," Marie Harriman Gallery, New York). — *Bangor News* (Bangor, Maine), March 9, 1942, illus. (review by Marguerite Kernodle of Sidney Janis, *They Taught Themselves*). — Sidney Janis, "The Paintings of Morris Hirshfield," *Bulletin of The Museum of Modern Art* (New York), vol. 10, May–June 1943, p. 13. — *New York Post*, June 30, 1943, illus. (review by Marguerite Kott of exhibition "The Paintings of Morris Hirshfield," MOMA).

Page 90

38 *Lion.* 1939.
608.67

Oil on canvas, 28 1/4 × 40 1/4 inches.
Signed lower left: "M. Hirshfield/1939."
PROVENANCE: Acquired from the artist, 1939.
EXHIBITIONS: "Sidney Janis Collection," Albright Art Gallery, Buffalo, Summer 1940. — "They Taught Themselves," San Francisco Museum of Art, August 5–September 3, 1941; Stendahl Art Galleries, Los Angeles, September 29–October 11, cat. no. 14. — "They Taught Themselves," Marie Harriman Gallery, New York, February 9–March 7, 1942, cat. no. 11. — "The Paintings of Morris Hirshfield, MOMA, June 23–August 1, 1943. — "Morris Hirshfield, 1872–1946, American Primitive Painter," SJG, March 2–April 3, 1965, cat. no. 4, illus. — "Werke und Werkstatt naiver Kunst," Städtische Kunsthalle, Recklinghausen, West Germany, April 29–June 27, 1971, cat. no. 115, illus.
BIBLIOGRAPHY: *San Francisco Chronicle*, August 10, 1941, illus. (review by Alfred Frankenstein of exhibition "They Taught Themselves," San Francisco Museum of Art). — Sidney Janis, "They Taught Themselves," *Art News* (New York), no. 40, September 1–30, 1941, illus. p. 14. — Sidney Janis, *They Taught Themselves: American Primitive Painters of the 20th Century*, New York: Dial Press, 1942, pp. 15–16, 26, 28, illus. p. 29. — *Newsweek*, July 5, 1943, illus. (review of exhibition "The Paintings of Morris Hirshfield," MOMA). — Sarane Alexandrian, *L'Art surréaliste*, Paris: Fernand Hazan, 1969, illus. p. 169, no. 170.

Page 90

39 *Inseparable Friends.* 1941.
609.67

Oil on canvas, 60 1/8 × 40 1/8 inches.
Signed lower left in white oil: "M. Hirshfield/1941."
PROVENANCE: Acquired from the artist, 1941.
EXHIBITIONS: "The Paintings of Morris Hirshfield," MOMA, June 23–August 1, 1943. — "Mor-

ris Hirshfield," Galerie Maeght, Paris, January 1951; Kunsthaus, Zurich, February 23–March 26, 1951, cat. no. 6. — "Le Monde des Naïfs," Museum Boymans-van Beuningen, Rotterdam, July 10–September 6, 1964; Musée National d'Art Moderne, Paris, October 14–December 6; cat. no. 74. — "Morris Hirshfield, 1872–1946, American Primitive Painter," SJG, March 2–April 3, 1965, cat. no. 9, illus. — "Werke und Werkstatt naiver Kunst," Städtische Kunsthalle, Recklinghausen, West Germany, April 29–June 27, 1971, cat. no. 116, illus.

BIBLIOGRAPHY: Sidney Janis, "The Paintings of Morris Hirshfield," *Bulletin of The Museum of Modern Art* (New York), vol. 10, May–June 1943, illus. p. 13. — M[aude] R[iley], "Tailor-Made Show Suits Nobody," *Art Digest* (New York), vol. 17, July 1, 1943, p. 15, illus. (review of exhibition "The Paintings of Morris Hirshfield," MOMA). — "Un Aspect peu connu de la peinture aux U.S.A.," *Labyrinthe* (Paris), January 15, 1946, p. 3, illus. — "Morris Hirshfield (1872–1946)," *Art d'Aujourd'hui* (Paris), sér. 2, March 1951, illus. p. 15. — François Stahly, "Grandma Moses, Hirshfield," *Graphis* (Zurich), vol. 7, no. 35, 1951, illus. p. 171.
Page 91

Morris Hirshfield. *Sacré Cœur, II.* 1946. Oil on canvas, 30 × 36 inches. Sidney Janis Gallery, New York

40 *Girl with Pigeons.* 1942. 610.67
Oil on canvas, 30 × 40 1/8 inches.
Signed lower left in white oil: "M. Hirshfield/ 1942."
PROVENANCE: Acquired from the artist, 1942.
EXHIBITIONS: "The Paintings of Morris Hirshfield," MOMA, June 23–August 1, 1943. — "Morris Hirshfield," Galerie Maeght, Paris, January 1951; Kunsthaus, Zurich, February 23–March 26, 1951, cat. no. 3. — "Le Monde des Naïfs," Museum Boymans-van Beuningen, Rotterdam, July 10–September 6, 1964; Musée National d'Art Moderne, Paris, October 14–December 6; cat. no. 75, illus. — "Morris Hirshfield, 1872–1946, American Primitive Painter," SJG, March 2–April 3, 1965, cat. no. 13, illus. — "Seventeen Naive Painters," Circulating exhibition organized by The Museum of Modern Art, New York: Charles and Emma Frye Art Museum, Seattle, March 4–27, 1966; Tennessee Fine Arts Centre, Nashville, May 10–June 5; University of Alabama, University, Alabama, July 25–August 15; San Francisco State College, September 6–27; Bates College, Lewiston, Maine, January 5–26, 1967; Wells College, Aurora, New York, February 10–March 4; Manatee Junior College, Bradenton, Florida, March 24–April 16.
BIBLIOGRAPHY: Sidney Janis, "The Paintings of Morris Hirshfield," *Bulletin of The Museum of Modern Art* (New York), vol. 10, May–June 1943, illus. p. 12. — *Brooklyn Eagle*, June 27, 1943, illus. (review of exhibition "The Paintings of Morris Hirshfield," MOMA). — Sidney Janis, *Abstract & Surrealist Art in America*, New York: Reynal & Hitchcock, 1944, p. 88, illus. p. 94. — François Stahly, "Grandma Moses, Morris Hirshfield," *Graphis* (Zurich), vol. 7, no. 35, 1951, illus. p. 174.
Page 92

41 *Parliamentary Buildings.* 1946. 611.67
Oil on canvas, 36 1/8 × 28 inches.
Signed lower right in white oil: "M. Hirshfield— 1946."
PROVENANCE: Acquired from the artist, 1946.
ALTERNATE TITLE: *Sacré Cœur.*
EXHIBITIONS: "Morris Hirshfield," Art of This Century Gallery, New York, February 1–March 1, 1947, cat. no. 22. — "Morris Hirshfield," Galerie Maeght, Paris, January 1951; Kunsthaus, Zurich, February 23–March 26, 1951, cat. no. 29. — "Morris Hirshfield, 1872–1946, American Primitive Painter," SJG, March 2–April 3, 1965, cat. no. 47, illus.
BIBLIOGRAPHY: Sidney Janis, "Morris Hirshfield Dies," *View* (New York), ser. 7, October 1946, illus. p. 14 — "You Too Can Paint," *Time*, February 24, 1947, p. 75, illus. — *Domus* (Milan), no. 403, June 1963, illus. p. 46.
Page 92

ALEXEY JAWLENSKY. Russian, 1864–
1941. Worked in Germany 1896–1914, 1922–
1941; in Switzerland 1914–1922.

42 *Meditation: Yellow Head.* 1936. 612.67
Oil on cloth-textured paper, $9^3/4 \times 7^3/8$ inches.
Signed lower left in red paint: "AJ"; dated lower
right in red paint: "36."
PROVENANCE: Acquired from Galerie Beyeler,
Basel, c. 1960.
EXHIBITIONS: "2 Generations: Picasso to Pol-
lock," SJG, March 3–April 4, 1964, cat. no. 40. —
"Alexei Jawlensky, A Centennial Exhibition,"
Pasadena Art Museum, April 14–May 19, 1964,
cat. no. 184. — "Ways of Looking," MOMA, July
28–November 1, 1971.
BIBLIOGRAPHY: For Meditation series, cf. *Art-
forum* (Los Angeles), vol. 2, May 1964, pp. 37–
40. — Shirley Hopps and John Coplans, cata-
logue of exhibition "Jawlensky and the Serial
Image," Irvine, California: University of Cali-
fornia, March 11–31, 1966.
Page 45

JASPER JOHNS. American, born 1930.
43 *0 through 9.* 1961 (plaster; this cast 1966).
 613.67
Cast aluminum, $26 \times 19^7/8 \times^7/8$ inches, irregular.
Signed and dated reverse in oil: "J. Johns/1961/
$^2/4$."
PROVENANCE: Acquired from the artist through
Leo Castelli, 1967.
EXHIBITION: "An Exhibit of Graphics by Jasper
Johns," Museum of the Sea, Harbour Town,
Sea Pines Plantation Co., Hilton Head Island,
South Carolina, May 27–June 5, 1971, cat. no.
34.
BIBLIOGRAPHY: Cf. Max Kozloff, *Jasper Johns,*
New York: Harry N. Abrams, 1969, pl. 82.
Page 149

WASSILY KANDINSKY. Russian, 1866–
1944. Worked in Germany 1896–1915, 1921–
1933. In France 1933–1944.
44 *Lightly Touching* (*Leicht berührt*). 1931. 614.67
Oil on cardboard, $27^5/8 \times 19^1/4$ inches.
Signed lower left in black oil: "K; signed

$\overline{31}$"

reverse upper left in black oil: "K

$\overline{\text{No-561}}$

1931."
PROVENANCE: Acquired from Mme Nina Kan-
dinsky, Neuilly-sur-Seine, 1949.
ALTERNATE TITLE: *Leicht gebunden.*
EXHIBITIONS: "Kandinsky," SJG, November 9–27,
1948, cat. no. 15. — "Oils and Watercolors by
Wassily Kandinsky," San Francisco Museum
of Art, February 16–March 12, 1949; illus.
in Museum's March calendar." Kandinsky," SJG,
November 21–December 24, 1949. — "Recent

French Acquisitions," SJG, December 7, 1953–
January 2, 1954, cat. no. 11. — "The Classic
Spirit in 20th Century Art," SJG, February 4–29,
1964, cat. no. 8, illus.
BIBLIOGRAPHY: "Concert by Kandinsky," *Art
Digest* (New York), vol. 24, December 1, 1949,
illus. p. 15 (review of exhibition "Kandinsky,"
SJG). — Will Grohmann, *Wassily Kandinsky,
Life and Work,* New York: Harry N. Abrams,
1958, pp. 216–17; c. c. 404, p. 383, illus.
Page 43

JOHN KANE. American, born Scotland.
1860–1934. To U.S.A. 1880.
45 *The Campbells Are Coming.* (1932). 615.67
Oil and gold paint on paper over composition
board, $20 \times 16^1/8$ inches.
Signed lower right in black and white paint:
"John Kane"; inscribed lower right: "Cambells
are/comeing/John Kane,"over previous inscrip-
tion, "Scotch Piper/by/John Kane."
PROVENANCE: Acquired from the artist's estate,
c. 1942.
EXHIBITIONS: "They Taught Themselves," San
Francisco Museum of Art, August 5–September
3, 1941; Stendahl Art Galleries, Los Angeles,
September 29–October 11; cat. no. 22. — "They

John Kane. *Self-Portrait.* 1929. Oil on canvas over
composition board, $36^1/8 \times 27^1/8$ inches.
The Museum of Modern Art, New York.
Abby Aldrich Rockefeller Fund

Taught Themselves," Marie Harriman Gallery, New York, February 9–March 7, 1942, cat. no. 17. — "Seventeen Naive Painters," Circulating exhibition organized by The Museum of Modern Art, New York (see no. 40 for tour). — "Werke und Werkstatt naiver Kunst," Städtische Kunsthalle, Recklinghausen, West Germany, April 29–June 27, 1971, cat. no. 140, illus. — "Naive Paintings: A Selection from the Museum Collection," MOMA, January 7–February 24, 1972.
Page 83

ELLSWORTH KELLY. American, born 1923.
46 *Spectrum, III.* 1967. 336.67
Oil on canvas in thirteen parts, overall 33 1/4 inches × 9 feet 5/8 inch.
Signed reverse on stretcher: "Kelly 1967."
PROVENANCE: Acquired from the artist, 1967.
BIBLIOGRAPHY: Cf. *Art International* (Zurich), vol. 11, May 1967, p. 58, for illus. of *Spectrum, II.*
Page 141

PAUL KLEE. German, born Switzerland. 1879–1940. In Germany 1906–1933. In Switzerland 1933–1940.
47 *Actor's Mask (Schauspielermaske).* 1924. 616.67
Oil on canvas mounted on board, 14 1/2 × 13 3/8 inches.
Signed upper left in black oil: "1924 252 Klee"; scratched into paint upper left: "1924 252"; scratched into paint upper right: "Klee/1924 252."
PROVENANCE: Galerie Alfred Flechtheim, Berlin; Elsa Schmidt (Mrs. J. B. Neumann), New York; acquired from J. B. Neumann, New York, 1931.
EXHIBITIONS: "Paul Klee," Galerie Georges Bernheim, Paris, February 1–15, 1929, cat. no. 6. — "Paul Klee," Galerie Alfred Flechtheim, Berlin, October 20–November 15, 1929, cat. no. 54. — "Weber, Klee, Lehmbruck, Maillol," MOMA, March 13–April 2, 1930, Klee cat. no. 12, illus. — "Sidney Janis Collection of Modern Paintings," The Arts Club of Chicago, April 5–24, 1935, cat. no. 10. — "Summer Exhibition: The Museum Collection and a Private Collection on Loan," MOMA, June 4–September 24, 1935. — "Sidney Janis Collection: Twentieth Century Painters," The University Gallery, University of Minnesota, Minneapolis, October 21–November 5, 1935, cat. no. 10. — "Fantastic Art, Dada, Surrealism," MOMA, December 7, 1936–January 17, 1937, cat. no. 238. — "Sidney Janis Collection," Albright Art Gallery, Buffalo, Summer 1940. — "Paul Klee," Buchholz Gallery–Willard Gallery, New York, October 9–November 2, 1940, cat. no. 47. — "Paul Klee Memorial Exhibition," Circulating exhibition

organized by The Museum of Modern Art, New York, 1941, cat. no. 32, illus.: Smith College Museum of Art, Northampton, Massachusetts, January 7–22; The Arts Club of Chicago, January 31–February 28; Portland Art Museum, Portland, Oregon, March 10–April 9; San Francisco Museum of Art, April 14–May 5; Stendahl Art Galleries, Los Angeles, May 8–18; City Art Museum of St. Louis, May 24–June 21; MOMA, June 30–July 27; Wellesley College, Wellesley, Massachusetts, October 14–November 2. — "Paintings from New York Private Collections," MOMA, July 2–September 22, 1946, cat. p. 6. — "Paintings, Drawings and Prints by Paul Klee from the Klee Foundation, Berne, Switzerland, with additions from American Collections," Circulating exhibition organized by The Museum of Modern Art, New York, cat. no. 31: San Francisco Museum of Art, March 24–May 2, 1949; Portland Art Museum, Portland, Oregon, May 16–June 21; Detroit Institute of Arts, September 15–October 19; City Art Museum of St. Louis, November 3–December 5; MOMA, December 20, 1949–February 14, 1950; Phillips Gallery, Washington, D.C., March 4–April 10; Cincinnati Art Museum, April 26–May 24. — "A Selection of 20th Century Art of 3 Generations," SJG, November 24–December 26, 1964, cat. no. 12, illus.
BIBLIOGRAPHY: Will Grohmann, *Paul Klee*, Paris: Éditions Cahiers d'Art, December 1929, p. 20, pl. 31. — Cary Ross, "Deutsche Kunst in den Sammlungen New York," *Museum der Gegenwart* (Berlin), vol. 2, no. 1, 1931, p. 11, illus. — *Art News* (New York), vol. 38, August 17, 1940, p. 17, illus. — Sidney Janis, *Abstract & Surrealist Art in America*, New York: Reynal & Hitchcock, 1944, illus. p. 26. — *Paul Klee*, with articles by Alfred H. Barr, Jr., Julia and Lyonel Feininger, and James Johnson Sweeney, 2nd rev. ed., New York: The Museum of Modern Art, 1945, p. 7, illus. p. 41. — Andrew Forge, *Klee (1879–1940)*, vol. 2, London: Faber and Faber, 1954, pp. 4–5, 12, pl. 5.
Page 39

48 *In the Grass (Im Gras).* 1930. 617.67
Oil on canvas, 16 5/8 × 20 3/4 inches.
Signed upper right in black oil: "Klee"; on back in ink: "Klee 1930/18."
PROVENANCE: Acquired from Galerie Alfred Flechtheim, Berlin, through J. B. Neumann, 1930.
EXHIBITIONS: "Weber, Klee, Lehmbruck, Maillol," MOMA, New York, March 13–April 2, 1930, Klee cat. no. 61. — "Landscape Painting," Wadsworth Atheneum, Hartford, January 20–February 9, 1931, cat. no. 133. — "Sidney Janis Collection of Modern Paintings," The Arts Club of Chicago, April 5–24, 1935, cat. no. 12. — "Summer Exhibition: The Museum Collection and a

Private Collection on Loan," MOMA, June 4–September 24, 1935. — "Sidney Janis Collection: Twentieth Century Painters," The University Gallery, University of Minnesota, Minneapolis, October 21–November 5, 1935, cat. no. 11. — "Cubism and Abstract Art," MOMA, March 2–April 19, 1936, cat. no. 113, fig. 199 (see no. 11 for tour). — "Sidney Janis Collection," Brooklyn Museum, Summer 1937. — "Paul Klee Memorial Exhibition," Circulating exhibition organized by The Museum of Modern Art, New York, 1941, cat. no. 46, illus. (see no. 47 for tour). — "Landscapes: Real and Imaginary," Circulating exhibition organized by The Museum of Modern Art, New York, cat. no. 13: Hamline University, St. Paul, Minnesota, October 29–November 19, 1946; The Arts Club of Chicago, December 2–28; Grand Rapids Art Gallery, Grand Rapids, Michigan, January 7–28, 1947; Norton Gallery and School of Art, West Palm Beach, Florida, February 8–March 2; Cranbrook Art Museum, Bloomfield Hills, Michigan, March 16–April 6; Indiana University, Bloomington, Indiana, April 22–May 13; San Francisco Museum of Art, June 3–24; Honolulu Academy of Arts, Honolulu, Hawaii, August 1–22. — "2 Generations: Picasso to Pollock," SJG, March 3–April 4, 1964.
BIBLIOGRAPHY: R. Vitrac, "À propos des œuvres récentes Paul Klee," *Cahiers d'Art* (Paris), vol. 5, no. 6, 1930, illus. p. 300. — Julien Levy, *Surrealism*, New York: Black Sun Press, 1936, pl. 49. — *Brooklyn Museum Quarterly*, vol. 24, July 1937, pp. 144–46. — *Paul Klee*, with articles by Alfred H. Barr, Jr., Julia and Lyonel Feininger, and James Johnson Sweeney, 2nd rev. ed., New York: The Museum of Modern Art, 1945, illus. p. 46.
Page 41

YVES KLEIN. French, 1928–1962.
49 *Blue Monochrome.* 1961. 618.67
Oil on cotton cloth over plywood, 6 feet 4⁷⁄₈ inches × 55¹⁄₈ inches.
Signed reverse in black paint: "Yves Klein"; dated reverse: "1961."
PROVENANCE: Acquired from Galerie Saqqârah, Gstaad, 1962.
EXHIBITION: "Ways of Looking," MOMA, July 28–November 1, 1971.
BIBLIOGRAPHY: Sidney Simon, "Yves Klein," *Art International* (Zurich), vol. 11, October 20, 1967, p. 23, illus.
Page 133

FRANZ KLINE. American, 1910–1962.
50 *Two Horizontals.* 1954. 619.67
Oil on canvas, 31¹⁄₈ × 39¹⁄₄ inches.
Signed lower center in purple and black oil: "Kline"; signed and dated reverse upper right:

"Franz Kline/54"; signed and dated middle of aluminum frame backing in black paint: "Franz Kline/54"; dated 1954 in black paint on backing.
PROVENANCE: Acquired from the artist, 1960.
EXHIBITION: "Franz Kline: Memorial Exhibition," SJG, December 3–28, 1963, cat. no. 4, illus.
Page 125
51 *Le Gros.* 1961. 620.67
Oil on canvas, 41³⁄₈ × 52⁵⁄₈ inches.
Signed reverse lower left, upside down: "Franz Kline '61"; inscribed top of stretcher, center: "Le Gros Kline."
PROVENANCE: Acquired from the artist, 1961.
EXHIBITIONS: "New Paintings by Franz Kline," SJG, December 4–30, 1961, cat. no. 31, illus. on cover. — "Franz Kline: Memorial Exhibition," SJG, December 3–28, 1963, cat. no. 26, illus. — "2 Generations: Picasso to Pollock," SJG, March 3–April 4, 1964. — "The New American Painting and Sculpture: The First Generation," MOMA, June 18–October 5, 1969, cat. no. 52. — "Abstract Expressionism and Pop Art," SJG, February 9–March 4, 1972.
Page 125

WILLEM DE KOONING. American, born the Netherlands 1904. To U.S.A. 1926.
52 *September Morn.* (1958). 621.67
Oil on canvas, 62⁷⁄₈ × 49³⁄₈ inches.
Signed lower right in gray oil: "de Kooning."
PROVENANCE: Acquired from the artist, 1959.
EXHIBITIONS: "Willem de Kooning," SJG, May 4–30, 1959. — "11 Abstract Expressionist Painters," SJG, October 7–November 2, 1963, cat. no. 2, illus.
Page 121
53 *A Tree in Naples.* (1960). 622.67
Oil on canvas, 6 feet 8¹⁄₄ inches × 70¹⁄₈ inches.
Signed lower right in blue oil: "de Kooning."
PROVENANCE: Acquired from the artist, 1961.
ALTERNATE TITLE: *A Tree Grows in Naples.*
EXHIBITIONS: "10 American Painters," SJG, May 8–June 3, 1961, cat. no. 7, illus. — "Recent Paintings by Willem de Kooning," SJG, March 5–31, 1962, cat. no. 26, repr. in color. — "Continuity and Change," Wadsworth Atheneum, Hartford, April 12–May 27, 1962.
BIBLIOGRAPHY: Thomas B. Hess, in catalogue of exhibition "Recent Paintings by Willem de Kooning," New York: Sidney Janis Gallery, March 5–31, 1962. — T[homas] B. H[ess], "6 Star Shows for Spring," *Art News* (New York), vol. 61, March 1962, pp. 40, 60, repr. in color p. 41. — Max Kozloff, "New York Letter," *Art International* (Zurich), vol. 6, May 1962, pp. 75–76, illus. — Dore Ashton, "New York Letter: de Kooning's Verve," *Studio International* (London), vol. 163, June 1967, pp. 216–17.
Page 121

Willem de Kooning. *Woman, I.* 1950–1952. Oil on canvas, 6 feet 3 ⁷⁄₈ inches × 58 inches. The Museum of Modern Art, New York. Purchase

Fernand Léger. *Nudes in the Forest.* 1909–1910. Oil on canvas, 47 ¹⁄₄ × 67 inches. Rijksmuseum Kröller-Müller, Otterlo, The Netherlands

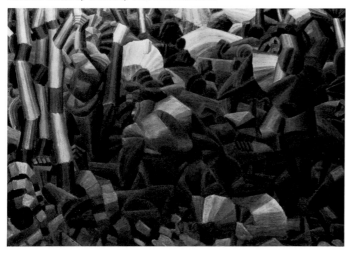

54 *Woman, XI.* (1961). 623.67
Oil and pastel on paper mounted on canvas, 29 × 22 ³⁄₈ inches.
Signed lower left in charcoal sprayed with fixative: "de Kooning."
PROVENANCE: Acquired from the artist, 1961.
EXHIBITIONS: "Recent Paintings by Willem de Kooning," SJG, March 5–31, 1962, cat. no. 41, illus. — "The Museum of Our Wishes," Moderna Museet, Stockholm, December 26, 1963–February 16, 1964. — "Selected Works from 2 Generations of European & American Artists Picasso to Pollock," SJG, January 3–27, 1967, cat. no. 46, illus. — "Ways of Looking," MOMA, July 28–November 1, 1971.
Page 123

FERNAND LÉGER. French, 1881–1955. In U.S.A. 1940–1946.
55 *Bridge.* (1908?). 624.67
Oil on canvas, 36 ⁵⁄₈ × 28 ⁵⁄₈ inches.
Signed lower left in black oil: "F Léger."
PROVENANCE: Galerie Pierre Loeb, Paris; Walter P. Chrysler, Jr., 1939; acquired by donor, 1952.
ALTERNATE TITLES: *Paysage; Composition # 1.*
EXHIBITIONS: "Collection of Walter P. Chrysler, Jr., Exhibited by ... Virginia Museum of Fine

Fernand Léger. *Woman Sewing.* Variously dated 1908, 1909, 1910. Oil on canvas, 28 ³⁄₈ × 21 ¹⁄₄ inches. Collection D.-H. Kahnweiler, Paris

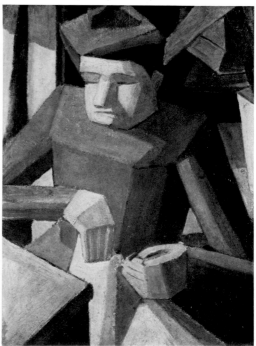

Arts ... Philadelphia Museum of Art," cat. no. 68, Richmond, January 16–March 4, 1941; Philadelphia, March 29–May 11, 1941. — "New Arrivals from France: Selected Examples by Artists from Picasso to Giacometti," SJG, October 24–November 26, 1955. — "Recent Acquisitions of European Art 1911–1950," SJG, May 21–June 9, 1956. — "Léger: Major Themes," SJG, January 2–February 2, 1957, cat. no. 1, illus. — "Fernand Léger," Galerie Beyeler, Basel, May–June 1964, cat. no. 1. — "Albert Gleizes and the Section d'Or," Leonard Hutton Gallery, New York, October 28–December 5, 1964, cat. no. 31, illus.

BIBLIOGRAPHY: E. Tériade, *Fernand Léger*, Paris: Éditions Cahiers d'Art, 1928, p. XIII (Introduction), illus. p. 6. — *Cahiers d'Art* (Paris), vol. 8, no. 3–4, 1933, n. p., illus. (special Léger issue). — Douglas Cooper, *Fernand Léger et le nouvel espace*, Paris: Éditions des Trois Collines, 1949, part II. — Edward F. Fry, *Cubism*, London: Thames and Hudson, 1966, pp. 19, 189.
Page 5

56 *Bargeman.* (1918). 625.67
Oil on canvas, 18 1/8 × 21 7/8 inches.
Signed lower right in black oil: "F Lege[r]" (final "r" lost in relining).
PROVENANCE: Galerie Pierre Loeb, Paris; to The Solomon R. Guggenheim Museum, New York, 1938; acquired by exchange, December 1958.
EXHIBITIONS: "Loan Exhibition of Paintings from The Solomon R. Guggenheim Museum, New York," Art Gallery of Toronto, April 2–May 9, 1954, cat. no. 48. — "The Solomon R. Guggenheim Museum — A Selection from the Museum Collection," Vancouver Art Gallery, November 16–December 12, 1954, cat. no. 48. — "Art in the 20th Century," exhibition held in connection with the Tenth Anniversary of the United Nations, San Francisco Museum of Art, June 17–July 10, 1955. — "Modern Masters from the Solomon Guggenheim Collection," Norfolk Museum of Arts and Sciences, Norfolk, Virginia, January 11–July 5, 1959. — "Léger," SJG, December 5, 1960–January 7, 1961, cat. no. 2, illus.
Page 7

57 *Animated Landscape (Paysage animé, 1er état).* 1921. 626.67
Oil on canvas, 19 7/8 × 25 3/8 inches.
Signed and dated reverse upper left in oil: "F Léger"; on reverse upper left in black oil:
21
"Paysage Animé I État / F Léger / 21."
PROVENANCE: Galerie Alfred Flechtheim, Berlin; André Lefèvre, Paris; acquired from The Mayor Gallery, London, 1949.
EXHIBITIONS: "Fernand Léger," Galerie Alfred Flechtheim, Berlin, February 6–March 2, 1928, cat. no. 16. — "Fernand Léger," The Mayor Gal-

lery Ltd., London, 1938, cat. no. 2. — "Early Léger," SJG, March 19–April 7, 1951, cat. no. 21. — "Fernand Léger," SJG, September 15–October 11, 1952, cat. no. 14. — "Léger: Major Themes," SJG, January 2–February 2, 1957, cat. no. 13, illus. — "In Memoriam," Exhibition circulated by The American Federation of Arts, cat. no. 17: Grand Rapids Art Gallery, Grand Rapids, Michigan, November 5–25, 1957; J. B. Speed Art Museum, Louisville, Kentucky, December 5–25; Jacksonville Art Museum, Jacksonville, Florida, January 8–28, 1958; Coe College, Cedar Rapids, Iowa, February 8–28; Bowling Green State University, Bowling Green, Ohio, March 13–April 2; Winston-Salem Public Library, Winston-Salem, North Carolina, April 16–May 7; Time, Inc., New York City, May 26–June 13; Quincy Art Club, Quincy, Illinois, October 1–22; Springfield Art Museum, Springfield, Missouri, November 3–30. — "Léger," SJG, December 5, 1960–January 7, 1961, cat. no. 7, illus. — "Fernand Léger," Réunion des Musées Nationaux, Grand Palais, Paris, October 12, 1971–January 10, 1972, cat. no. 56, illus.
BIBLIOGRAPHY: *Cahiers d'Art* (Paris), vol. 8, no. 3–4, 1933, n. p., illus. (special Léger issue).
Page 7

58 *Two Divers.* 1942. 627.67
Oil on canvas, 50 × 58 1/8 inches.
Signed lower right in black oil: "F. Léger/N.Y. 42."
PROVENANCE: Acquired from the artist by James Johnson Sweeney, New York, 1942; acquired 1961.
EXHIBITIONS: "Fernand Léger," SJG, September 15–October 11, 1952, cat. no. 23. — "Léger," The Art Institute of Chicago, April 2–May 17, 1953; cat. no. 48, illus.; San Francisco Museum of Art, June 15–August 23, 1953; MOMA, October 6, 1953–January 3, 1954. — "Selected Works from 2 Generations of European & American Artists: Picasso to Pollock," SJG, January 3–27, 1967, cat. no. 10, illus.
BIBLIOGRAPHY: Katharine Kuh, *Léger*, Chicago: The Art Institute of Chicago, 1953, p. 54, illus.
Page 9

ROY LICHTENSTEIN. American, born 1923.
59 *Modern Painting with Bolt.* (1966). 666.67
Synthetic polymer paint and oil partly silk-screened on canvas, 68 1/4 × 68 3/8 inches.
Signed reverse upper right in charcoal: "ry Lichtenstein."
PROVENANCE: Acquired from the artist through Leo Castelli, 1966.
EXHIBITIONS: "Roy Lichtenstein," The Pasadena Art Museum, April 18–May 28, 1967; Walker Art Center, Minneapolis, June 23–July 30, 1967; cat. no. 38, repr. in color.

BIBLIOGRAPHY: John Coplans, "Lichtenstein," *Artforum* (New York), vol. 5, May 1967, pp. 34–39, repr. in color. — Diane Waldman, "Remarkable Commonplace," *Art News* (New York), vol. 66, October 1967, illus. p. 30.
Page 153

EL LISSITZKY (Lazar Markovich Lissitzky). Russian, 1890–1941.
60 Study for page from *About Two Squares in Six Constructions: A Suprematist Story*. (1920).
628.67
Watercolor and pencil on cardboard, $10^1/8 \times 8$ inches.

PROVENANCE: Acquired from Private collection, Amsterdam, 1956.
EXHIBITIONS: "El Lissitzky," Stedelijk van Abbemuseum, Eindhoven, December 3, 1965–January 16, 1966; Kunsthalle, Basel, January 27–March 6, 1966; Kestner-Gesellschaft, Hanover, March 22–April 17, 1966, cat. no. B 5 a, illus.
BIBLIOGRAPHY: Cf. El Lissitzky, *About Two Squares in Six Constructions: A Suprematist Story*, Berlin: Skythen, 1922 (in Russian); *De Stijl*, vol. 5, September 1922, n. p. (in Dutch). — Camilla Gray, *The Great Experiment: Russian Art 1863–1922*, New York: Harry N. Abrams, 1962, p. 248, pl. 225. — *Nouveau dictionnaire de la peinture moderne*, Paris: Fernand Hazan, 1963, p. 205, illus. (repr. sideways). — Camilla Gray, "El Lissitzky's Typographical Principles," in catalogue of exhibition "El Lissitzky," Hanover: Kestner-Gesellschaft, Kat. 4, 1965/66, p. 21. — Sophie Lissitzky-Küppers, *El Lissitzky: Life, Letters, Texts*, Greenwich, Connecticut; New York Graphic Society, 1968, pp. 8, 24, 380–81, pl. 80–91.
Page 37

STANTON MACDONALD-WRIGHT. American, born 1890. In France 1907–1916.
61 *Synchromy in Blue*. (c. 1917–1918). 629.67
Oil on canvas, $26^1/4 \times 20^1/8$ inches.

PROVENANCE: Stieglitz "291" Gallery, New York; Mrs. Charles Liebman, New York; acquired at Parke-Bernet auction, 1955.
EXHIBITION: "The Art of Stanton Macdonald-Wright," National Collection of Fine Arts, Washington, D.C., May 4–June 18, 1967, cat. no. 19.
BIBLIOGRAPHY: Cf. William C. Agee, catalogue of exhibition "Synchromism and Color Principles in American Painting, 1910–1930," New York: M. Knoedler & Co., October 12–November 6, 1965.
Page 21

62 *Trumpet Flowers*. 1919. 630.67
Oil on canvas, $18^1/8 \times 13^1/8$ inches.
Signed upper left in pencil: "S. Macdonald-Wright"; signed and dated reverse above center in red paint: "S. Macdonald-Wright/1919."

PROVENANCE: Charles Daniel Gallery, New York; acquired c. 1959.
EXHIBITION: "The Art of Stanton Macdonald-Wright," National Collection of Fine Arts, Washington, D.C., May 4–June 18, 1967, cat. no. 21.
Page 21

RENÉ MAGRITTE. Belgian, 1898—1967.
63 *The Palace of Curtains, III*. (1928–1929).
631.67
Oil on canvas, $32 \times 45^7/8$ inches.
Signed lower left in black paint: "Magritte."

PROVENANCE: Acquired from E. L. T. Mesens, Brussels, 1954.
EXHIBITIONS: "Magritte: Word vs Image," SJG, March 1–20, 1954, cat. no. 11. — "René Magritte in America," The Dallas Museum for Contemporary Arts, December 8, 1960–January 8, 1961; The Museum of Fine Arts, Houston, February 1961; cat. no. 6, illus. — "A Selection of Paintings & Sculpture from the Gallery Collection," SJG, October 30–December 2, 1961, cat. no. 23, illus. — "René Magritte," MOMA, December 15, 1965–February 27, 1966, cat. no. 11, illus.; Rose Art Museum, Brandeis University, Waltham, Massachusetts, April 3–May 8; The Art Institute of Chicago, May 30–July 3; Pasadena Art Museum, August 1–September 4; University Art Museum, University of California, Berkeley, October 1–November 1. — "Selected Works

René Magritte. *The Empty Mask*. 1928. Oil, $28^3/4 \times 36^1/4$ inches. Garick Fine Arts, Inc., Philadelphia

Geoff Hendricks. *Left Turn Sky.* 1966. Oil on canvas, 66×36 inches. Private collection, New York

from 2 Generations of European & American Artists: Picasso to Pollock," SJG, January 3–27, 1967, cat. no. 31, illus. — "El Arte del Surrealismo," cat. p. 30 (see no. 5 for tour).
BIBLIOGRAPHY: James Thrall Soby, *René Magritte*, New York: The Museum of Modern Art, 1965, p. 24, illus. — Suzi Gablik, *Magritte*, Greenwich, Connecticut: New York Graphic Society, 1971, p. 134, illus. no. 117.
Page 57

MARISOL (Marisol Escobar). Venezuelan, born France 1930. To U.S.A. 1950.
64 *Portrait of Sidney Janis Selling Portrait of Sidney Janis by Marisol, by Marisol.* (1967–1968).
2356.67
Mixed media on wood, 69×61¹/₂×21⁵/₈ inches.
PROVENANCE: Commissioned from the artist, 1967.
EXHIBITION: "Marisol," Worcester Art Museum, Worcester, Massachusetts, September 23–November 14, 1971.
BIBLIOGRAPHY: José Ramon Medina, *Marisol*, Caracas: Ediciones Armitano, 1968, pp. 45–49, repr. in color.
Page 169

MATTA (Sebastian Antonio Matta Echaurren). Chilean, born 1912. In U.S.A. 1939–1948. In France since 1948.
65 *Paysage flammifère.* (1940). 632.67
Crayon and pencil on paper, 18¹/₈×22¹/₂ inches.
PROVENANCE: Acquired from Art of This Century Gallery, New York, 1944.
EXHIBITION: "Ways of Looking," MOMA, July 28–November 1, 1971.
BIBLIOGRAPHY: Irving Sandler, "The Surrealist Emigrés in New York," *Artforum* (New York), vol. 6, May 1968, illus. p. 30.
Page 75

PIET MONDRIAN. Dutch, 1872–1944. In Paris 1912–1914, 1919–1938. In New York 1940–1944.
66 *Red Amaryllis with Blue Background.* (c. 1907).
1773.67
Watercolor, 18³/₈×13 inches.
Signed bottom left near neck of bottle: "Piet Mondrian."
PROVENANCE: Mrs. Chr. H. Karsten-Oberschofheide, 1931; acquired 1967.
ALTERNATE TITLE: *Amaryllis.*
BIBLIOGRAPHY: Cf. Piet Mondrian, "Toward the True Vision of Reality," in *Plastic Art and Pure Plastic Art, 1937 and Other Essays, 1941–1943* (Documents of Modern Art series), New York: Wittenborn and Company, 1945, p. 10. — Michel Seuphor, *Piet Mondrian: Life and Work*, New York: Harry N. Abrams, 1956, p. 370, c. c. no. 158, illus. — Robert Welsh, in catalogue of exhibition "Piet Mondrian 1872–1944," Toronto: Art Gallery of Toronto, February 12–March 20, 1966, pp. 114–115.
Page 25
67 *Composition, V.* 1914. 633.67
Oil on canvas, 21⁵/₈×33⁵/₈ inches.
Signed lower left in black oil: "Mondrian 1914."
PROVENANCE: Rev. H. van Assendelft, Gouda, the Netherlands; Mrs. van Assendelft-Hoos, Gouda, the Netherlands, 1928; Suzanne Feigel, Basel; acquired c. 1951.
ALTERNATE TITLE: *Façade, 5.*
EXHIBITIONS: "Season's Résumé," SJG, April 28–May 31, 1952. — "50 Years of Mondrian," SJG, November 2–30, 1953, cat. no. 22, illus. — "Mondrian," SJG, September 30–November 2, 1957, cat. no. 10, illus. — "Piet Mondrian, The Early Years," The Solomon R. Guggenheim Museum, New York, December 11, 1957–January 19, 1958; San Francisco Museum of Art, February 6–March 16, 1958. — "Paintings, Drawings and Watercolors by Piet Mondrian," SJG, November 4–30, 1963, cat. no. 18, illus. — "A Selection of 20th Century Art of 3 Generations," SJG, November 24–December 26, 1964,

Piet Mondrian. *Dying Chrysanthemum.*
c. 1907–1908. Oil on canvas, 33 1/2 × 21 3/8 inches.
Gemeentemuseum, The Hague

Piet Mondrian. *Blue Façade (Composition 9).*
1913–1914. Oil on canvas, 37 1/2 × 26 5/8 inches. The
Museum of Modern Art, New York. Gift of Mr. and
Mrs. Armand P. Bartos

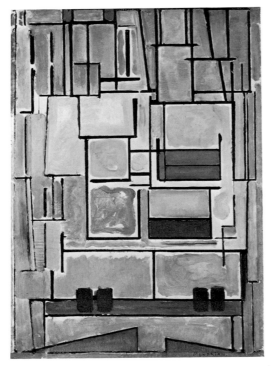

cat. no. 16, illus. — "Piet Mondrian Centennial
Exhibition," The Solomon R. Guggenheim Museum, New York, October 7–December 12, 1971,
cat. no. 58; Berner Kunstmuseum, Berne, Switzerland, February 9–April 9, 1972.

BIBLIOGRAPHY: Michel Seuphor, *Piet Mondrian:
Life and Work,* New York: Harry N. Abrams,
1956, p. 380, c.c. no. 272 (misidentified as *Façade 7*), illus. — Irving Sandler, *The Triumph of
American Painting: A History of Abstract Expressionism,* New York and Washington, D.C.:
Praeger, 1970, p. 114, fig. 8.11.
Page 27

68 *Composition with Color Planes, V.* 1917.

1774.67

Oil on canvas, 19 3/8 × 24 1/8 inches.
Signed and dated bottom left: "PM 17."
PROVENANCE: J. D. Waller, The Hague; G. David
Thompson, Pittsburgh; acquired from Galerie
Beyeler, Basel, 1966.

EXHIBITIONS: "Paintings from the G. David
Thompson Collection," Kunsthaus, Zurich, October 15–November 15, 1960; Kunstmuseum,
Düsseldorf, Winter 1960/61; Gemeentemuseum,
The Hague, Spring 1961; Museo Civico, Turin,
Fall 1961. — "The Museum of Our Wishes,"
Moderna Museet, Stockholm, December 26,
1963–February 16, 1964, cat. no. 76, illus. — "Piet
Mondrian," Galerie Beyeler, Basel, November
1964–January 1965, cat. no. 35, repr. in color. —
"Konstruktive Malerei 1915–1930," Frankfurter
Kunstverein, Frankfurt, 1966, cat. no. 43, illus. —
"Ways of Looking," MOMA, July 28–November
1, 1971.

BIBLIOGRAPHY: Michel Seuphor, *Piet Mondrian:
Life and Work,* New York: Harry N. Abrams,
1956, p. 382, c.c. no. 288, illus.
Page 28

69 *Composition, I.* 1931. 634.67
Oil on canvas, 19 7/8 × 19 7/8 inches.
Signed and dated bottom center in red paint:
"PM 31"; signed reverse on crossbar of stretcher
in black paint: "P. Mondrian."

PROVENANCE: F. Vordemberge-Gildewart, Amsterdam; acquired by donor c. 1949–1950; sold
to Mr. and Mrs. John L. Senior, Jr., reacquired
1956.

ALTERNATE TITLE: *Composition in Red and Blue.*
EXHIBITIONS: "Piet Mondrian Retrospective Exhibition," Kunsthalle, Basel, February 6–March
2, 1947, cat. no. 14. — "Piet Mondrian," SJG, February 5–March 17, 1951, cat. no. 26. — "Selections from 5 New York Private Collections,"
MOMA, June 26–September 9, 1951. — "5th Anniversary Exhibition: 5 Years of Janis," SJG,
September 29–October 31, 1953, cat. no. 39,
illus. — "50 Years of Mondrian," SJG, November 2–30, 1953, cat. no. 31 — "Mondrian," SJG,
September 30–November 2, 1957, cat. no. 17,
illus. — "Examples of the Classic Phase of Arp &

PABLO PICASSO. Spanish, born 1881. In France since 1904.

77 *Head.* (Spring 1913). 640.67
Collage, pen and ink, pencil, and watercolor on paper, $17 \times 11^{3}/_{8}$ inches, irregular.
PROVENANCE: Daniel-Henry Kahnweiler, Paris; Cahiers d'Art, Paris; acquired from Theodore Schempp, Paris, 1929.
ALTERNATE TITLE: *Man's Head.*
EXHIBITIONS: "Sidney Janis Collection of Modern Paintings," The Arts Club of Chicago, April 5–24, 1935, cat. no. 2. — "Summer Exhibition: The Museum Collection and a Private Collection on Loan," MOMA, June 4–September 24, 1935. — "Sidney Janis Collection: Twentieth Century Painters," The University Gallery, University of Minnesota, Minneapolis, October 21–November 5, 1935, cat. no. 2. — "Cubism and Abstract Art," MOMA, March 2–April 19, 1936, cat. no. 218 (see no. 11 for tour). —"Sidney Janis Collection," Brooklyn Museum, New York, Summer 1937. — "Picasso and Man," The Art Gallery of Toronto, January 10–February 16, 1964; Montreal Museum of Fine Arts, February 28–March 31, 1964, cat. no. 61, illus. — "Picasso in the Collection of the Museum of Modern Art," MOMA, February 3–May 1, 1972.
BIBLIOGRAPHY: Maurice Raynal, *Picasso*, Munich: Delphin Verlag, 1921, pl. XXI. — *Documents* (Paris), vol. 1, April 1929, illus. p. 47. — Carl Einstein, *Die Kunst des 20. Jahrhunderts*, 3rd ed., Berlin: Propyläen Verlag, 1931, illus. p. 314. — *Brooklyn Museum Quarterly*, vol. 24, July 1937, pp. 144–46. — Christian Zervos, *Pablo Picasso: vol. 2***, *Oeuvres de 1912 à 1917*, Paris: Éditions Cahiers d'Art, 1942, no. 403, illus. p. 190. — Robert Rosenblum, "Picasso and the Coronation of Alexander III: A Note on the Dating of some *Papiers Collés*," *Burlington Magazine* (London), vol. 113, October 1971, pp. 604–607, fig. 471. — William Rubin, *Picasso in the Collection of The Museum of Modern Art*, New York: The Museum of Modern Art, 1972, pp. 80, 210, illus.
Page 11

78 *Glass, Guitar, and Bottle.* (Spring 1913). 641.67
Oil, pasted paper, gesso, and pencil on canvas, $25^{3}/_{4} \times 21^{1}/_{8}$ inches.
PROVENANCE: Daniel-Henry Kahnweiler, Paris; Pierre Loeb, Paris; acquired from Marie Harriman Gallery, New York, 1934.
ALTERNATE TITLES: *Still Life with Guitar; La Table; Guitar and Glass.*
EXHIBITIONS: "Picasso," Galeries Georges Petit, Paris, June 16–July 30, 1932, cat. no. 88, illus. p. 32. — "French Paintings," Marie Harriman Gallery, New York, February 21–March, 1933, cat. no. 4. — "Abstract Paintings by Four Twentieth Century Artists: Picasso, Braque, Gris,

Léger," The Renaissance Society, University of Chicago, January 12–February 2, 1934, cat. no. 12. — "Pablo Picasso," Wadsworth Atheneum, Hartford, February 6–March 1, 1934, cat. no. 24, illus. — "Sidney Janis Collection of Modern Paintings," The Arts Club of Chicago, April 5–24, 1935, cat. no. 3 — "Summer Exhibition: The Museum Collection and a Private Collection on Loan," MOMA, June 4–September 24, 1935. — "Sidney Janis Collection: Twentieth Century Painters," The University Gallery, University of Minnesota, Minneapolis, October 21–November 5, 1935, cat. no. 3. — "Cubism and Abstract Art," MOMA, March 2–April 19, 1936, cat. no. 220, fig. 67 (see no. 11 for tour). — "Sidney Janis Collection," Brooklyn Museum, New York, Summer 1937. — "Picasso: Forty Years of His Art," MOMA, November 15, 1939–January 7, 1940; The Art Institute of Chicago, February 1–March 3, 1940; cat. no. 111, illus. — "Pioneers of American and European Contemporary Art," Nierendorf Gallery, New York, December 5–31, 1944. — "Sidney Janis Collection," Albright Art Gallery, Buffalo, Summer 1940. — "20th Century Old Masters," SJG, February 27–March 25, 1950, cat. no. 12. — "Climax in 20th Century Art, 1913," SJG, January 2–February 3, 1951, cat. no. 4, illus. — "A Selection of 20th Century Art of 3 Generations," SJG, November 24–December 26, 1964, cat. no. 17, illus. — "Picasso in the Collection of The Museum of Modern Art," MOMA, February 3–May 1, 1972.
BIBLIOGRAPHY: Maurice Raynal, *Les Maîtres du cubisme: Pablo Picasso*, 2e sér., Paris: Éditions de "L'Effort Moderne," 1921, pl. 22. — Eugenio d'Ors, *Pablo Picasso*, Paris: Éditions des Chroniques du Jour, 1930, pl. 21. — *Creative Art* (New York), vol. 12, March 1933, illus. p. 229. — James Thrall Soby, *After Picasso*, New York: Dodd Mead, 1935, pl. 30. — *Brooklyn Museum Quarterly*, vol. 24, July 1937, pp. 144–46. — Helen Mackenzie, *Understanding Picasso*, Chicago: University of Chicago Press, 1940, pl. VIII. — Christian Zervos, *Pablo Picasso: vol. 2***, *Oeuvres de 1912 à 1917*, Paris: Éditions Cahiers d'Art, 1942, no. 419, illus. p. 195. — Alfred H. Barr, Jr., *Picasso: Fifty Years of His Art*, New York: The Museum of Modern Art, 1946, p. 82, illus. — William Rubin, *Picasso in the Collection of The Museum of Modern Art*, New York: The Museum of Modern Art, 1972, pp. 80–81, 210, illus.
Page 12

79 *Glass, Newspaper, and Bottle.* (Fall 1914).
 642.67
Oil and sand on canvas, $14^{1}/_{4} \times 24^{1}/_{8}$ inches.
Signed lower left: "Picasso."
PROVENANCE: Léonce Rosenberg, Paris; acquired from Valentine Dudensing, New York, 1933.

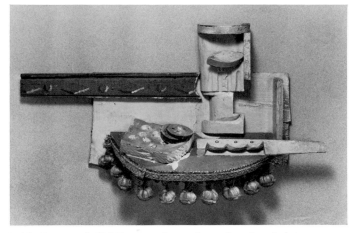

Pablo Picasso. *Still Life.* 1914. Painted wood with upholstery fringe, 10 1/8 × 18 × 4 inches. The Tate Gallery, London

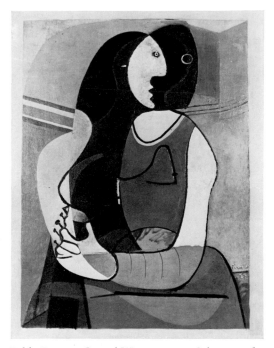

Pablo Picasso. *Seated Woman.* 1927. Oil on wood, 51 1/8 × 38 1/4 inches. The Museum of Modern Art, New York. Gift of James Thrall Soby

ALTERNATE TITLE: *Still Life.*

EXHIBITIONS: "Abstractions of Picasso," Valentine Gallery, New York, January 1931, cat. no. 1, illus. — "Abstract Paintings by Four Twentieth Century Artists: Picasso, Braque, Gris, Léger," The Renaissance Society, University of Chicago, January 12–February 2, 1934, cat. no. 13. — "Pablo Picasso," Wadsworth Atheneum, Hartford, February 6–March 1, 1934, cat. no. 26. — "Sidney Janis Collection of Modern Paintings," The Arts Club of Chicago, April 5–24, 1935, cat. no. 4. — "Summer Exhibition: The Museum Collection and a Private Collection on Loan," MOMA, June 4–September 24, 1935. — "Sidney Janis Collection: Twentieth Century Painters," The University Gallery, University of Minnesota, Minneapolis, October 21–November 5, 1935, cat. no. 4. — "Selection of Modern Art from Brancusi to Giacometti," SJG, April 22–May 11, 1957. — "New Acquisitions of 20th Century Paintings & Sculpture," SJG, December 30, 1957–January 25, 1958. — "2 Generations: Picasso to Pollock," SJG, March 3–April 4, 1964. — "Picasso," Tel Aviv Museum, January 2–March 3, 1966; Israel Museum, Jerusalem, March 24–May 6, 1966, cat. no. 19, illus. — "Picasso in the Collection of The Museum of Modern Art," MOMA, February 3–May 1, 1972.

BIBLIOGRAPHY: Maurice Raynal, *Les Maîtres du cubisme: Pablo Picasso*, 2e sér., Paris: Éditions de "L'Effort Moderne," 1921, pl. 22. — *L'Esprit Nouveau* (Paris), no. 13, 1921, illus. p. 1498. — *Bulletin de l'Effort Moderne* (Paris), no. 4, April 1924. — Christian Zervos, *Pablo Picasso: vol. 2***, *Oeuvres de 1912 à 1917*, Paris: Éditions Cahiers d'Art, 1942, no. 531, illus. p. 245. — William Rubin, *Picasso in the Collection of The Museum of Modern Art*, New York: The Museum of Modern Art, 1972, pp. 96, 214, illus. *Page 12*

80 *Seated Woman.* December 1926. 643.67
Oil on canvas, 8 3/4 × 5 inches.
Signed upper left: "Picasso"; dated on stretcher in artist's hand in black ink: "Decembra [*sic*] 26."

PROVENANCE: Acquired from the artist, 1932.

EXHIBITIONS: "Abstract Paintings by Four Twentieth Century Artists: Picasso, Braque, Gris, Léger," The Renaissance Society, University of Chicago, January 12–February 2, 1934, cat. no. 22. — "Pablo Picasso," Wadsworth Atheneum, Hartford, February 6–March 1, 1934, cat. no. 62. — "Sidney Janis Collection of Modern Paintings," The Arts Club of Chicago, April 5–24, 1935, cat. no. 6. — "Summer Exhibition: The Museum Collection and a Private Collection on Loan," MOMA, June 4–September 24, 1935. — "Sidney Janis Collection: Twentieth Century Painters," The University Gallery, University of Minnesota, Minneapolis, October 21–November 5, 1935, cat. no. 6. — "Sidney Janis Collection," Brooklyn Museum, Summer 1937. — "Picasso: Forty Years of His Art," MOMA, November 15, 1939–January 7, 1940; The Art Institute of Chicago, February 1–March 3, 1940, cat. no. 211. — "Picasso in the Collection of The

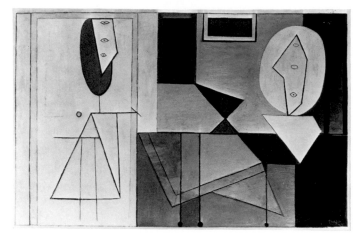

Pablo Picasso. *The Studio.* 1927–1928. Oil on canvas, 59×91 inches. The Museum of Modern Art, New York. Gift of Walter P. Chrysler, Jr.

Museum of Modern Art," MOMA, New York, February 3–May 1, 1972.

BIBLIOGRAPHY: *Cahiers d'Art* (Paris), vol. 2, no. 6, 1927, illus. p. 197. — *Cahiers d'Art* (Paris), vol. 7, no. 3–5, 1932, illus. p. 171. — *Brooklyn Museum Quarterly*, vol. 24, July 1937, pp. 144–46. — Christian Zervos, *Pablo Picasso: vol. 7, Oeuvres de 1926 à 1932*, Paris: Éditions Cahiers d'Art, 1955, no. 60, illus. p. 28. — William Rubin, *Picasso in the Collection of The Museum of Modern Art*, New York: The Museum of Modern Art, 1972, pp. 124, 222, illus.

Page 15

81 *Painter and Model.* 1928. 644.67
Oil on canvas, 51 1/8 × 64 1/4 inches.
Signed lower left: "Picasso/28."

PROVENANCE: Acquired from Paul Rosenberg, Paris, 1933.

ALTERNATE TITLES: *Artist and Model; The Painter with His Models; Abstraction.*

EXHIBITIONS: "Picasso," Paul Rosenberg, Paris, 1929. — "Picasso," Galeries Georges Petit, Paris, June 16–July 30, 1932, cat. no. 181. — "Picasso," Kunsthaus, Zurich, September 11–October 30, 1932, cat. no. 175. — "Pablo Picasso," Wadsworth Atheneum, Hartford, February 6–March 1, 1934, cat. no. 63. — "French Painting from the Fifteenth Century to the Present Day," The California Palace of the Legion of Honor, San Francisco, June 8–July 8, 1934, cat. no. 226. — "Sidney Janis Collection of Modern Paintings," The Arts Club of Chicago, April 5–24, 1935, cat. no. 7, illus. on cover. — "Summer Exhibition: The Museum Collection and a Private Collection on Loan," MOMA, June 4–September 24,

1935. — "Sidney Janis Collection: Twentieth Century Painters," The University Gallery, University of Minnesota, Minneapolis, October 21–November 5, 1935, cat. no. 4. — "Cubism and Abstract Art," MOMA, March 2–April 19, 1936, cat. no. 228, illus. fig. 88 (see no. 11 for tour). — "Sidney Janis Collection," Brooklyn Museum, Summer 1937. — "Picasso: Forty Years of His Art," MOMA, November 15, 1939–January 7, 1940; The Art Institute of Chicago, February 1–March 3, 1940, cat. no. 216, illus. — "Sidney Janis Collection," Albright Art Gallery, Buffalo, Summer 1940. — "Masterpieces of Picasso," MOMA, July 16–September 7, 1941, cat. no. 216. — "Paintings from New York Private Collections," MOMA, July 2–September 22, 1946, cat. p. 6. — "Timeless Aspects of Modern Art," MOMA, November 16, 1948–January 23, 1949, cat. no. 10. — "Picasso," The Art Gallery of Toronto, April 1949, cat. no. 19. — "20th Century Old Masters," SJG, February 27–March 25, 1950. — "The Struggle for New Form," World House Galleries, New York, January 22–February 23, 1957, cat. no. 63. — "Picasso: 75th Anniversary," MOMA, May 22–September 8, 1957; The Art Institute of Chicago, October 29–December 8, 1957, cat. p. 65, illus. — "Picasso," Philadelphia Museum of Art, January 8–February 23, 1958, cat. no. 118, illus. — "Picasso," Musée Cantini, Marseilles, May 11–July 31, 1959, cat. no. 37. — "Picasso," The Arts Council of Great Britain/Tate Gallery, London, July 6–September 18, 1960, cat. no. 117, illus. pl. 296. — "Picasso," Dallas Museum of Fine Arts, February 8–March 26, 1967, cat. no. 48. — "Picasso in the Collection of The Museum of Modern Art," MOMA, February 3–May 1, 1972.

BIBLIOGRAPHY: *Documents* (Paris), vol. 1, April 1929, pp. 41–43. — Eugenio d'Ors, *Pablo Picasso*, Paris: Éditions des Chroniques du Jour, 1930, pl. 46. — Carl Einstein, *Die Kunst des 20. Jahrhunderts*, 3rd ed., Berlin: Propyläen Verlag, 1931, illus. p. 338. — Sheldon Cheney, *Expressionism in Art*, New York: Tudor, 1934, illus. p. 336. — James Johnson Sweeney, *Plastic Redirections in 20th Century Painting*, Chicago: University of Chicago Press, 1934, pl. XII. — Alfred H. Barr, Jr., *Cubism and Abstract Art*, New York: The Museum of Modern Art, 1936, pp. 77–78, illus. (essay on *Painter and Model* by Harriet Janis). — *New York Herald Tribune*, April 26, 1936, illus. — *Times Literary Supplement* (London), July 11, 1936 (review of Barr, *Cubism and Abstract Art*), illus. — Julien Levy, *Surrealism*, New York: Black Sun Press, 1936, pl. 56. — *Brooklyn Museum Quarterly*, vol. 24, July 1937, pp. 144–46. — Alfred H. Barr, Jr., *Picasso: 50 Years of His Art*, New York: The Museum of Modern Art, 1946, p. 156. — *Modern Art: Old and New*, Teaching Portfolio with in-

troductory pamphlet by René d'Harnoncourt, New York: The Museum of Modern Art, 1950, pl. 5a. — Maurice Gieure, *Initiation à l'œuvre de Picasso*, Paris: Éditions des Deux Mondes, 1951, chap. 8, fig. 83. — John Richardson, "Picasso's Ateliers and Other Recent Works," *Burlington Magazine* (London), vol. 99, June 1957, pp. 183–93. — Antonina Vallentin, *Pablo Picasso*, Paris: Club des Éditeurs, 1957, p. 274. — Christian Zervos, *Pablo Picasso: vol. 7, Oeuvres de 1926 à 1932*, Paris: Éditions Cahiers d'Art, 1955, no. 143, illus. p. 64. — Roland Penrose, *Picasso: His Life and Work*, London: Victor Gollancz, 1958, p. 234, pl. XII. — William Rubin, *Picasso in the Collection of The Museum of Modern Art*, New York: The Museum of Modern Art, 1972, pp. 130–131, 224, illus.
Page 17

JACKSON POLLOCK American, 1912–1956.
82 *Free Form.* 1946. 645.67
Oil on canvas, 19 1/4 × 14 inches.
Signed and dated lower left center in black oil: "Jackson Pollock/46."
PROVENANCE: Acquired from the artist, 1955: sold to Mr. and Mrs. Marcel T. Freudmann, 1956; reacquired at auction, Sotheby's, London, June 28, 1961.
EXHIBITIONS: "Art Lending Service Retrospective Exhibition, 1950–1960," MOMA, January 26–March 20, 1960, no. 42. — "2 Generations: Picasso to Pollock," SJG, March 3–April 4, 1964, illus. in exhibition announcement. — "The New American Painting and Sculpture: The First Generation," MOMA, June 18–October 5, 1969, cat. no. 99.
Note: According to Sidney Janis, the title was not given to this painting by Pollock but was probably suggested by Janis himself.
Page 119
83 *White Light.* 1954. 337.67
Oil, aluminum, and enamel paint on canvas, 48 1/4 × 38 1/4 inches.
Signed bottom right edge in oil: "Jackson Pollock 54"; reverse, top center: "Jackson Pollock/1954."
PROVENANCE: Acquired from the Barnett Collection, 1955.
EXHIBITIONS: "15 Years of Jackson Pollock," SJG, November 28–December 31, 1955, cat. no. 15, illus. — "Jackson Pollock," SJG, November 3–29, 1958, cat. no. 37, illus. — Documenta II, Kassel, July 11–October 11, 1959, vol. 1, cat. p. 324, cat. no. 15. — "2 Generations: Picasso to Pollock," SJG, March 3–April 4, 1964. — "Jackson Pollock," MOMA, April 5–June 4, 1967, cat. no. 80, illus. p. 128; Los Angeles County Museum, July 19–September 3, 1967. — "The New American Painting and Sculpture: The First Generation," MOMA, June 18–October 5, 1969, cat. no. 108. —

"Abstract Expressionism and Pop Art," SJG, February 9–March 4, 1972.
BIBLIOGRAPHY: Bryan Robertson, *Jackson Pollock*, New York: Harry N. Abrams, 1960, pl. 166. — Francis V. O'Connor, *Jackson Pollock*, New York: The Museum of Modern Art, 1967, pp. 72, 134, illus. p. 128. — Italo Tomassoni, *Pollock*, New York: Grosset and Dunlap, 1968, p. 78, illus.
Page 119

JAMES ROSENQUIST. American, born 1933.
84 *Marilyn Monroe, I.* 1962. 646.67
Oil and spray enamel on canvas, 7 feet 9 inches × 6 feet 1/4 inch.
Signed and dated reverse upper left in black paint: "James Rosenquist/72" × 93" 1962."
PROVENANCE: Acquired from the artist, 1962.
EXHIBITIONS: "New Realists," SJG, November 1–December 1, 1962. — "Americans 1963," MOMA, May 22–August 18, 1963, cat. p. 111, illus. p. 92. — "Amerikansk Pop-konst," Moderna Museet, Stockholm, February 29–April 12, 1964, cat. no. 79. — "The 1960s," MOMA, June 28–September 24, 1967. — "Homage to Marilyn Monroe," SJG, December 6–30, 1967, cat. no. 39, illus. — "Abstract Expressionism and Pop Art," SJG, February 9–March 4, 1972. — "James Rosenquist," Whitney Museum of American Art, New York, April 10–May 29, 1972.
Page 155

MARK ROTHKO. American, born Latvia. 1903–1970. To U.S.A., 1913.
85 *Horizontals, White over Darks.* 1961. 647.67
Oil on canvas, 56 1/2 inches × 7 feet 9 3/8 inches.
Signed and dated reverse, left center, in black oil: "Mark Rothko/1961."
PROVENANCE: Acquired from the artist, 1962.
EXHIBITION: "2 Generations: Picasso to Pollock," SJG, March 3–April 4, 1964, cat. no. 32. — "Abstract Expressionism and Pop Art," SJG, February 9–March 4, 1972.
Page 129

KURT SCHWITTERS. British subject, born Germany. 1887–1948. In England 1940–1948.
86 *Merz 88: Red Stroke (Rotstrich).* 1920. 648.67
Paper collage, 5 1/4 × 4 1/8 inches.
Signed on mat in pencil lower right: "Kurt Schwitters 1920"; inscribed in pencil in artist's hand lower left on mat: "Mz 88/Rotstrich."
PROVENANCE: Ernst Schwitters, Oslo; acquired from Klipstein and Kornfeld Gallery, Berne, 1959.
EXHIBITIONS: "Kurt Schwitters," Kestner-Gesellschaft, Hanover, February 4–March 11, 1956, cat. no. 82. — "75 Collages by Schwitters," SJG,

February 2–March 7, 1959, cat. no. 6, illus. — "The Art That Broke the Looking Glass," Dallas Museum for Contemporary Arts, November 15–December 31, 1961, cat. no. 115. — "50 Collages by Kurt Schwitters," SJG, April 2–May 5, 1962.
Page 65

87 *Merz 252: Colored Squares (Farbige Quadrate).* 1921. 649.67
Paper collage, 7 1/8 × 5 3/4 inches.
Signed on mat in pen and ink lower left: "Mz 252/K. Schwitters 1921"; inscribed on mat lower right in pen and ink: "Farbige Quadrate."
PROVENANCE: Acquired from Klipstein and Kornfeld Gallery, Berne, 1959.
EXHIBITIONS: "75 Collages by Schwitters," SJG, February 2–March 7, 1959, cat. no. 10, illus. — "The Art That Broke the Looking Glass," Dallas Museum for Contemporary Arts, November 15–December 31, 1961, cat. no. 114. — "50 Collages by Kurt Schwitters," SJG, April 2–May 5, 1962. — "The Classic Spirit in 20th Century Art," SJG, February 4–29, 1964, cat. no. 16, illus.
BIBLIOGRAPHY: Werner Schmalenbach, *Kurt Schwitters*, New York: Harry N. Abrams, 1970, fig. 58.
Page 66

88 *Famiglia.* 1922. 650.67
Paper collage, 5 3/4 × 4 1/4 inches.
Signed on mat lower left in pencil: "Kurt Schwitters 1922."
PROVENANCE: Ernst Schwitters, Oslo; Berggruen Gallery, Paris; acquired from Klipstein and Kornfeld Gallery, Berne, 1956.
EXHIBITIONS: "Kurt Schwitters," Kestner-Gesellschaft, Hanover, February 4–March 11, 1956, cat. no. 116. — "57 Collages by Kurt Schwitters," SJG, October 22–November 17, 1956, cat. no. 11.
Page 66

89 *Merz 48: Berlin.* 1926. 651.67
Paper collage, 4 3/4 × 3 1/2 inches.
Signed and dated on mat lower right in pencil: "Kurt Schwitters 26"; inscribed on mat lower left in artist's hand: "Mz 26 48/Berlin."
PROVENANCE: Ernst Schwitters, Oslo; Berggruen Gallery, Paris; Klipstein and Kornfeld Gallery, Berne, 1956.
EXHIBITIONS: "Kurt Schwitters," Kestner-Gesellschaft, Hanover, February 4–March 11, 1956, cat. no. 134. — "50 Collages by Kurt Schwitters," SJG, April 2–May 5, 1962.
Page 67

90 *V-2.* 1928. 652.67
Paper collage, 5 1/8 × 3 1/2 inches, irregular.
Signed and dated on mount lower left in pencil: "Kurt Schwitters 1928."
PROVENANCE: Ernst Schwitters, Oslo; acquired from Klipstein and Kornfeld Gallery, Berne, 1956.

EXHIBITIONS: "Kurt Schwitters," Kestner-Gesellschaft, Hanover, February 4–March 11, 1956, cat. no. 150. — "57 Collages by Kurt Schwitters," SJG, October 22–November 17, 1956, cat. no. 33.
Page 67

GEORGE SEGAL. American, born 1924.
91 *Portrait of Sidney Janis with Mondrian Painting.* (1967). 653.67
Plaster figure with Mondrian's *Composition*, 1933, on an easel; figure, 66 inches high; easel, 67 inches high (for Mondrian *Composition*, see pages 31, 196).
PROVENANCE: Acquired from the artist, 1967.
Page 167

SAUL STEINBERG. American, born Rumania 1914. To U.S.A. 1942.
92 *Railway.* 1951. 654.67
Pen and ink on paper, 20 1/2 × 25 3/8 inches.
Signed and dated lower right in pen and ink: "Steinberg 1951."
PROVENANCE: Acquired from the artist, 1960.
EXHIBITIONS: "Steinberg," Galerie Maeght, Paris, April–May 1953. — "Steinberg," Stedelijk Museum, Amsterdam, 1954. — "Ways of Looking," MOMA, July 28–November 1, 1971.
BIBLIOGRAPHY: Saul Steinberg, *The Passport*, New York: Harper and Brothers, 1954, n.p., illus. — François Stahly, "Galerie Maeght, Paris: Book Design and Advertising Art," *Graphis* (Zurich), vol. 10, no. 56, 1954, p. 520, illus. — Saul Steinberg, *Dessins*, Paris: Gallimard, 1955. — Cf. *Derrière le Miroir* (Paris), March–April 1953 (special Steinberg issue).
Page 145

CLYFFORD STILL. American, born 1904.
93 *Painting.* 655.67
Oil on canvas, 8 feet 8 1/4 inches × 7 feet 3 1/4 inches.
Signed lower left reverse in blue crayon: "Cly Still/1944–N."
PROVENANCE: Mme de Neufville, Paris; acquired from William Rubin, New York, c. 1965.
ALTERNATE TITLE: *1944–N*; *Red Flash on Black Field.*
EXHIBITIONS: "Paintings by Clyfford Still," The Buffalo Fine Arts Academy, Albright Art Gallery, Buffalo, November 5–December 13, 1959, cat. no. 9, illus. — "The New American Painting and Sculpture: The First Generation," MOMA, June 18–October 5, 1969, cat. no. 144.
Page 127

PATRICK J. SULLIVAN. American, 1894–1967.
94 *The Fourth Dimension.* (1938). 656.67
Oil on canvas, 24 1/4 × 30 1/4 inches.

Signed lower right in black paint: "P. J. Sullivan."

PROVENANCE: Acquired from the artist, 1938.

EXHIBITIONS: "They Taught Themselves," San Francisco Museum of Art, August 5–September 3, 1941; Stendahl Art Galleries, Los Angeles, September 29–October 11, cat. no. 45. — "They Taught Themselves," Marie Harriman Gallery, New York, February 9–March 7, 1942, cat. no. 36. — "Americans 1943: Realists and Magic Realists," MOMA, February 10–March 21, 1943, cat. no. 241, illus. — "Seventeen Naive Painters," Circulating exhibition organized by The Museum of Modern Art (see no. 40 for tour). — "Werke und Werkstatt naiver Kunst," Städtische Kunsthalle, Recklinghausen, West Germany, April 29–June 27, 1971, cat. no. 355, illus. — "Naive Paintings: A Selection from the Museum Collection," MOMA, January 7–February 24, 1972.

BIBLIOGRAPHY: John Wyant, Jr., "Wheeling House Painter Takes Up Art as Hobby and Wins International Fame Quickly," *Wheeling Intelligencer*, April 25, 1939. — Anita Brenner, "American Primitives," *New York Times Magazine*, April 6, 1941. — Sidney Janis, "They Taught Themselves," *Art News* (New York), vol. 40, September 1941, p. 19, illus. — Sidney Janis, *They Taught Themselves: American Primitive Painters of the 20th Century*, New York: Dial Press, 1942, pp. 53–61, 70–72, illus. — Oto Bihalji-Merin, *Modern Primitives: Masters of Naïve Painting*, New York: Harry N. Abrams, 1961, pp. 93–94.

Page 85

MARK TOBEY. American, born 1890. Worked in England 1931–1938, except for trip to Far East, 1934. In Switzerland since 1960.

95 *Fata Morgana.* 1944. 657.67
Tempera on cardboard, 14 1/8 × 22 1/4 inches.
Signed and dated lower right in brown paint: "Tobey/44"; dated reverse, left of center, in white paint: "44"; inscribed on reverse: "Fata Morgana/'44."

PROVENANCE: Gift of the artist, 1944.

ALTERNATE TITLE: *White Writing.*

Page 117

96 *Wild Field.* 1959. 658.67
Tempera on cardboard, 27 1/8 × 28 inches.
Signed and dated lower right in brown paint: "Tobey 59."

PROVENANCE: Otto Seligman Gallery, Seattle; Mr. and Mrs. Frederick R. Weisman, Beverly Hills, California, 1962; acquired at Parke-Bernet auction, 1965.

EXHIBITIONS: "Mark Tobey," Otto Seligman Gallery, Seattle, May 9–July 31, 1962. — "Selected Works from 2 Generations of European & American Artists: Picasso to Pollock," SJG, January 3–27, 1967, cat. no. 43, illus.

Page 117

JOAQUÍN TORRES-GARCÍA. Uruguayan, 1874–1949. Worked in Spain 1891–1920, 1932–1934. In New York 1920–1922. In Italy 1922–1925. In Paris 1925–1932. In Montevideo from 1934.

97 *Constructive Painting.* (c. 1931). 659.67
Oil on canvas, 29 5/8 × 21 7/8 inches.

PROVENANCE: Acquired from the artist, 1950.

EXHIBITIONS: "Joaquín Torres-García," SJG, April 3–22, 1950, cat. no. 1. — "Recent French Acquisitions," SJG, December 7, 1953–January 2, 1954. — "Selection of Modern Art from Brancusi to Giacometti," SJG, April 22–May 11, 1957. — "New Acquisitions of 20th Century Paintings & Sculpture," SJG, December 30, 1957–January 25, 1958. — "Joaquín Torres-García," University Art Museum, The University of Texas at Austin, December 1, 1971–January 16, 1972, cat. no. 20, illus. on cover of checklist.

Page 47

VICTOR VASARELY. French, born Hungary 1908. To France 1930.

98 *Capella 4 B.* (1965). 660.67
Tempera on composition board in two parts, overall 50 5/8 × 32 3/4 inches.
Signed bottom center in black ballpoint pen: "Vasarely-."

PROVENANCE: Acquired from the artist, 1965.

Page 143

LOUIS VIVIN. French, 1861–1936.

99 *The Pantheon.* (1933). 661.67
Oil on canvas, 15 × 21 3/4 inches.
Signed lower left: "L. Vivin."

PROVENANCE: Acquired from Galerie Bing, Paris, 1950.

EXHIBITION: "Vivin," SJG, December 27, 1949–January 28, 1950, cat. no. 23. — "Naive Paintings: A Selection from the Museum Collection," MOMA, January 7–February 24, 1972.

Page 95

ANDY WARHOL. American, born 1925.

100 *Self-Portrait.* 1966. 662.67.1–6
Synthetic polymer paint and enamel silkscreened on six canvases, each 22 5/8 × 22 5/8 inches.
Signed on reverse of panels one through four, and six, in blue acrylic: "Andy Warhol 66."

PROVENANCE: Acquired from the artist through Leo Castelli, 1966.

EXHIBITION: "Abstract Expressionism and Pop Art," SJG, February 9–March 4, 1972.

BIBLIOGRAPHY: *Artscanada* (Toronto), vol. 25, December 1968, pp. 21–22, illus.
Page 163

101 *Seven Decades of Janis.* (1967). 2355.67 a–h
Synthetic polymer paint silkscreened on eight joined canvases, each $8^1/_8 \times 8^1/_8$ inches; overall $16^1/_4 \times 32^3/_8$ inches.
PROVENANCE: Acquired from the artist, 1967.
ALTERNATE TITLE: *Portraits.*
BIBLIOGRAPHY: Emily Farnham, *Charles Demuth: Behind a Laughing Mask*, Norman, Oklahoma: University of Oklahoma Press, 1971, p. 185, pl. 25 B.
Page 164

102 *Sidney Janis.* (1967). 2354.67
Photosensitive gelatin and tinted lacquer on silkscreen on wood frame, 7 feet $11^1/_8$ inches × 6 feet $4^1/_8$ inches.
PROVENANCE: Acquired from the artist, 1967.
Page 165

TOM WESSELMANN. American, born 1931.

103 *Mouth 7.* 1966. 663.67
Oil on shaped canvas, 6 feet $8^1/_4$ inches × 65 inches.
Signed and dated on stretcher on reverse, upper left: "Wesselmann 1966."
PROVENANCE: Acquired from the artist, 1966.
EXHIBITION: "New Paintings by Wesselmann," SJG, May 10–June 4, 1966, cat. no. 26.
BIBLIOGRAPHY: Grace Glueck, "New York Gallery Notes, ABC to Erotic," *Art in America* (New York), vol. 54, September 1966, p. 105, illus. — Cf. J. A. Abramson, "Tom Wesselmann and the Gates of Horn," *Arts Magazine* (New York), vol. 40, May 1966, pp. 46–47.
Page 157

Man Ray. *Observatory Time—The Lovers.* 1932–1934. Oil on canvas, 39 × 99 inches. Collection the artist

APPENDIX: POLLOCK *ONE*

JACKSON POLLOCK American, 1912–1956

One. (Number 31, 1950). 1950. Oil and enamel on canvas, 8 feet 10 inches × 17 feet 5 inches

This great painting, a key work in Jackson Pollock's career and one of the milestones in American painting, was not part of The Sidney and Harriet Janis Collection; but when it became available in 1968, the year following the gift of the collection to the Museum, Mr. Janis generously amended the terms of the original agreement in order to make it possible for the Museum to acquire it from its former owners, Mr. and Mrs. Ben Heller of New York.

As William Rubin pointed out at the time the acquisition was announced, "Contrary to public opinion, Pollock painted only three immense, wall-size pictures during his classic 'drip' period (from late 1946 through 1950), and only two later. These were pioneering works in the development of a new kind of large picture that was neither an easel painting nor a mural." He further observes that this scintillating painting culminates Pollock's interest in impressionists effects, announced as early as his *Sounds in the Grass: Shimmering Substance* of 1946 (The Museum of Modern Art). *One,* whose title refers to the concept of wholeness and unity basic to Pollock's allover style, represents a new stage in the artist's continuing dissolution of impasto effects in favor of a more disembodied flicker of light. Many of its passages were stained into, rather than painted on, the surface—a technique that modifies the linearity characteristic of Pollock's earlier drip paintings.

This painting was included in the large Pollock retrospective circulated throughout Europe in 1958 and 1959 under the auspices of The International Council of The Museum of Modern Art. When it was shown in Rome, the young critic Marcello Venturoli, writing in the Communist daily *Paese Sera,* modified his strong position against abstract art and declared: "We must admit we were wrong in one of our tenets, and that is, we did not believe it possible today to paint or sculpt without a minimum of reference to exterior reality. Pollock, after Kandinsky, has succeeded in convincing us. ... The big painting *One* is the most dramatic and tormented painting, not in the least casual or decorative. ... It is the clear mirror of a temperament that unites, in a protest of anarchic origin, good and evil, harmonic and irrational forms with a universal result. This painting is a warning, a message, an irreducible and candid way of looking at the world." (Quoted in English translation in Francis V. O'Connor, *Jackson Pollock,* New York: The Museum of Modern Art, 1967, p. 76.)

JACKSON POLLOCK. American, 1912–1956.
One (Number 31, 1950). (1950). 7.68
Oil and enamel on canvas, 8 feet 10 inches × 17
feet 5 inches.
Inscribed reverse upper right corner: "Top/No
31 1950/Jackson Pollock."
PROVENANCE: Selected by Ben Heller, New York,
from the artist and purchased through SJG, 1955;
acquired by MOMA, 1968, Gift of Sidney Janis.
EXHIBITIONS: "Jackson Pollock," Betty Parsons
Gallery, New York, November 28–December
16, 1950. — "Jackson Pollock," Studio Paul
Facchetti, Paris, March 7–31, 1952. — "Jackson
Pollock," MOMA, December 19, 1956–February
3, 1957, cat. no. 24, repr. in color. — "Jackson
Pollock 1912–1956," organized by the Inter-
national Council of the Museum of Modern
Art, New York, IV Bienal, São Paulo, Brazil,
September 22–December 31, 1957, cat. no. 21,
repr. in color; subsequently circulated to Gal-
leria Nazionale d'Arte Moderna, Rome, March
1–31, 1958; Kunsthalle, Basel, April 19–May
26; Stedelijk Museum, Amsterdam, June 6–July
7, 1958; Kunstverein, Hamburg, July 19–
August 21; Hochschule für bildende Künste,
Berlin, September 1–October 1; Whitechapel
Art Gallery, London, November 5–December
14; Musée National d'Art Moderne, Paris, Jan-
uary 16–February 15, 1959; cat. no. 20. — "The
Collection of Mr. & Mrs. Ben Heller," circu-
lating exhibition of The Museum of Modern
Art, New York: The Art Institute of Chicago,
September 22–October 22, 1961; Baltimore
Museum of Art, December 3–31; Contempo-
rary Art Center, Cincinnati, January 22–Feb-
ruary 25, 1962; Cleveland Museum of Art,
March 13–April 10; California Palace of the
Legion of Honor, San Francisco, April 30–June
3; Portland Art Museum, Portland, Oregon,
June 15–July 22; Los Angeles County Museum,
September 5–October 14, cat. no. 29. — "Jack-
son Pollock," MOMA, April 5–June 4, 1967, cat.
no. 45. — "The New American Painting and
Sculpture: The First Generation," MOMA, June
18–October 5, 1969, cat. no. 105.
BIBLIOGRAPHY: Sam Hunter, "Jackson Pollock,"
Bulletin of The Museum of Modern Art (New
York), vol. 24, no. 2, 1956–1957, repr. in color.
— Marcello Venturolli, [Review of "Jackson
Pollock 1912–1956"], *Paese Sera*, Rome, March
13/14, 1958. — B. H. Friedman, "The New Col-
lectors," *Art in America* (New York), vol. 46,
Summer 1958, p. 16, illus. pp. 14–15. — Frank
O'Hara, *Jackson Pollock*, New York: Braziller,
1959, pp. 14, 26, illus. p. 51. — Bryan Robertson,
Jackson Pollock, New York: Harry N. Abrams,
1960, pp. 19, 20, 29, 52, 102, pl. 37. — Henry
Geldzahler, "Heller: New American-Type Col-
lector," *Art News* (New York), vol. 60, Septem-
ber 1961, pp. 29–30. — William S. Rubin, "Jack-
son Pollock and the Modern Tradition, Part I,"
Artforum (Los Angeles), vol. 5, February 1967,
p. 14; "Part II," March 1967, pp. 29, 33; "Part
IV," May 1967, illus. (detail) p. 33. — Francis
V. O'Connor, *Jackson Pollock*, New York: The
Museum of Modern Art, 1967, pp. 56, 76, 133,
illus. p. 106. — Italo Tomassoni, *Pollock*, trans.
from the Italian by Carolyn Beamish, New
York: Grosset & Dunlap, 1968, p. 23, pl. 59. —
Horst W. Janson, *History of Art*, rev. ed., New
York: Harry N. Abrams, 1969, p. 540, illus. (fig.
808). — Alberto Busignani, *Jackson Pollock*,
Florence: Sansone Editore, 1970, illus. pp. 34–
35. — Irving Sandler, *The Triumph of American
Painting: A History of Abstract Expressionism*,
New York and Washington: Praeger, 1970,
p. 118, pl. V.

CHRONOLOGY

This chronology includes writings by and about Sidney and Harriet Janis, as well as a record of exhibitions at the Sidney Janis Gallery from its opening in September 1948 through the date of the gift of the collection to The Museum of Modern Art in 1967. Excerpts identified as "Interview, June 1967" are from an interview, conducted by Helen Franc, of which a transcript is available in the Museum's Library. The chronology has been corrected and edited in collaboration with Mr. Janis, who has been untiring in his efforts to provide information and verify facts included in it.

sjg = Sidney Janis Gallery

1896	Sidney Janis born July 8 in Buffalo, New York. Father, Isaac, a traveling salesman; mother Celia, née Cohn. Two older brothers, Martin and Soloman; later, a younger brother, Carroll, and sister, Carolyn.
1898	Harriet Grossman born September 2 in New York City to Natsi and Charlotte Grossman; three older brothers, Morris, Isadore, and Martin; a younger brother, Eugene.
1902–14	Janis attends public and technical schools in Buffalo.
1904–16	Harriet Grossman attends New York public schools, earning high school diploma.
1914–17	After leaving Technical High School, Buffalo, in senior year, Janis works as professional dancer with partner Grace Hickie at Palais de Danse, Buffalo, and later on the Gus Sun Time vaudeville circuit. Travels and demonstrates at cabarets and nightclubs new ballroom dances, hesitation waltz, one-step, and tango.
1917–18	Joins U.S. Naval Reserve Force and completes courses in aeronautical mechanics at Great Lakes Naval Base, Illinois; earns credits for high school diploma. At time of Armistice is instructor in aeronautics at San Diego, California.
1919–24	Returns to Buffalo and enters shoe business owned by his eldest brother Martin. While on business trips to New York, begins frequenting museums and art galleries. December 31, 1924: Meets Harriet ("Hansi") Grossman at New Year's Eve party in Greenwich Village.
1925	After moving to New York, marries Harriet Grossman, September 2, 1925; first home in Sunnyside, Queens.
1926	Opens M'Lord Shirt Company, manufacturing exclusively a novel two-pocket white shirt; Hansi acts as bookkeeper and amanuensis. Acquires first work of art, a Whistler etching.
1927–28	In repayment of $1,250 loan made to artist Ben Kopman to finance latter's trip abroad, acquires about 39 of Kopman's paintings. Acquires small Matisse oil, *Interior at Nice*, c. 1923, in exchange for Whistler etching and some cash. Son Conrad born February 11, 1928. Janises move to house in Mamaroneck, New York. Summer 1928: First of many yearly visits to Paris; meets Léger.
1929	Purchases Picasso's *Head* from Theodore Schempp, Paris; begins acquiring other School of Paris works. Meets Arshile Gorky, then teaching at Grand Central School of Art in New York, and through him other artists, including Stuart Davis, John Graham, and Willem de Kooning.
1930–31	Buys two Klee paintings, *In the Grass* and *The Zoo* (later acquired by his brother for his collection), out of The Museum of Modern Art's exhibition "Weber, Klee, Lehmbruck, Maillol" (March 12–April 2, 1930). Through Julien Levy, acquires de Chirico's *Evangelical Still Life* and Dali's *Illumined Pleasures*. In 1931, acquires Klee's *Actor's Mask* from J. B. Neumann in exchange for 39 Kopman paintings. Son Carroll born November 19, 1931.
1932	Summer: Trip to Paris. Janises visit Picasso exhibition at Galeries Georges Petit (June 16–July 30), where they see *Glass, Guitar, and Bottle* (which they acquire two years later from Marie Harriman Gallery) and *Painter and Model* (which they acquire a year later from Paul Rosenberg by exchange for Matisse's *Interior at Nice*). Meet Picasso, from whom they purchase *Seated Woman*. Visit Mondrian in his studio and select *Composition*, which Mondrian completes and sends to them a year later.

Sidney Janis with Grace Hickie, Buffalo,
c. 1914

Henri Rousseau's *The Dream*, 1910, acquired by the Janises in 1934.
It came to The Museum of Modern Art in 1954 as a gift of
Nelson A. Rockefeller

"The day after the opening of the Picasso show at the Galeries Georges Petit (which
Picasso did not attend), we visited a little gallery in an *impasse* off la Boétie, and there we
saw a dynamic fellow surrounded by other people listening to his every word. Hansi said
to me, 'Who's that little fellow?' and just then he looked up and saw my lips say, 'Picasso.'
He came over, shook hands with both of us, and asked why we were in Paris (not many
Americans were in Paris during the Depression). When he learned that we had arrived
only the day before, had come to Paris expressly to see the Picasso show, and were leaving
the next day, he was very much touched and invited us to come to the studio. There, he let
me go through stacks of little pictures that he had on the floor, and out of them I selected
this one [*Seated Woman*]. Then he said, 'I have to sign it'; we both watched as he painted
his signature, and—believe it or not—it took him about fifteen minutes to sign that picture,
though it looks as if were done spontaneously. . . .
"My first meeting with Mondrian was at his studio in rue du Départ in Paris in 1932. He
was completing the *Composition*, which I liked and decided to buy. He told me the price
in francs; since it was my first day in Paris, I had to go to the bank to purchase the re-
quired amount, which came to about $70. When I returned to Mondrian's studio, he said,
'You know, the picture isn't completed—I have to give it another coat of blue.' Now, this
was an area at the bottom, of about 1×5 inches; but I didn't get the picture for a whole
year! When he sent it, he wrote expressing regrets at seeing the canvas leave his hands—'it
was like a rose!'" —Interview, June 1967
Fall: Janises move to apartment at 25 Central Park West.

1934 In January, Janises acquire from Knoedler's *The Dream* by Henri Rousseau (formerly
 Collection Ambroise Vollard). It greatly stimulates Sidney Janis's interest in primitive
 painting and leads him to search during the next few years for work by American naïve
 artists. Acquires from Louis Eilshemius *Nymph* and *Dancing Nymphs*.
 "Eilshemius and I spent a great deal of time together. We went to many exhibitions, and
 later, after his automobile accident, I frequently visited him at his home on East Fifty-
 seventh Street." —Interview, June 1967
 In recognition of the growing importance of his collection, Janis is invited to membership
 on the Advisory Committee of The Museum of Modern Art, serving until the opening of
 his gallery in 1948.

1935 April 5–24: "Sidney Janis Collection of Modern Paintings" shown at The Arts Club of
 Chicago. It includes nineteen works: six Picassos, three Klees, two Légers, and one paint-
 ing each by de Chirico, Matisse, Gris, Dali, Mondrian, Gorky, Rousseau, and Kane.
 Catalogue foreword by Harriet Janis.

Guests at the first U.S. exhibition in 1939 of Picasso's *Guernica* (right) for the benefit of Spanish Civil War refugees; left to right, Dr. Jan Tiegrin, Valentine Dudensing, Carl Van Vechten, Dr. Tiegrin's secretary, Mrs. Dudensing, Sidney Janis, and Mr. Del Vayo

June 4–September 24: Collection loaned anonymously to summer exhibition at The Museum of Modern Art, "The Museum Collection and a Private Collection on Loan."
October 21–November 5: "Sidney Janis Collection: Twentieth Century Painters" exhibited at The University Gallery, University of Minnesota, Minneapolis.

1937 Summer: The Sidney Janis Collection exhibited at the Brooklyn Museum.

1938 Continuing their interest in American primitive painting, the Janises acquire from Patrick J. Sullivan, a West Virginia steelworker, his painting *The Fourth Dimension* (having discovered and bought his first painting, *Man's Procrastinating Pastime*, at the Society of Independent Artists show the previous year).
April 27–July 24. Lends three paintings by Sullivan to "Masters of Popular Painting: Modern Primitives of America and Europe," organized by MOMA in collaboration with Grenoble Museum, and writes section on Sullivan for its catalogue.
At spring outdoor art show in Washington Square, New York, buys William Doriani's *Flag Day*.
Fall: Janises move to apartment at 1 West Eighty-fifth Street, which remains their residence thereafter.

1939 Janis sells M'Lord Shirt Company in order to devote his time to writing and lecturing on art.
Writes foreword for catalogue of exhibition "Doriani" at the Marie Harriman Gallery, New York, March 13–April 1.
Serves as Chairman of Exhibition Committee for bringing to U.S. Picasso's *Guernica*, including drawings and studies, for exhibition organized by The American Artists Congress for benefit of Spanish Refugee Relief Campaign; presented at Valentine Gallery, New York, May 5–27, and (with cosponsorship of Motion Picture Artists' Committee) at Stendahl Galleries, Los Angeles, August 10–21.
Organizes opening exhibition of Advisory Committee of The Museum of Modern Art, "Contemporary Unknown American Painters," October 18–November 18, and writes introduction to catalogue. Nine of the thirty-one paintings shown are lent by Janis himself, including two of three canvases recently acquired from the retired Brooklyn slipper manufacturer Morris Hirshfield, *Angora Cat* and *Beach Girl* (the third being *Lion*). Grandma Moses is also represented in exhibition by three paintings.
At about this date, acquires Dali's *Frontispiece for Second Surrealist Manifesto*.

1940 Prepares second exhibition of The Museum of Modern Art's Advisory Committee, "Picasso's Seated Nude, 1911: A Visual Analysis of a Cubist Painting"; after being shown in

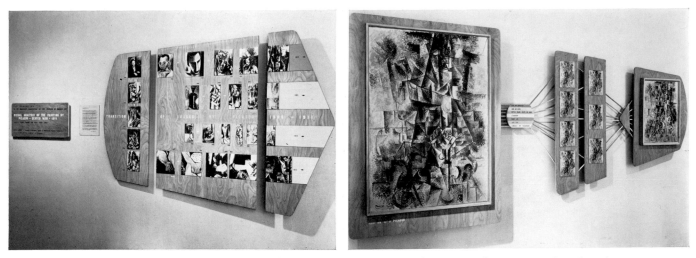

Views of Sidney Janis's installation, with detailed analysis, of Picasso's *Seated Nude*, 1911, at The Museum of Modern Art in 1940

Members' Room January 1–30, it is circulated (to December 1941) to Iowa State University, Middlebury College (Vermont), Texas State College for Women, University of Minnesota, Yale University, Philbrook Art Museum at Tulsa, and Wilmington Society of Fine Arts. Janis lectures at several of exhibiting institutions.

Summer 1940: Janis collection shown at Albright Art Gallery, Buffalo.

1941 Janis's interest in American primitive painters, on whom he is preparing a book, leads him to organize exhibition, "They Taught Themselves," shown at San Francisco Museum of Art, August 5–September 3, 1941, and Stendahl Galleries, Los Angeles, September 29–October 11; he also publishes two articles of the same title, which appear respectively in *Decision* (New York), vol. 2, July 1941, pp. 26–29, and *Art News* (New York), vol. 40, September 1941, pp. 14, 19.

Simultaneously, Janis acquires increasing familiarity with European artists in exile, then resident in New York, including Léger and Mondrian, whom he had known previously in Paris, and others whom he now meets for the first time. Visits them in their studios in preparation for an article, principally on Léger, Mondrian, Ernst, and Matta, which under the title "School of Paris Comes to U.S." is published in *Decision* (New York), vol. 2, November–December 1941, pp. 85–95. Some excerpts follow:

"Léger says this country makes him work faster. This sums up in a simple manner more than a question of speed, for the whole character and spirit of his work have stepped up as well. . . . There is a new departure to be seen in his painting today. . . . Instead of modeling, Léger separates the elements that make up modeling: line, color, light and shade, and puts them to work in such a way as to suggest rather than state this function. . . . Contrasts and dynamics strongly motivate Léger's work again today, and these properties he finds abundantly in America. . . .

"Interestingly enough, Mondrian independently made the statement made by Léger, that he works much faster here than he did abroad. He uses a technical shortcut which he learned in this country, laying out his composition with strips of adhesive. However he still spends months on a painting. . . . The interior of his studio is a reflection of his personal discipline, of a piece with his paintings. It is brilliantly lighted, carefully planned, simply but ingeniously furnished, clinically clean. The white surfaces of the walls are broken by rectangular color areas of cardboard—red, blue, yellow, unequal in size, placed to form a typical Mondrian arrangment. To him the oblique is weak and the curve weaker still, so he has covered the curves on his studio doorway with rectangular shapes to eliminate the offending note. . . . In his last canvas, where colored lines supplant the usual black ones, there is a complex counterplay of light and color, and Mondrian, long an

appreciator of jazz and since coming to America a devotee of boogie-woogie, feels he has created here corresponding mood and rhythm. . . . [Two later versions of this theme are The Museum of Modern Art's *Broadway Boogie Woogie,* 1942–1943, and Mondrian's last canvas, left unfinished at his death, *Victory Boogie Woogie,* 1943–1944 (Collection Mr. and Mrs. Burton Tremaine, Meriden, Connecticut).]

"New York is supplanting Paris as the art center of the world. This naturally means that the whole of America will play its part. Appreciation is gaining momentum on a nation-wide scale, but distribution . . . is still a problem of large proportions. An extensive and imaginative merchandising plan aimed to encourage a vast American public to participate by purchasing the works of their time, will be a step in the right direction." . . . [This statement preceded the opening of the Sidney Janis Gallery by seven years.]

"Picasso's Guernica: A Film Analysis" by Sidney Janis, with commentary by Harriet G. Janis, is published in *Pacific Arts Review* (San Francisco, M. H. de Young Memorial Museum, vol. 1, Winter 1941, pp. 14–23); it evokes a response from the academic painter Frederic Taubes, "Guernica, the Critic's Mystification" (vol. 2, Summer 1942, pp. 4–6), to which Janis writes a rejoinder (vol. 2, Winter 1942, pp. 57–64).

1942–43 Publication of *They Taught Themselves: American Primitive Painters of the 20th Century* (New York: Dial Press, 1942), with foreword by Alfred H. Barr, Jr. Concurrently with its issuance, the exhibition "They Taught Themselves" is shown at Marie Harriman Gallery, New York, February 9–March 7, 1942; André Breton contributes statement for catalogue.

February 28: Brief note on Janis, "Traveller," appears in "Talk of the Town" in *The New Yorker* magazine.

April: Article by Sidney Janis, "Journey into a Painting by Ernst" (*Two Children Are Threatened by a Nightingale,* 1924, The Museum of Modern Art), included in special Max Ernst issue of *View* (New York), ser. 2, no. 1, pp. 10–12.

Janis serves among editorial advisors for newly founded Surrealist review *VVV,* edited by David Hare, with Breton and Ernst as chief advisors; first issue appears June 1942 (last, February 1944).

September: son Conrad joins cast of play *Junior Miss,* later touring United States; Harriet Janis travels with him.

With Katherine S. Dreier, Peggy Guggenheim, James Johnson Sweeney, and others, Janis serves as sponsor of "First Papers of Surrealism," exhibition organized for Coordinating Council of French Relief Societies, shown at Whitelaw Reid Mansion, Madison Avenue, New York; Duchamp creates twine webbing for installation. Janis writes foreword to catalogue and lends Hirshfield's *Girl with Pigeons* to show.

About this time, acquires Brauner's *Nude and Spectral Still Life.*

Throughout 1942–1943, research for his forthcoming book, *Abstract & Surrealist Art in America,* brings Janis into frequent contact both with European artists in exile and avant-garde American artists, many then relatively unknown.

"The first publisher to whom I submitted the book turned it down, after looking at the photographs, and gave as his reason that the works were too difficult to understand. Gorky called a meeting at his studio inviting all the artists whose work had been selected. Many came to the meeting, and we engaged in a long evening of discussion about art and not a few bitter words about critics. It was very gratifying to me that the artists were ready to take up their cudgels in defense of the ideas in the book, as well as the works to be included in it. Later, Reynal & Hitchcock decided to do the book, and it proceeded."

—Interview, June 1967

April 1943: Article by Harriet and Sidney Janis, "Albright: Compulsive Painter," published in *View* (New York), ser. 3, no. 1, pp. 24–26, 31, 35.

June 23–August 1: "The Paintings of Morris Hirshfield," artist's first one-man show, comprised of his entire work to date, presented at The Museum of Modern Art. Janis directs show, prepares wall panels with detailed visual and written analyses of several pictures, and writes article of same title for Museum's *Bulletin* (vol. 10, May–June 1943, pp. 12–14). Critical reaction to show generally unfavorable; especially acerbic review by Howard Devree in *The New York Times,* quoted by Maude Riley in *Art Digest,* inspires letters from readers supporting their criticism and replies in defense of Hirshfield from Alfred H. Barr, Jr., and Janis himself ("Janis of the Modern Defends Hirshfield," *Art Digest,* vol. 18, August 1943, p. 17). Hirshfield's work is also greatly admired by Mondrian, though this admiration is not reciprocated.

December: Janis's review of *Santos, the Religious Folk Art of New Mexico* by Mitchell

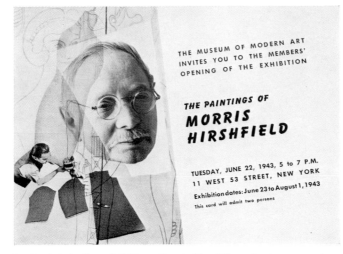

Invitation to the exhibition, directed by Sidney Janis,
of "The Paintings of Morris Hirshfield," 1943,
at The Museum of Modern Art. Janis is at left

A. Wilder with Edgar Breitenbach appears in *Magazine of Art* (Washington), vol. 36, 1943, p. 317.

1944 Selects and writes catalogue introduction for exhibition "Abstract and Surrealist Art in the United States," assembled in cooperation with Cincinnati Modern Art Society and circulated by San Francisco Museum of Art (which publishes catalogue). Show includes one work by each of eighty-five artists, divided into four categories: American Pioneers of Twentieth Century Painting; American Abstract Painters; American Surrealist Painters; American Works by Artists in Exile. Tour includes Cincinnati Art Museum (February 8–March 12), Denver Art Museum (March 26–April 23), Seattle Art Museum (May 7–June 10), Santa Barbara Museum of Art (June–July), and San Francisco Museum of Art (July). Janis delivers lectures on exhibition at its first showing in Cincinnati in February, and later in San Francisco.

April: At Mark Tobey's invitation, writes foreword for catalogue of his one-man show at Willard Gallery, New York, April 4–29; it includes one of first discussions in print of Tobey's "white writing" and helps to popularize this term. Several months later, Tobey presents Janis with one of his works in that style, *Fata Morgana* (alternatively titled *White Writing*).

November: Excerpt from Janis's forthcoming book *Abstract & Surrealist Art in America* appears in *Arts and Architecture* (Los Angeles), vol. 61, November 1944, pp. 16–19, 37.

December: Publication of *Abstract & Surrealist Art in America* (New York: Reynal & Hitchcock, 1944). Janis directs two exhibitions paralleling sections of book: "European and American Pioneers in Twentieth-Century Art," Nierendorf Gallery, New York, December 1–14, and "Abstract and Surrealist Art in America," Mortimer Brandt Gallery, New York, November 29–December 30. The book is responsive to the way in which abstract painting is melding both with Surrealism and with Expressionism. In describing a painting of Hofmann as both "abstract and expressionist," it comes close to suggesting the term which would come into use later.

About this time, acquires Matta's *Paysage flammifère* from Peggy Guggenheim's gallery, Art of This Century.

1945 January: Article by Harriet Janis, "Notes on Piet Mondrian," published in *Arts and Architecture* (Los Angeles), vol. 62, pp. 28–30, 48–49.

March: Article by Harriet and Sidney Janis, "Marcel Duchamp: Anti-Artist," included in special Duchamp issue of *View* (New York), ser. 5, no. 1. pp. 18–19, 21 (reprinted in *Horizon*, London, vol. 12, October 1945, pp. 257–68, and subsequently in anthology edited by Robert Motherwell, *The Dada Painters and Poets* (New York: Wittenborn, Schultz, 1951).

Marcel Duchamp, Alfred H. Barr, Jr., and Sidney Janis at the judging
of the Bel Ami International Art Competition in 1946

After exploring various facets of Duchamp's genius, the article concludes:
"But the treasure trove of subtleties in creative ideas and techniques in Duchamp's work
is still essentially untouched. Tapping these resources will provide a rich yield for the new
generation of painters, in whose awareness lies the future of twentieth-century painting;
for here, deeply embedded with meaning, is one of the great, little explored veins in con-
temporary art."
July: Publication of article by Harriet Janis, "Evsa Model's American City," *Arts and
Architecture* (Los Angeles), vol. 62, pp. 22–23, 46–48.
July 2–September 22: Eight paintings from Janises' collection included in "Paintings from
New York Private Collections" at The Museum of Modern Art.
September: Harriet Janis joins Editorial Advisory Board of *Arts and Architecture* (Los
Angeles), serving until March 1958.
December: Janis makes first postwar trip to Europe, remaining in Paris until March 1946.

1946 January: Article by Harriet and Sidney Janis, "Painting of Ivan Albright," published in
Art in America (New York), vol. 34, pp. 43–49.
January 4: Harriet Janis, in association with Rudi Blesh and her brother Eugene Gross-
man, founds Circle Records; among jazz artists eventually put on disc by this company
are Sidney Bechet, Eubie Blake, Wild Bill Davison, Baby Dodds, Conrad Janis, James P.
Johnson, George Lewis, Jelly Roll Morton, Kid Ory, Hot Lips Page, and Bessie Smith.
February: Article by Harriet Janis, "Paintings a Key to Psychoanalysis," using Dali's *Illu-
mined Pleasures* as example, appears in *Arts and Architecture* (Los Angeles), vol. 63,
pp. 38–40, 60.
During sojourn in Paris, Janis spends nine weeks in Picasso's studio in preparation for
forthcoming book; Picasso's confidential secretary Jaime Sabartés has artist's permission
to show him everything there and allow him to photograph whatever he likes.
Meets a number of artists, including Brauner, from whom he acquires *Talisman*:
"Brauner painted in a little studio that had belonged to the *douanier* Rousseau, and after
our visit, on the way downstairs, we went through the back door into a kind of alleyway,
and there, outside, being thrown away that day, was a red couch exactly of the color and
type of the one in *The Dream*, now in the Museum's collection, but which Mrs. Janis and
I owned for a period of twenty years. When Brauner saw this couch, tears began to form
in his eyes; he was certain Fate had placed it there, that the piece was being thrown out
the very day I visited his studio by someone who had picked it up out of Rousseau's
studio (after his death in 1910; this was 1946!); and since he knew I had the picture of
Yadwigha's *Dream*, he as a fatalist believed that this was all ordained. Brauner was always

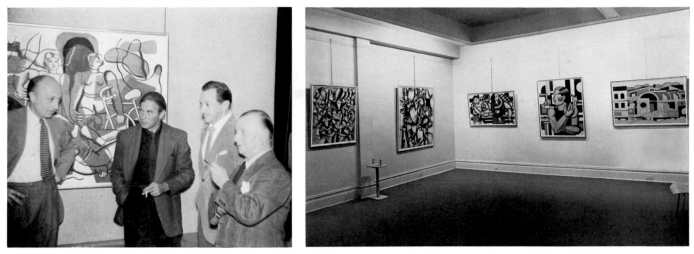

Opening of the Sidney Janis Gallery in 1948 with exhibition "F. Leger: 1912–1948"; left, a guest chats with Evsa Model, Sidney Janis, and Frederick Kiesler at the opening; right, a view of the installation

a mystic and looked for these unusual meanings behind everyday occurrences."

—Interview, June 1967

Having brought to Paris a number of Hirshfield's paintings, Janis shows them to several artists, among them Giacometti, who is much taken with them and declares, "After looking at them, you all look different to me."

On return to America in March, Janis serves with Marcel Duchamp and Alfred H. Barr, Jr., as juror for Bel Ami International Art Competition, "The Temptation of St. Anthony," which Harriet Janis had suggested to Albert Lewin in order to provide a fine modern painting for the Loew-Lewin film *The Private Affairs of Bel Ami,* based on novel by Guy de Maupassant. First prize awarded to Max Ernst. The exhibition of eleven paintings by noted European and American artists is circulated in United States and England by The American Federation of Arts, 1946–1947; catalogue includes essay, "Competition and Exhibition," by Sidney and Harriet Janis. Harriet Janis also publishes article, "Artists in Competition," discussing contest and describing each painting, in *Arts and Architecture* (Los Angeles), vol. 63, April 1946, pp. 30–33, 53–55.

Fall: Publication of *Picasso: The Recent Years, 1939–1946* (New York: Doubleday, 1946) by Harriet and Sidney Janis; contains first extensive treatment of Picasso's work during German Occupation of France.

October: Sidney Janis's obituary for Morris Hirshfield appears in *View* (New York), ser. 7, no. 1, p. 14, accompanied by reproduction of *Sacré Coeur, II* (second version of *Parliamentary Buildings;* reproduced page 187):

"On July 26th last, Morris Hirshfield, aged 74, died of a heart attack. . . . On my last visit with Hirshfield the day before he died, he seemed in reasonably good health. More than anything else, he was interested in discussing a canvas he was about to start. The subject was to be Adam and Eve. The following morning he died suddenly, within ten minutes, before help could be summoned. . . .

"I had sent him a card from Paris, selected, not at random, but with the hope that the subject would appeal to him. It was a view of the Sacré Coeur, a wide angle, asymmetric arrangement. Upon my return to New York, I was delighted to learn that Hirshfield was making a painting of it . . . which he called 'Parliamentary Buildings.' No longer a view of a church in the strict sense, the painting is nevertheless infused with a high degree of spirituality and philosophic overtone. As Hirshfield's final work, it symbolizes life after death, and virtually becomes the painter's own monument."

1947 February: Memorial exhibition of work of Morris Hirshfield at Art of This Century gallery, New York, for which Janis writes catalogue introduction.

217

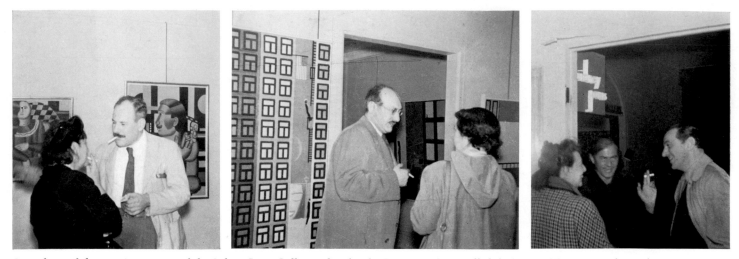

Snapshots of the opening season of the Sidney Janis Gallery taken by the Janises' son Carroll: left, Barnett Newman with another visitor at the Léger opening; center, Mark Rothko at the opening of Evsa Model's one-man show; and right, Harriet and Sidney Janis with Model

Most of year spent in travel and planning for opening of Sidney Janis Gallery.

1948–49 February: Article, "Mobiles," by Harriet Janis appears in *Arts and Architecture* (Los Angeles), vol. 65, pp. 26–28.

Janis visits Europe to obtain initial group of works by leading twentieth-century European artists for forthcoming opening of Sidney Janis Gallery. Hans Arp assigns him his reliefs, Curt Valentin continuing to handle the sculpture (until Valentin's death in 1954, when Janis becomes Arp's sole American representative).

"I knew Jean Arp for many, many years and used to visit his studio at Meudon on the same afternoon that I would visit Nelly van Doesburg. . . . I was very much interested, to begin with, in his white-on-white reliefs. I thought they were quite wonderful things. When I opened my gallery in 1948, Curt Valentin had the sculptures by Arp and I was assigned the reliefs, which I admired very much, although I didn't have any friends or clients who shared my enthuisasm. . . . Later, when Curt Valentin died, Arp sent all his sculptures and reliefs to me, and we became the sole representatives of Arp; and it was amusing at the time that I didn't take on his artists who were more desired by collectors than Arp—such as Moore and Calder and one or two others who were famous—but I was quite happy with Arp." —Interview, June 1967

Acquires Delaunay's *Windows*.

Essay on Picasso included in catalogue of exhibition "Picasso, Gris, Miró: The Spanish Masters of Twentieth Century Painting," San Francisco Museum of Art, September 14–October 17; Portland Art Museum, October 26–November 28, 1948.

September 21: Sidney Janis Gallery opens at 15 East Fifty-seventh Street, New York.

Exhibitions, first season:

September 21–October 16, 1948	"F. Léger: 1912–1948"
October 19–November 6	"Evsa Model"
November 9–27	"Kandinsky"
Through December 24	"Lucia"
December 27, 1948–January 22, 1949	"The Early Delaunay"
January 24–February 12	"Albers: Paintings Titled Variants"
February 14–March 12	"xx Century Painting"
March 14–April 2	"Matta: Color-Drawing 1937–1948"
April 11–May 14	"Modern Primitive Painters: French & American"
May 16–June 11	"Post-Mondrian Painters"

Offerings of first season already indicative of direction gallery will follow, with exhibitions ranging from major retrospectives of established modern masters to group shows of more

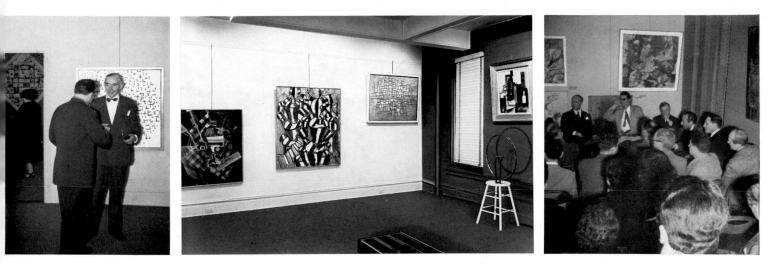

Left, Janis, his back to the camera, chatting with the director of the Kröller-Müller Museum, Holland, at the opening of the 1949 Mondrian exhibition; center, installation of "Climax in 20th Century Art, 1913" at the Sidney Janis Gallery; right, participants in the symposium "Parallel Trends in Vanguard Art in the U.S. and France": facing the camera, Bradley Walker Tomlin, Leo Castelli, Frederick Kiesler, Nicolas Calas, Theodore Brenson (moderator), and Richard Huelsenbeck

immediate contemporaries, and including styles as diverse as Cubism, Expressionism, Surrealism, varying types of abstraction, and modern primitives. Exhibition of Delaunay, first one-man show of his work in United States.

1949–50 Exhibitions, second season:

September 19–October 8, 1949	"Artists: Man & Wife"
October 10–November 12	"Piet Mondrian: Paintings 1910 through 1944"
November 21–December 24	"Kandinsky"
December 27, 1949–January 28, 1950	"Vivin"
January 30–February 25	"Paintings in Collaboration: Arp & S. Taeuber-Arp"
February 27–March 25	"20th Century Old Masters"
April 3–22	"Joaquín Torres-García"
April 24–May 20	"xxth Century Young Masters"
June 12–24	"Xceron"

Season opens with theme show featuring artists who are man and wife, including Willem and Elaine de Kooning, Jackson Pollock and Lee Krasner, Hans Arp and Sophie Taeuber-Arp, Ben Nicholson and Barbara Hepworth. Second exhibition, Mondrian retrospective, first comprehensive showing of artist's work in United States. Exhibition of Torres-García, planned in cooperation with him as retrospective, becomes memorial following his death before show's opening; Janis acquires *Constructive Painting* from this exhibition. "20th Century Old Masters" includes works by Bonnard, Braque, de Chirico, Duchamp, Gris, Kandinsky, Klee, Léger, Matisse, Modigliani, Picasso, Rouault, and Soutine; "xxth Century Young Masters" includes Brauner, Dali, Delvaux, Dubuffet, Ernst, Giacometti, Lam, Magritte, Matta, Miró, Tanguy.

1950–51 Exhibitions, third season:

September 25–October 21, 1950	"Challenge and Defy: Extreme Examples by xx Century Artists, French & American"
October 22–November 11	"Young Painters in U.S. & France"
November 13–December 23	"Les Fauves"
January 2–February 3, 1951	"Climax in 20th Century Art, 1913"
February 5–March 17	"Piet Mondrian"
March 19–April 7	"Early Léger"
April 16–May 5	"Matta"
May 7–June 2	"Painters of de Stijl"
June 4–30	"Delvaux"

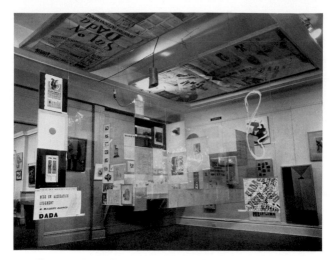

Installation of "Dada 1916–1923" at the Sidney Janis Gallery
in April–May 1953

Following opening exhibition, "Challenge and Defy," devoted to theme of artist as rebel,
exhibition "Young Painters in U.S. & France," organized by Leo Castelli, features work of
avant-garde European artists and American Abstract Expressionists Gorky, de Kooning,
Kline, Pollock, and Rothko. It generates so much interest that Galerie de France invites
Sidney Janis Gallery to organize group show of that tendency for exhibition in Paris fol-
lowing year. November 10: Open meeting held at SJG to discuss "Parallel Trends in Van-
guard Art in the U.S. and France," moderated by Theodore Brenson and with Leo Castelli,
Clement Greenberg, Harold Rosenberg, Frederick Kiesler, Nicolas Calas, and Andrew
Carnduff Ritchie as participants. "Les Fauves" includes forty-six paintings by Braque,
Derain, Dufy, Matisse, van Dongen, Vlaminck, and others. For "Climax in 20th Century
Art, 1913," demonstrating importance of that year in annals of modern art, Janis writes
broadside charting movements leading up to and away from that date; with Janis's collab-
oration, Duchamp re-creates his *Bicycle Wheel* for show.
Publication of book on jazz by Rudi Blesh and Harriet Janis, *They All Played Ragtime*
(New York: Alfred A. Knopf, 1950).

1951–52 Exhibitions, fourth season:
 September 17–October 27, 1951 "Brancusi to Duchamp"
 November 5–December 22 "Henri Rousseau"
 December 26, 1951–January 5, 1952 "American Vanguard Art for Paris Exhibition"
 January 7–26 "Albers: Homage to the Square; Transformations
 of a Scheme"
 January 28–February 16 "Saul Steinberg: Drawings"
 February 18–March 22 "French Masters 1901–50"
 March 31–April 22 "Ancient Tarascan Art"
 April 28–May 31 "Season's Résumé"
 Catalogue for "Henri Rousseau" includes essay by Tristan Tzara, "Le Douanier Henri
 Rousseau: The Role of Time and Space in His Work." Group show of Abstract Expression-
 ists ("American Vanguard Art...") prepared at invitation of Galerie de France shown at
 SJG before being sent to Paris; it includes works by Baziotes, Brooks, de Kooning, Gorky,
 Gottlieb, Guston, Hofmann, Kline, Motherwell, Pollock, Reinhardt, Tobey, and Tomlin.

1952–53 Exhibitions, fifth season:
 September 15–October 11, 1952 "Fernand Léger"
 October 13–November 8 "Kurt Schwitters"
 November 10–29 "Jackson Pollock"
 December 8–29 "Aubusson Tapestries by 12 Abstract Artists"

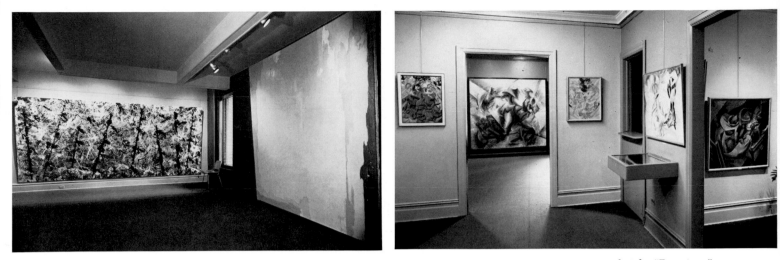

Two exhibitions from the 1953–54 season: left, "9 American Painters Today," featuring Abstract Expressionist artists, and right "Futurism," one of the first major exhibitions of that style in the U.S.

December 29, 1952–January 17, 1953	"Recent Paintings by Herbin"
January 19–February 14	"French Masters 1905–1952"
February 16–March 14	"Arshile Gorky in the Final Years"
March 16–April 11	"Willem de Kooning"
April 15–May 9	"Dada 1916–1923"

Season characterized by five notable one-man shows, opening with one devoted to Léger and followed by exhibition of Schwitters' collages, paintings, reliefs, and sculpture, which subsequently travels to Arts Club of Chicago (November 25–December 16); its catalogue includes essay by Tristan Tzara, translated by Duchamp. Pollock leaves Betty Parsons, goes to SJG and is given one-man show in November; Gorky and de Kooning exhibitions in the spring are also first one-man shows of these artists at SJG. De Kooning's includes paintings from Woman series, arousing great controversy among Abstract Expressionists because of artist's seeming return to figurative painting. Herbin's *Composition on the Word "Vie,"* 2 among paintings in his midwinter exhibition. Season ends with "Dada 1916–1923," arranged by Duchamp, who also designs catalogue—large sheet of paper crumpled into ball and including statements by Tzara, Arp, Richard Huelsenbeck, and Jacques Levesque.

1953–54	Exhibitions, sixth season:	
	September 29–October 31, 1953	"5th Anniversary Exhibition: 5 Years of Janis"
	November 2–30	"50 Years of Mondrian"
	December 7, 1953–January 2, 1954	"Recent French Acquisitions"
	January 4–23	"9 American Painters Today"
	February 1–27	"Jackson Pollock"
	March 1–20	"Magritte: Word vs Image"
	March 22–May 1	"Futurism"
	May 3–24	"French Art"

Opening exhibition comprises selection of notable works lent by collections to which they had been sold by SJG during its first five years. Davis, de Kooning, Gorky, Hofmann, Kline, Pollock, Rothko, Still, and Tobey are nine artists included in "9 American Painters Today." For gallery's second one-man show of Pollock, Janis urges him to go back to naming rather than numbering his paintings; as he recalls:

"I thought it might be confusing for historians. He gave the matter consideration, taking into account not only the historian, the critic, and the observer, but also that it wasn't even original . . . and it became monotonous. About six weeks before his exhibition, his trucker—the Home Sweet Home movers—delivered his works to the gallery, and he came in with his wife, Lee Krasner, from Springs, where they were living by that time. One of

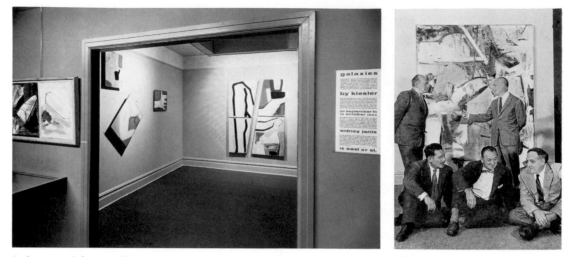

Left, view of the installation of Kiesler's Galaxies at the Sidney Janis Gallery in 1954; right, Mark Rothko and Willem de Kooning (standing) and Franz Kline, Sidney Janis, and Philip Guston (seated) in front of *Easter Monday*, 1955, at opening of de Kooning's one-man show at the Janis Gallery, 1956

the first things he said was, 'I've been ruminating about this idea of naming these pictures, but I don't have a single title.' Lee shook her head in despair, but at that moment she was called to the telephone. The pictures were spread around the showroom, and he began to study them. Suddenly he pointed to one picture and said, 'That picture is *Sleeping Effort*'; he pointed to another and gave that another poetic title. I jotted down the titles as quickly as I could, and in about fifteen minutes, he had hit upon at least fifteen beautiful, poetic titles. When Lee returned, I reeled off the titles, and she was incredulous, but exclaimed, 'Marvelous!'" —Interview, June 1967

Buys *The Palace of Curtains, III* from exhibition "Magritte: Word vs Image," but only one painting from that show is sold to the public; it is bought by Saul Steinberg. "Futurism," one of first major exhibitions of that movement to be held in United States, includes works by Balla, Boccioni, Carrà, Russolo, and Severini; among them is Boccioni's *Dynamism of a Soccer Player*, acquired from Donna Benedetta Marinetti, widow of founder of Futurism. Decides to sell Rousseau's *The Dream*; in fulfillment of promise made years before to Alfred H. Barr, Jr., offers it first to The Museum of Modern Art, which, however, does not have purchase funds available. At the suggestion of Alfred Barr, it is then offered to Nelson Rockefeller, who buys it, considers hanging it in his Washington house, but, finding it too large for the space there, donates it to the Museum on occasion of its Twenty-fifth Anniversary.

1954–55 Exhibitions, seventh season:
 September 27–October 19, 1954 "Galaxies by Kiesler"
 October 25–November 29 "xxth Century Masters"
 December "Ceramics by Léger"
 Opens January 3, 1955 "Matta: New Paintings"
 January 31–February 26 "Acting Colors by Josef Albers"
 February 28–April 9 "Selection of French Art: 1906–1954"
 April 11–May 14 "New Paintings: Rothko"
 Season's one-man shows include SJG's first of Rothko, who had recently joined the gallery. January 19, 1955: Acquires Eilshemius's *Samoa* at Parke-Bernet auction of collection of Henry McBride, who after an initial hostile reaction had become (along with Duchamp) an early and enthusiastic advocate of Eilshemius's work.

1955–56 Exhibitions, eighth season:
 September 26–October 22, 1955 "Drawings for Principal Paintings by Gorky"
 October 24–November 26 "New Arrivals from France: Selected Examples by Artists from Picasso to Giacometti"

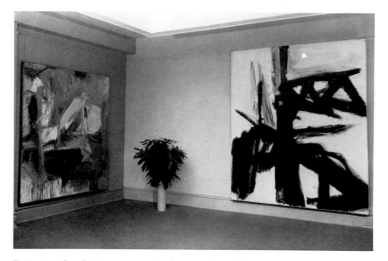

Paintings by de Kooning and Kline in the exhibition of "8 Americans"
at the Sidney Janis Gallery in April 1957

November 28–December 31 "15 Years of Jackson Pollock"
January 3–February 4, 1956 "Cubism 1910–1912"
February 6–March 3 "Recent Paintings by Philip Guston"
March 5–31 "Franz Kline"
April 2–28 "Willem de Kooning"
April 30–May 19 "Younger Americans: Brach, Goldberg,
 Goodnough, Mitchell"
May 21–June 9 "Recent Acquisitions of European Art 1911–1950"

Among season's five one-man shows devoted to leading Abstract Expressionists, those of Guston and Kline are their first at SJG. Group show of "Younger Americans" features four among "second-generation" artists of that tendency.

December 7, 1955: Acquires Macdonald-Wright's *Synchromy in Blue* at Parke-Bernet auction.

"The picture went at a very reasonable price; and on the way out two different collectors stopped me and asked me if I would sell them the picture at a profit. Why they didn't bid on it, I'll never know! I wasn't through bidding by any means when I bought it; but sometimes it happens that way. . . . And having that picture, incidentally, in the same room with the *Footballer* [*Dynamism of a Soccer Player*] by Boccioni is quite an experience. The Boccioni was painted in 1913 and this was painted in 1916, and actually I have found forms in the Macdonald-Wright that look identical to images in the Boccioni. . . . Now and then a passage in the Macdonald-Wright canvas—in the handling of light or form—reveals interestingly a conscious or unconscious influence of the one painter upon the other.
—Interview, June 1967

1956–57 Exhibitions, ninth season:
September 24–October 20, 1956 "Recent Paintings by 7 Americans"
October 22–November 17 "57 Collages by Kurt Schwitters"
November 19–December 29 "Selection of 20th Century Paintings 1905–1955"
January 2–February 2, 1957 "Léger: Major Themes"
February 4–March 2 "Fautrier"
March 4–30 "51 Paintings by Alexei von Jawlensky"
April 1–20 "8 Americans"
April 22–May 11 "Selection of Modern Art from Brancusi to
 Giacometti"
May 13–June 8 "Robert Motherwell"

Opening show of season includes as "7 Americans" Albers, de Kooning, Gorky, Guston, Kline, Pollock, and Rothko; same group comprised in April exhibition of "8 Americans,"

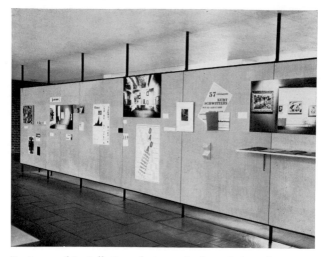

Posters and installation photographs from Sidney Janis
Gallery exhibitions on view at Hetzel Union Gallery,
Pennsylvania State University, in February 1958

with addition of Motherwell, who is given first one-man show at sJG in late spring. One-man shows by European artists include one of the Expressionist Jawlensky and another by Fautrier, whose "*art informel*" is often considered an independent development analogous to American Abstract Expressionism.

1957–58	Exhibitions, tenth season:
	September 30–November 2, 1957 "Mondrian"
	November 4–30 "40 Drawings by Jackson Pollock"
	December 2–28 "33 Paintings by Arshile Gorky"
	December 30, 1957–January 25, 1958 "New Acquisitions of 20th Century Paintings & Sculpture"
	January 27–February 22 "New Paintings by Mark Rothko"
	February 24–March 22 "Philip Guston"
	March 24–April 19 "Albers: 70th Anniversary Exhibition"
	April 21–May 17 "Modern French Tapestries by Braque, Léger, Matisse, Miró, Picasso, Rouault"
	May 19–June 14 "New Paintings by Franz Kline"

January 6–27, 1958: Harriet Janis has first one-man show (pastels) at Zabriskie Gallery, New York; reviewer in *Art News* describes them: "Her images, derived from sunlight, have a flickering fin-de-siècle feeling and the color has the memory of sunlight."

February 3–24: Artists associated with sJG shown in "An Exhibition in Tribute to Sidney Janis," Hetzel Union Gallery, Pennsylvania State University. On this occasion, Clement Greenberg writes an "appreciation" of Janis:

". . . Sidney Janis started visiting the studios of artists like Arshile Gorky, Willem de Kooning, and Jackson Pollock when their names were not known beyond the circle of their friends and acquaintances. He wrote about them and reproduced examples of their work in one of the very first books [*Abstract & Surrealist Art in America*] that so much as noticed the 'movement' which they and a few other painters in New York were beginning to constitute. . . . In that book Baziotes, Carles, Adolph Gottlieb, Hofmann, Motherwell, Pollock, Rothko, de Kooning, Gorky, and other Americans were discussed and illlustrated—without apology or qualification—side by side with Braque, Chagall, Kandinsky, Léger, Mondrian, and Picasso.

"When Sidney Janis opened his gallery in New York, in September 1948, he did not show many American artists. His 'strategy' . . . was in line with that of his book. First he made of his place a kind of museum-cum-seminar. The 20th century masters—from Bonnard to Miró—were exhibited in a depth and variety, as well as with an exertion of taste, that no

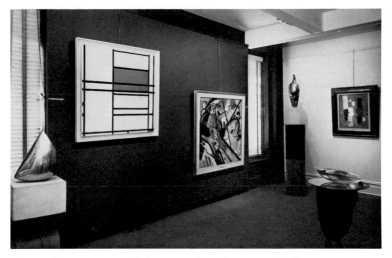

The tenth anniversary exhibition at the Sidney Janis Gallery in
September–November 1958

formal museum in the country was able to match. ... This was the context in which he
began, after a while, to present American art consistently. His policy not only implied, it
declared, that Pollock, de Kooning, Kline, Guston, Rothko, and Motherwell were to be
judged by the same standards as Matisse and Picasso, without condescension, without
making allowances. ...
"Sidney Janis's success has been a commercial as well as artistic one, and more power to
him for that. ... Self-respect as well as material welfare was at stake. The real issue was
whether ambitious artists could live in this country by what they did ambitiously. Sidney
Janis helped as much as anyone to see that it was decided affirmatively. ..."

1958–59 Exhibitions, eleventh season:
 September 29–November 1, 1958 "10th Anniversary Exhibition: X Years of Janis"
 November 3–29 "Jackson Pollock"
 December 1, 1958–January 3, 1959 "Selection"
 January 5–31 "8 American Painters"
 February 2–March 7 "75 Collages by Schwitters"
 March 9–April 4 "Robert Motherwell"
 April 6–May 2 "Marcel Duchamp"
 May 4–30 "Willem de Kooning"
 Opening exhibition consists of thirty-eight loans of works of art sold by the gallery during its
 first ten seasons; catalogue also reproduces thirty-seven other works not available for ex-
 hibition. Spring exhibition of Duchamp is one of very few one-man shows ever devoted
 to him during his lifetime.
 Spring 1959: In article on outstanding galleries and dealers, Kenneth Sawyer assesses sjg
 ("The Importance of a Wall," *Evergreen Review*, New York, Spring 1959, pp. 133–135):
 "... it is the Sidney Janis Gallery that commands the most respectful attention today. ...
 He has selected his group astutely and promoted its work with singular success ... a veri-
 table pantheon of contemporary Americana. ... As well, Mr. Janis has been an ardent par-
 tisan of French art in America. ...
 "Sidney Janis is a thoughtful, enterprising man with a large and remarkably faithful clien-
 tele; ... he has been, on the whole, perhaps the most successful promoter of contemporary
 Americans. More important, collectors and museum directors are aware that in dealing
 with Janis they are dealing with a man who knows and provides the best."

1959–60 Exhibitions, twelfth season:
 September 28–October 24, 1959 "35 Selected Drawings from the Late Work of
 Arshile Gorky"

Installation of "European Artists from A to V," Sidney Janis Gallery, in January 1961

October 26–November 28	"New Acquisitions"
November 30–December 26	"Albers"
December 28, 1959–January 23, 1960	"29 Recent Paintings by Philip Guston"
January 25–March 5	"Examples of the Classic Phase of Arp & Mondrian"
March 7–April 2	"New Paintings by Franz Kline"
April 4–23	"9 American Painters"
April 25–May 21	"Picasso"
May 23–June 11	"Kemeny"

Baziotes added to artists included in group shows of two previous seasons to make up "9 American Painters."

Publication of monograph *de Kooning* by Harriet Janis and Rudi Blesh (New York: Evergreen Gallery Books, no. 8, 1960).

April 15–May 15; "Catalogues and Posters of Exhibitions at the Sidney Janis Gallery, 1948–1960" shown in Commons Lounge, Bennington College, Bennington, Vermont.

1960–61 Exhibitions, thirteenth season:

October 3–November 5, 1960	"xxth Century Artists"
November 7–December 3	"Gottlieb"
December 5, 1960–January 7, 1961	"Léger"
January 9–February 4	"European Artists from A to V"
February 13–March 11	"New Paintings by Philip Guston"
March 13–April 8	"William Baziotes"
April 10–May 6	"Recent Paintings and Collages by Robert Motherwell"
May 8–June 3	"10 American Painters"

Gottlieb receives first one-man show at SJG, and his work is added to that of nine artists included in group show of previous season to constitute "10 American Painters."

Publication of extensive "profile" of Sidney Janis, "Why Fight It?" by James Brooks, in *The New Yorker*, November 12, 1960; it begins:

"Art and commerce, it is generally assumed, are forces as inexorably opposed as weight and buoyancy. A successful commercial dealer in works of art, for whom these forces apparently defy natural law by pulling in the same direction, therefore lives permanently in a state of paradox. In fact, an ideal art dealer should probably be something of a paradox himself, and on this count Sidney Janis, the leading dealer in what is currently by far the most favored style of contemporary American painting—Abstract

Installation of "New Realists," the first Pop art group show at Sidney Janis Gallery

Expressionism—qualifies superbly. For one thing, Janis, a former vaudeville hoofer and shirt manufacturer who never went to college and has no formal art education, is considered one of the most scholarly and historical-minded of New York's horde of art dealers. For another, although Janis . . . has the reputation of being an art merchant as shrewd, unsentimental, and calculating as any frontier horse trader or Stock Exchange specialist, he is noted for his open-faced simplicity and naïve enthusiasm in defending a picture's artistic merit or place in art history, and for the patient, bland earnestness of his efforts to educate the unenlightened to his point of view. . . . Janis's knack for selling pictures is undoubtedly related to his ability to explain their importance in the history of art and, at the same time, to communicate his own enthusiasm for them."

Harriet Janis meets Yves Klein during his monochrome show at Leo Castelli Gallery (April 4–29, 1961); they discover their mutual interest in jazz and become friends.

April 8–May 7: Exhibition of "The Sidney Janis Painters" at John and Mable Ringling Museum of Art, Sarasota, Florida; catalogue introduction by Dore Ashton, foreword by Kenneth Donahue who writes a "Tribute to Sidney Janis," calling him the gallery-owner who represents "the greatest number of those American artists who occupy for students today the place which Picasso held a generation ago."

June 28: Janis reacquires at Sotheby's auction, London, Pollock's *Free Form*, paying about $14,000; five years earlier, this had been the first Pollock sold by SJG and went for less than $300—which Janis terms "a wry commentary on my own judgment."

1961–62 Exhibitions, fourteenth season:

October 2–28, 1961	"Albers"
October 30–December 2	"A Selection of Paintings & Sculpture from the Gallery Collection"
December 4–30	"New Paintings by Franz Kline"
January 2–February 4, 1962	"Paintings by Mondrian, Early and Late and Work in Process"
February 5–March 3	"Paintings by Arshile Gorky from 1929 to 1948"
March 5–31	"Recent Paintings by Willem de Kooning"
April 2–May 5	"50 Collages by Kurt Schwitters"
May 7–June 2	"10 American Painters"

Publication of *Collage: Personalities, Concepts, Techniques* by Harriet Janis and Rudi Blesh (Philadelphia and New York: Chilton Company, 1962); condensation, "Collage," appears in *Craft Horizons* (New York), vol. 22, October 1962, pp. 30–33, 48.

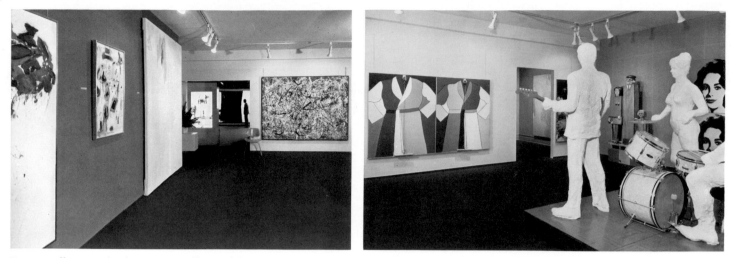

Two installations of Sidney Janis Gallery exhibitions; left, "11 Abstract Expressionist Painters," October–November 1963, and right, "A Selection of 20th Century Art of 3 Generations," November–December 1964

1962–63	Exhibitions, fifteenth season:	
	October 1–27, 1962	"16 Recent Paintings by Adolph Gottlieb"
	November 1–December 1	"New Realists"
	December 4–29	"New Paintings and Collages by Robert Motherwell"
	January 2–29, 1963	"New Wood Sculpture in Black, White, and Gold by Louise Nevelson"
	February 4–March 2	"New Paintings by Jim Dine"
	March 4–30	"New Paintings by Josef Albers"
	April 1–27	"Arman"
	April 29–May 25	"Sculpture by Jean Arp in Marble, Bronze, and Wood Relief from the Years 1923–63"

In addition to SJG's first one-man shows of Nevelson and Arman, season is distinguished for giving impetus to Pop art. "New Realists" is a large assemblage of works by seventeen European artists (from England, France, Italy, and Sweden) and twelve Americans working in this tendency; show housed in SJG and rented store farther along Fifty-seventh Street. Among works included are Dine's *Five Feet of Colorful Tools* (which Janis acquires from show), Rosenquist's *Marilyn Monroe, I,* and Oldenburg's *Pastry Case, II* (Collection Mr. and Mrs. Morton C. Neumann, Chicago). Later in season, Janis gives Dine one-man show.

From Oldenburg's one-man show at Green Gallery (September 18–October 13, 1962), Janis buys *Pastry Case, I*—his first Pop art acquisition, followed by Rosenquist's *Marilyn Monroe, I* and Dine's *Five Feet of Colorful Tools.*

"*Pastry Case* is so luscious, I always sort of drool over it. Not only the grandchildren but some of the neighbors express a marked interest in this piece; little visitors coming to the house want to be picked up so that they can examine closely those chocolate cookies and ice-cream sundaes, and that gives us a lot of pleasure."

"When I bought *Marilyn Monroe,* Rosenquist was incredulous that I wanted it; he kept shaking his head and saying, 'This is too much.'" —Interview, June 1967

1963–64	Exhibitions, sixteenth season:	
	October 7–November 2, 1963	"11 Abstract Expressionist Painters"
	November 4–30	"Paintings, Drawings and Watercolors by Piet Mondrian"
	December 3–28	"Franz Kline: Memorial Exhibition"
	January 3–February 1, 1964	"4 Environments by 4 New Realists"

Installation of "Pop & Op" at the Sidney Janis Gallery
in December 1965

February 4–29	"The Classic Spirit in 20th Century Art"
March 3–April 4	"2 Generations: Picasso to Pollock"
April 7–May 2	"Recent Work by Claes Oldenburg"
May 5–29	"7 New Artists"

Opening show of season, directed by William Rubin, includes de Kooning, Francis, Gorky, Gottlieb, Guston, Kline, Motherwell, Newman, Pollock, Rothko, and Still. Two Pop shows are "4 Environments by 4 New Realists" (Dine, Oldenburg, Rauschenburg, and Rosenquist), for which Oldenburg creates *Bedroom Ensemble* (reproduced at MOMA retrospective of his work, 1969), and one-man show of Oldenburg on Home theme. Final show, "7 New Artists," includes Arakawa, Bell, Hinman, Irwin, Ives, Slutzky, and Whitman.
November 11, 1963: Harriet Grossman Janis dies after long illness.

1964–65 Exhibitions, seventeenth season:

September 28–October 24, 1964	"40 New Paintings by Josef Albers: Homage to the Square"
October 27–November 21	"Jim Dine"
November 24–December 26	"A Selection of 20th Century Art of 3 Generations"
December 29, 1964–January 27, 1965	"Arman"
January 26–February 27	"Abstract Trompe l'Oeil"
March 2–April 3	"Morris Hirshfield, 1872–1946, American Primitive Painter"
April 6–May 1	"Recent Painting by Ellsworth Kelly"
May 5–30	"Recent Work by Arman, Dine, Fahlström, Marisol, Oldenburg, Segal"

SJG's offerings during season epitomize Janis's wide range of interests over many years, including in "3 Generations" Cubists and Surrealists, Abstract Expressionists, and Pop artists—who are also featured in Dine's one-man show and group show concluding season; geometrical abstraction is represented by Albers, Op art by "Abstract Trompe l'Oeil," minimal art by Kelly, assemblage by Arman, and American primitives by Hirshfield.
Janis acquires Still's *Painting*, which he had first seen in artist's one-man show at Albright Art Gallery, Buffalo (November 5–December 13, 1959).

1965–66 Exhibitions, eighteenth season:

October 4–30, 1965	"New Sculpture by George Segal"
November 3–27	"New Paintings by Richard Anuszkiewicz"
December 1–31	"Pop & Op"
January 5–February 5, 1966	"Recent Paintings by Vasarely"

View of the January 1968 exhibition of The Sidney and Harriet Janis Collection
at The Museum of Modern Art

February 8–March 5	"Old Masters in xxth Century European Art"
March 9–April 2	"New Work by Claes Oldenburg"
April 13–May 7	"New Work by Marisol"
May 10–June 4	"New Paintings by Wesselmann"

Season dominated by two contrasting tendencies, Pop and Op; aside from exhibition pairing them, former is represented in one-man shows by Segal, Oldenburg, Marisol, and Wesselmann, and latter by one-man shows of Anuszkiewicz and Vasarely.

1966–67 Exhibitions, nineteenth season:

October 3–29, 1966	"Erotic Art '66"
November 1–26	"New Paintings, Sculpture & Drawings by Jim Dine"
November 29–December 24	"Recent Work by Saul Steinberg"
January 3–27, 1967	"Selected Works from 2 Generations of European & American Artists: Picasso to Pollock"
February 1–25	"New Works by Öyvind Fahlström"
March 1–25	"New Work by Ellsworth Kelly"
March 29–April 22	"New Work by George Segal"
April 26–May 27	"New Work by Claes Oldenburg"

Opening show of season, "Erotic Art '66," including work by twenty-one Pop artists, elicits vigorous response from public and critics.

June 1967: Announcement of gift of The Sidney and Harriet Janis Collection to The Museum of Modern Art. Janis offers 103 works in his personal collection to the Museum, under terms that allow them to be shown as a group immediately, both in United States and abroad, and separately thereafter whenever deemed desirable. He also provides that within ten years after his death, the Museum may dispose of any work in order to acquire others consistent with spirit of original collection, particularly by artists of then prevailing avant-garde. Gift includes many very recent works, including three portraits of Janis himself (not yet completed at time of gift) by Marisol, Segal, and Warhol, and Oldenburg's *Giant Soft Fan*, then hanging in U.S. Pavilion at Expo '67, Montreal.

1968–69 January 12, 1968: Museum announces that owing to Sidney Janis's generosity, he has amended original terms of his gift in order to enable the Museum to acquire Pollock's *One*, 1950 (formerly Collection Mr. and Mrs. Ben Heller, New York); it is immediately placed on view in Museum's Main Hall.

January 17–March 4, 1968: The Sidney and Harriet Janis Collection is shown at The Museum of Modern Art; foreword for checklist written by Alfred H. Barr, Jr.

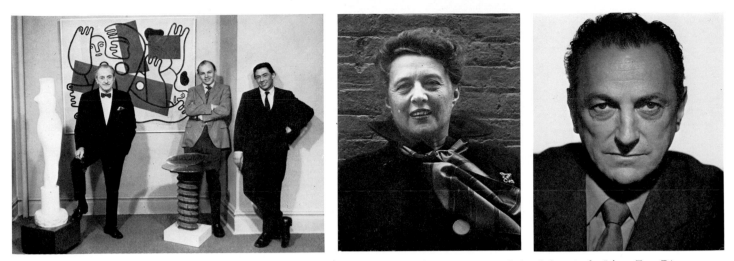

Left, Janis with his sons Conrad and Carroll at the Sidney Janis Gallery, 15 East 57th Street, in 1968; behind them is the Léger *Two Divers*, part of the Janis collection; center and right, Harriet and Sidney Janis as photographed in the 'fifties

Collection begins tour of United States on following itinerary: The Minneapolis Institute of Arts, May 15–July 28, 1968; The Portland Art Museum, September 13–October 13; The Pasadena Art Museum, November 11–December 15; San Francisco Museum of Art, January 13–February 16, 1969; Seattle Art Museum, March 12–April 13; Dallas Museum of Fine Arts, May 14–June 8; Albright-Knox Art Gallery, Buffalo, September 15–October 19; Cleveland Museum of Art, November 18–January 4, 1970.

1970–71 On completion of its American tour in January 1970, The Sidney and Harriet Janis Collection is sent abroad on European tour: Kunsthalle, Basel, February 28–March 30, 1970; Institute of Contemporary Arts, London, May 1–31; Akademie der Künste, Berlin, June 12–August 2; Kunsthalle, Nürnberg, September 11–October 25; Württembergischer Kunstverein, Stuttgart, November 11–December 27; Palais des Beaux-Arts, Brussels, January 7–February 11, 1971; Kunsthalle, Cologne, March 5–April 18.

PHOTOGRAPH CREDITS